SOUTHERN
ARIZONA
FOLK ARTS

S☀UTHERN ARIZ☀NA F☀LK ARTS

JAMES S. GRIFFITH

THE UNIVERSITY OF ARIZONA PRESS
TUCSON

The University of Arizona Press
Copyright © 1988
The Arizona Board of Regents
All Rights Reserved

Manufactured in the U.S.A.
This book was set in 11/13 Linotron 202 Aldus.

Library of Congress Cataloging in Publication Data

Griffith, James S.
 Southern Arizona folk arts / James S. Griffith.
 p. cm.
 Includes bibliographies and index.
 ISBN 0-8165-1001-6 (alk. paper)
 1. Ethnic arts—Arizona. I. Title.
NX510.A6G75 1988 88-17471
700'.9791—dc19 CIP

British Library Cataloguing in Publication data are available.

Contents

Illustrations

Acknowledgments

A book such as this one may be written by one person, but it almost inevitably reflects the research and insights of many. Such is indeed the case in this instance. Some of those to whom I am indebted are the authors of works cited in the bibliographic essays; others are listed here.

Over the course of writing the whole book I have freely consulted and discussed ideas with Bernard Fontana of the University of Arizona Library and Larry Evers of the same institution's English Department. They have listened patiently to my ideas and offered excellent advice and criticism. Each read and commented upon an early stage of the manuscript as well.

Kathe Kubish has developed much of my film and printed most of the pictures used in this book. Helga Teiwes and the Arizona State Museum supplied a photograph, as did Tucson Meet Yourself photographers Gary Tenen, Helga Teiwes, David Burckhalter, and Bill Doyle. Tom Harlan did some emergency darkroom work.

I am indebted to the Provost's Author Support Fund of the University of Arizona for a grant to help with the expense of publishing this manuscript.

For the chapter on Mexican-American folk art, I have relied heavily on the perceptions and common sense of my good friend Richard Morales. His influence can also be detected in much of Chapter 2. Celestino Fernández shared his ideas on corridos, as did James Officer. All three have been my companions in fieldwork; with all three I share some fine memories.

Much of my interest in the Tohono O'odham was stimulated by Bernard Fontana, who has provided many ideas and much insight. Danny Lopez, Daniel Joaquin, and Blaine Juan have each helped me greatly in my attempts to understand their rich cultural traditions. Ted Rios accompanied me on most of my earlier trips to visit O'odham folk chapels; he was a fine companion and source of understanding.

For my initial interest in and understanding of Yaqui traditional arts I am indebted to the late Edward H. Spicer. Among the most important things I learned from him was that respect for other cultural traditions could be expressed by accurate reporting of those traditions for a wider audience. I was privileged to know the late Muriel Thayer Painter and to learn from her concerning Yaqui Easter. Felipe Molina taught me much about pascola and deer-dance traditions and the complex ideas that lie behind them.

Robert K. Thomas of the American Indian Studies Program of the University of Arizona has provided constant insight into Native American traditions, especially powwow. I am indebted to him for inviting me to serve on the Wa:k Pow Wow committee, thus enabling me to learn about that tradition from the inside. Tom Wolff has cleared up much confusion concerning powwow songs and dance and regalia styles.

The late Van Holyoak introduced me to many aspects of traditional cowboy culture, among them biscuit cooking, poetry reciting, and some magnificent "windies." As another old-timer remarked to Van's widow, "He was one of us, and there ain't many of us left." I am proud to have been his friend. Pat Jasper of Texas Folklife Resources, Inc., shared some good ideas with me. Mike Korn of the Montana Folklife Project discussed cowboy lore and equipment and all kinds of western music with me; his mark lies on this book.

Worth Long of Atlanta, Georgia, made a trip to Arizona to introduce me to Afro-American folk culture. I shall always be in his debt. Pack Carnes has provided constant encouragement and ideas, specifically concerning Asian cultures, but his hand has touched much

of this book. Carol Kestler and Rabbi Joseph S. Weizenbaum were most helpful concerning traditional Jewish arts and culture. Karen Seger offered suggestions about the Middle East as it manifests itself in southern Arizona. Bess Hawes of the Folk Arts Division of the National Endowment for the Arts has always encouraged me and every other folklorist working in the public sector and inspired us to do better than we knew how. My public-sector colleagues in the western states have given freely of ideas, support, and enthusiasm.

A lot of people have accompanied me in the field. Some are folk artists, some colleagues, some friends, some relatives. Among the latter, my wife, Loma, and my children, Kelly and David, deserve special recognition and thanks. They suffered through much, helping with fieldwork, listening to agonies of indecision, and most particularly working on fourteen years of a folklife festival.

In addition to these good friends, I am indebted to a host of men, women, and children, some named in this book and many more anonymous. Tortilla cooks, fiddlers, poets, Easter-egg decorators and many, many others have provided the inspiration for my work over the last twenty years. They are the folk artists of Arizona and Sonora, and life would be far different and much less pleasant were they not among us. This book is dedicated to them all with my respect and gratitude, and in the hope that I "got some of it right."

SOUTHERN ARIZONA FOLK ARTS

Introduction

In 1853, James Gadsden, the American Minister to Mexico, negotiated an agreement whereby that country was to sell 29,670 square miles of land to the United States. This parcel—the Gadsden Purchase—included virtually all of what is now Arizona south of the Gila River. It is a vast, varied country, which includes pine-covered mountain ranges, rich river valleys, parts of the Chihuahuan and Sonoran deserts, and, toward the west, a stretch so hot and dry that to this day it is called El Camino del Diablo—The Devil's Road. The Tohono O'odham, formerly called the Papago Indians, live in the territory covered by the Gadsden Purchase. So do miners, ranchers, farmers, and an increasing number of city dwellers. Since the Second World War, this region of mild winters (but often brutally hot summers) has seen an unprecedented influx of settlers. They have been drawn here by the University of Arizona, by Fort Huachuca and Davis-Monthan Air Force Base, and by the lure of business opportunities, the Southwestern spaces and life-style, and by the climate.

This book is an introduction to the public, traditional arts (often called folk arts) of the peoples of southern Arizona. Although it concentrates on the Tucson area, much of what it says is applicable

1

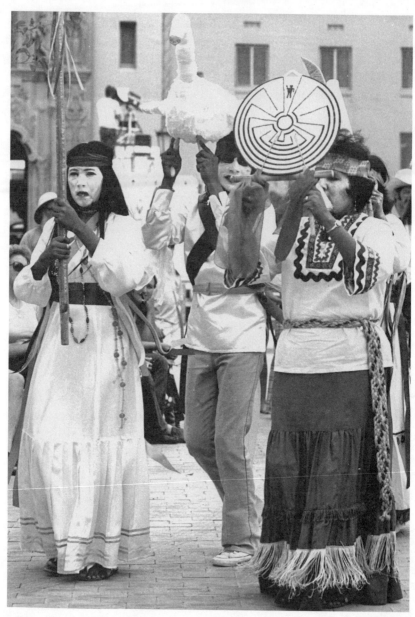

Folk art in a public setting. Members of The Desert Indian Dancers, a Tohono O'odham dance team, perform a *chelkona* dance at the first edition of Tucson Meet Yourself, October 1974. The woman to the right holds a flat basket with the I'itoi ki motif; the young man carries a representation of one of the large white birds that are believed to herald rain on the desert. All have their faces painted white for the dance. In the background is part of the facade of the old Pima County Courthouse, a 1920s stylistic recognition of Tucson's Spanish colonial heritage. *Photo by Gary Tenen, courtesy of the Southwest Folklore Center.*

throughout southeast and south central Arizona. Yuma, isolated from the rest of Arizona by a particularly harsh stretch of desert, has remained culturally distinct from other parts of the land of the Gadsden Purchase. But much of the music, food, and other art forms described herein can be found anywhere south of the Gila River.

By limiting this book to publicly accessible folk art, I have excluded many important categories of folklore and other folk art: legends, traditional medical beliefs and practices, and domestic arts. These traditions richly deserve to be made generally known. This book, however, is intended to help the resident or visitor in our region to understand the various art forms that he or she is likely to encounter in public places: on the streets, in churches and cemeteries, in bars and restaurants, and at festivals and public celebrations. I will venture into the more intimate setting of the home only to prove a point or to show how a formerly domestic craft has become commercially or symbolically important.

Many people and communities in our region maintain their own traditional art forms, often as a means of retaining their sense of well-being and identity in a rapidly changing world. By decorating their lives in these traditional ways, they also offer each and every one of us opportunities for enriching our lives. This book is my attempt to share what I have been privileged to learn and perhaps to aid residents and visitors to the area in recognizing and understanding the richness of our cultural surroundings. I hope what I have written brings with it my awe for the human spirit that persistently creates beauty, and my deep respect for those communities and individuals who have lovingly maintained their creative traditions and trustingly shared them with the rest of us.

THE ART

The concept of *art* is a difficult one, and one that has several definitions, even within the framework of our own cultural tradition. The term as it is used in this book involves aesthetics—the realm of words and concepts like ugliness or beauty. If a man-made object or activity makes us want to say things like "that's beautiful" or "I wouldn't touch that mess with a ten-foot pole," we are reacting aesthetically to it; we are treating it as a work of art. Under this definition, the

purpose for which it was created becomes unimportant. We may be discussing a saddle, the arrangement of food on a plate, a piece of dance music, or even the motions of the dancers as they respond to the music in culturally patterned ways. We may be deep underground looking at the cut rock and timbering of a mine, or out in a barn examining the intricate weave of a pair of braided leather reins. Whatever the object or activity we may be observing, it may well affect us—and those who create or created it—aesthetically. To the extent that we respond to it in aesthetic terms, we can discuss it as a work of art.

There are many different kinds of objects within our cultural tradition that are called art. Some students of our complex industrial society distinguish three kinds of art based on for whom and by whom they are created. *High art* or *fine art* is produced (or selected) as material for aesthetic contemplation by trained specialists called artists. It is supported by such formal aesthetic institutions as museums and universities, and its changing appearance and content are affected by complex interactions between those institutions and the world of connoisseurs, dealers, and collectors. (What I am calling the fine arts are frequently referred to simply as the arts.) Although fine art can respond to regionality, it tends not to be particularly regional in nature. Fine artists all over the world experience one another's work and exchange ideas through recordings, films, journals, and catalogs, as well as by personal interaction.

Popular art is produced for the broadest possible spectrum of society. The institutions which create and distribute popular art are those of the marketplace and the mass media—the advertising industry, television, the great record and film studios, those media whose interests lie in reaching as many people in as wide an area as possible.

The term *folk art* is used in a variety of ways, but here it will refer to the traditional expressive forms of the smaller communities within our greater society. Folk art (also called traditional art) is produced primarily for consumption within its own community. While fine artists and popular artists are usually trained in formal institutions, folk artists are trained within their own communities, frequently by such methods as apprenticeship and example.

Yet another category—that of *idiosyncratic art*—appears to cut across the other three. This is the highly individualistic art of creative "loners" within a society, and will not be included in this book,

although it can be aesthetically exciting, and is sometimes referred to as folk art. Sam Rodia's Watts Towers in Los Angeles is considered by many to be an example of this kind of art.

What are these smaller folk communities? They are groups of people within the larger fabric of society who hold enough in common that they identify with one another as well as with the larger society. Such communities are usually old enough to have developed their own aesthetic and creative traditions. The folk community may be based on older, tribal societies, such as the Native American groups of Arizona. It may stem from a sense of shared ethnicity, as with blacks, Mexican Americans, or Ukrainian Americans; from shared occupation, as with cowboys, ranchers, or miners; or shared religion, as with Jews and Mormons.

Folk art, then, is an integral part of the culture of the community in which it is found, and it reflects the traditional values and aesthetic standards of that community. Furthermore, the people who produce and use it need not consider it art. It may be thought of simply as something that people do in the normal course of living. And it certainly need not keep up with the changing fashions of the fine arts.

For example, Mission San Xavier del Bac stands twelve miles south of Tucson in the San Xavier district of the Tohono O'odham (formerly Papago) Indian Reservation. (Tohono O'odham, usually pronounced "TO-ho-no AH-ah-tam" and meaning "the Desert People," are the people we used to call Papagos. They have always called themselves Tohono O'odham in their own language; the phrase became the official name for the tribe in 1986.) San Xavier is a Spanish colonial church built in the 1790s to serve the same community that it does today—the Indians who live in the nearby village of Wa:k. It is a noted tourist attraction in southern Arizona, and for good reason: it's the most complete example of the baroque style of Mexican colonial architecture surviving in the continental United States. Inside and out, with a few relatively minor exceptions, it remains much as it was when it was completed in 1797.

The baroque style of architecture in Mexico was to a great extent a style of interior and exterior building decoration, in contrast to the baroque of Europe, where there was more emphasis on experimentation with space and lighting. Basic characteristics of the style include an emphasis on symmetry, a fascination with movement and dramatic

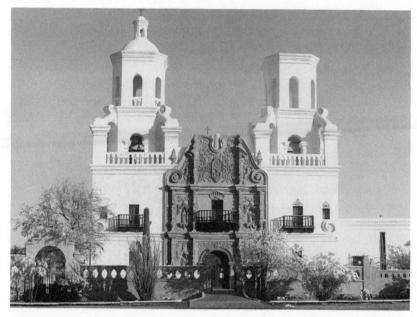

The facade of San Xavier del Bac as it stands today. The dramatic contrast between plain and decorated surfaces that is an important baroque characteristic is well expressed here. Many details that may seem purely decorative have a specific meaning. The shell over the central window, for instance, is a symbol of Santiago (Saint James) de Compostella, patron saint of Spain, in addition to being a wonderfully complex, shadow-catching sculptural motif. The eighteenth-century wrought-iron cross on the dome is visible between the two towers. The snow on the trees and bushes is an occasionally added touch. February 1987 photo.

contrasts, a taste for opulence reflected in the use of color and precious materials, and an emphasis on complex compositions involving innumerable tiny details. San Xavier, with its two towers, its central facade covered with lush, richly symbolic relief sculpture, and its nave and main altar packed with a thousand tiny, colorful details, is a wonderful example of frontier baroque architecture. At Christmastime, when colored lights, tinsel strings, artificial and natural flowers, white gowns for the angels over the main altar, a Nativity scene, and other details are added to the already crowded interior, the effect is intensified. And this intensification gives us a clue to the fact that, while the baroque as an officially sanctioned art style may have gone out of fashion in the cities of New Spain in the late 1700s, it still persists as a major aesthetic force among the O'odham and Mexican folk some two centuries later!

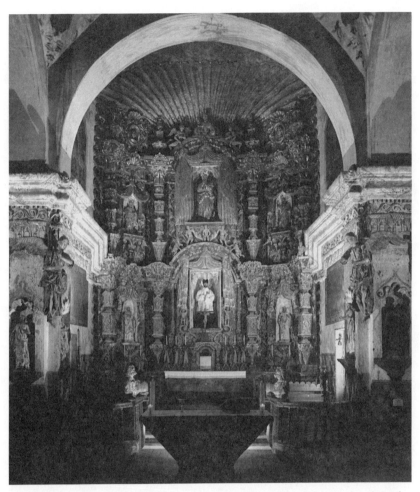

The main altar of Mission San Xavier del Bac. This remarkable church has stood twelve miles south of Tucson since 1797, a constant baroque presence in southern Arizona. With its richness of materials and color, its exuberant combination of the myriad of independent details, and its sense of high drama expressed through contrast and motion, this interior typifies the baroque impulse that is still such an important organizational factor in Mexican-American folk art. This photograph was taken in the 1960s; the lions flanking the main altar have subsequently been stolen. *Helga Teiwes photo, courtesy of the Arizona State Museum at the University of Arizona.*

I know a man—he wishes to remain anonymous—who supplements his income by making religious shrines for Mexican Americans and Yaquis living in the Tucson area. One such front-yard shrine consists of a three-foot-high, freestanding niche of cement built over a chicken-wire frame. The front is painted white and overlaid with

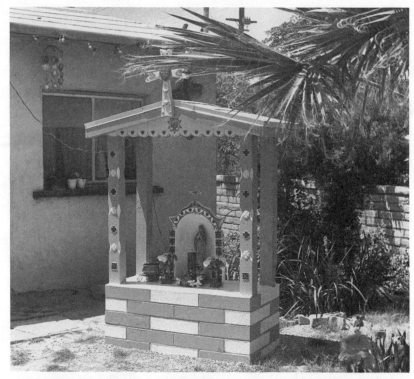

The yard shrine described in the text as being in the contemporary baroque idiom. This shrine
stands on West 38th Street, near the Yaqui chapel of San Martín de Porres. The base colors
are green and white. In addition to the complex details of the shrine itself, note the string of
colored lights on the adjacent house. Photo taken in 1985.

square and curvilinear plastic tiles. These are painted black, red, and
blue. At the apex of the niche is a white wooden cross, also decked out
with bright colors. Inside the shrine is a statue of the Blessed Virgin,
glowing with reds and blues. In front of her are candle holders and
small bunches of artificial flowers. The niche stands on a rectangu-
lar brick platform, the bricks painted alternately in white and green.
This, in turn, becomes a sort of wishing well with the addition of four
corner posts supporting a pitched wooden roof. The outlines of the
posts are scalloped, and the posts themselves are painted green and
overlaid with black and white cruciform plastic tiles. A white cross,
also overlaid with plastic tiles and bearing a red plastic heart at its
center, stands in the middle of the gable; directly below it is an auto-

mobile decal featuring the Mexican and American flags and Our Lady of Guadalupe. The scalloped wooden gable is decorated with small, heart-shaped plastic tiles. The shrine is accented with tiny, colored Christmas-tree lights that flash on and off; larger colored lights are strung on the eves of the house directly behind it. The effect on the unprepared viewer can be overwhelming.

For a person who is deeply immersed in the fine-art traditions of our culture, there may be only one word to describe such a shrine: kitsch. Within the standards of that person's own tradition, this judgment may be perfectly accurate. However, judging art by canons brought in from outside the culture in which it is produced does not get one any farther toward understanding the object or tradition in question. We all should have the privilege of choosing the aesthetic systems with which we feel the most comfortable. But to ignore the possibility of other canons of beauty which may be perfectly valid within the context of their own traditions is to place our own values at the center of the universe and cut ourselves off from many of the peoples and traditions with whom we share the world. In this case, our shrine maker is functioning within a basically baroque aesthetic as surely as were the artists and craftspeople who created San Xavier almost two hundred years ago. San Xavier itself, with its colors, its rich use of gold, and its multiplicity of saints' images, often comes as a considerable shock to people who have been raised in and around the religious architecture of Protestantism. It is totally different in both spirit and detail, for example, from a New England church with its bare, whitewashed walls and its central steeple.

This is not an isolated example. Many folk communities tend to maintain their own aesthetic rules, which are reflected in their traditional arts. It is this, of course, that makes the study of folk art so fascinating. It can provide the interested outsider with a glimpse into values and aesthetic systems other than his own. The objects, events, and ways of doing things that communities have evolved and maintained for the purpose of bringing beauty into the lives of their members can provide us with a unique opportunity for cross-cultural understanding and enjoyment. The perfection of form and technique which can cause something as utilitarian as a rock wall or the cast of a lasso to give satisfaction to its creator can please us as well, if we only let it.

Some of the art forms treated in this book are like the ones I just mentioned—objects and acts of everyday life, raised to aesthetic distinction through mastery of the process involved. Others are designed to give pleasure to those who experience them. Still others are public statements of group identity—forms which have been chosen by their communities for sharing with their neighbors. All are public. They can be found in restaurants, in bars and dance halls, and at public gatherings. They may be glimpsed in cemeteries, in front yards, and in churches. They may be part of normal work, worship, or leisure, or they may be selected for presentation at festivals, fairs, or other public occasions where symbols of group identity are needed. In one way or another, the art forms celebrated in this book are available to all of us, and have the potential of decorating our world as well as those of their creators.

THE PLACE AND ITS PEOPLE

To say that the American Southwest is occupied by three cultures —the Indian, the Hispanic, and the Anglo—is to indulge in oversimplification. Consider the Indian culture of southern Arizona, the land of the Gadsden Purchase. Along the Colorado River are Cocopahs and Quechans (or Yumas, as they used to be called). In the great desert west of Tucson are Tohono O'odham, with Pimas to the north along the Gila River. Each group has its own language and its own culture and traditions. In addition, southern Arizona has five communities of Yaquis—Indians whose ancestors brought their rich traditions of Catholic ceremonialism from their Sonoran homeland. Living in urban Tucson are Sioux, Cherokees, Hopis, Apaches, Navajos, and others. Many of these groups have brought with them the traditions of their people. In addition, there is a large body of intertribal songs, dances, and beliefs based on a common sense of Indianness. Indians of many tribes attend powwows where they sing songs and perform dances that have their origin with the tribes of the Great Plains, but which are now common property of all Indians. These same individuals may also participate in their tribes' own traditional religious and social occasions. All this diversity and change makes it hard to talk about a single Indian culture.

The Hispanic culture of southern Arizona presents an equally complex picture. Some families have lived in Tucson since the city was a Spanish presidio. Other Spanish-speaking Tucsonans are descended from nineteenth- or early twentieth-century Arizona and Sonora families, while immigrants from all over the Republic of Mexico are constantly arriving. Southern Arizona is also home to people from many parts of Latin America, and there is a small, proud community of Spaniards who wish not to be mistaken for Mexicans or Latin Americans. There also are Mexican-American families who are so assimilated into mainstream American culture that they speak only English. Others have maintained a traditional Arizona-Sonoran ranch culture. And young urban Chicanos have developed their own traditions.

Everyone else—all those people whose cultural heritage is neither Native American nor Hispanic in origin—is traditionally subsumed under the word *Anglo*. Literally, this means Anglo-Americans, Americans of English descent. Of course, this leaves out Afro Americans, and Americans of mainland European and Asian heritage. (It also excludes Americans of Irish descent; I once referred to "us Anglos" in conversation with an Irish priest. The resulting comments left no doubt in my mind that I had committed a serious error.) Finally, by assuming a common cultural identity for all Americans whose ancestry stretches back to the British Isles, the term glosses over the real differences between, for instance, New Englanders and people from the Deep South.

Contemporary southern Arizona is home to a multi-cultural community in the midst of rapid growth. As the population grows, so does the cultural complexity of the area. Individuals and families come to Arizona from all over the world, bringing their traditional skills, arts, and world views with them. Contemporary southern Arizona is tremendously diverse in its cultural makeup, combining its traditional regional, occupational, and ethnic cultures with the traditions of all the groups who have come into the area within the last forty years. And this richness and diversity are reflected in the public statements of cultural identity which are the subject of this book.

1

* * *

The Arts of Mexican Americans

Southern Arizona is close to Mexico geographically, historically, and culturally. In these areas the international border which separates us from Sonora is no more a reality than it was before the Gadsden Purchase. The two neighboring regions are bound together in a number of ways. Certainly, the historic and contemporary presence of Sonoran culture in and around Tucson gives the region a special ambience, distinct from that of the neighboring border areas of California, New Mexico, and Texas. There has been a constant, documented Hispanic presence in our part of Arizona since the arrival of permanent Jesuit missionaries at the beginning of the eighteenth century. The Presidio of Tucson was founded in 1775 as a cavalry outpost in response to constant Apache raiding. Many Tucson families can trace their lineage to persons who served the Spanish Crown in the military forces in Arizona. Other families immigrated from Sonora during the period after Mexican Independence in 1821, and still others after the Gadsden Purchase. This immigration process continues. It involves not only families and individuals from most Mexican states, but also includes native Sonorans, many with relatives in Arizona,

12

who cross the border to become United States residents or citizens. It provides continuous enrichment and renewal of Mexican traditional culture as people bring customs from many of Mexico's varied regions to add to the local blend.

In this chapter we will examine traditions that are indigenous to the Arizona-Sonora border country as well as some that have been imported from other parts of the Mexican and Mexican-American worlds. Some of the traditions have become well established over time; others are relatively recent developments. Mexican culture in southern Arizona is dynamic. While some traditions are old and others are relatively new, all must continue to be relevant to the life of the people if they are to survive. This accounts for seeming paradoxes such as piñatas in the shape of Superman; peanut butter and jelly burritos; and a traditional Mexican folk procession which appears to have been introduced locally with the help of an Anglo-American schoolteacher. Among the most visible forms of traditional art are those which grow out of a community's need for celebrations. Important among these arts is food preparation. Regional cookery is one of the cultural features that serves to distinguish the Arizona-Sonora border country from its neighbors.

THE ARTS OF CELEBRATION

Food

Mexican cookery, a complex blend of Spanish and Indian culinary traditions, is richly varied, having developed over the five-hundred-year span since Cortez conquered the Valley of Mexico. Although each region of Mexico (including our border country) has its own specialties and distinctive flavors, certain foods and techniques are common to the whole country. The staple foods are corn, beans, squash, and chiles, along with whatever meat, fowl, or fish may be regionally available. At the heart of much Mexican cooking is the corn tortilla, a flat, thin cake made of corn which has been soaked in a mixture of water and lime and then ground. The tortilla is baked on a comal, or ungreased griddle, and can be eaten in a number of ways. It can be used as combination spoon and pusher with whatever other foods are served. It can be wrapped around almost any food to form a taco.

(While tacos in the United States are almost invariably made of crisp, fried tortillas filled with ground meat, cheese, and lettuce, the Mexican taco is commonly made with a soft tortilla and an endless variety of fillings.) To make an enchilada, the tortilla is cooked briefly in a red chile sauce, rolled around meat or cheese, and then baked with more sauce. Fried crisp and heaped with meat, cooked beans, cheese, or other edibles, the tortilla becomes a tostada. Chopped stale tortillas can be lightly fried and served with sauce and cheese as chilaquiles, or fried crisp for topopos or chips.

There are innumerable varieties of chile in Mexico. While some are relatively mild, others would seem to require an asbestos mouth. The flavors can be varied even more when the chiles are dried, smoked, or pickled. Much of the regional character of Mexican cookery comes from the use of local chile varieties. (Chiles of the same variety grown in different regions can taste differently. For example, an ordinary red or green Anaheim chile which has been grown in New Mexico will be infinitely hotter than the same species of plant from Arizona.) Chiles can be eaten raw by themselves or as an ingredient in other dishes. They can be filled with meat or cheese and fried in batter to make chiles rellenos—stuffed chiles. They can be chopped and combined with tomatoes or other vegetables in sauces. Fresh or dried, they add flavor to almost any dish.

Mexico boasts of a remarkable assortment of beans, from the pintos of the north to the tiny black beans of the southeast. Whatever variety, they can be cooked, perhaps with an onion or some herbs, as *frijoles de la olla*—beans in the pot. Any beans left over are often mashed and fried in lard to become frijoles refritos, commonly called refried beans, although "well-fried beans" may be a more accurate translation. A little milk or cheese is often added to this latter dish.

A region's culture is inseparable from its history, and the Mexican-American cuisine of south-central Arizona certainly reflects that fact. In 1687 Father Eusebio Francisco Kino, S.J., crossed the so-called Rim of Christendom into the Pimeria Alta—the land of the Upper Pimas. Along with the Catholic religion and the concept of the Spanish Empire, he brought with him many of the crops and domestic animals of the Mediterranean world. Among these were wheat and cattle, both of which have made a lasting impression on the foodways of the region.

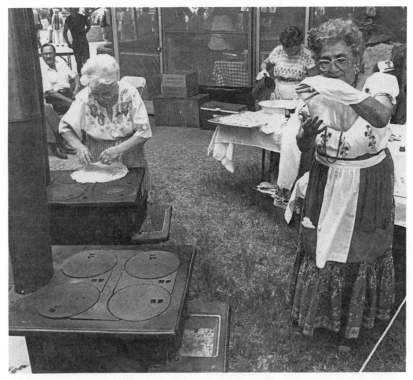

Members of COMWOLEI Club making flour tortillas at the 1987 Tucson Meet Yourself. Mary Lara on the right is stretching a tortilla to its full size while Delia Lopez turns a tortilla that is cooking on the top of a wood-burning stove. COMWOLEI (the acronym stands for COMmunity, WOrk, and LEIsure) is a Tucson Mexican-American women's club that regularly makes tortillas at local cultural events. *David Burckhalter photo, courtesy of the Southwest Folklore Center.*

Sonora and Arizona have been wheat-growing regions since the eighteenth century. Until well into the present century, large wheat crops were grown in the Gila and Santa Cruz valleys as well as in the desert area which is now the Tohono O'odham Nation. The regional tortilla, a gigantic affair of wheat flour, water, and lard, attests to this fact. Although large flour tortillas are now made in other parts of Mexico and the United States, they are but poor substitutes for the traditional *tortilla de harina* of the Pimeria Alta of northern Sonora and southern Arizona. It is almost translucent because of its lard content and can be stretched thin to a diameter of nearly two feet by a skilled tortilla maker. The lard comes from hogs, another of Father

Kino's introductions. The ubiquitous fat for deep frying comes from the same source.

This huge, soft tortilla defines two other important regional foods: the *burro* and the *chimichanga*. Burros are simply flour tortillas wrapped around more solid food—beans or beef and chile are local favorites. Some Mexican-American teenagers in the Santa Cruz Valley construct peanut butter and jelly burros. Outside its native land where huge tortillas are not always available, the burro frequently shrinks to burrito size, but within the region, burros can be ten inches long and two or three inches thick.

Sometime after 1940, someone had the idea of deep frying a burro. Thus came the chimichanga. The name is a mystery and has been the subject of considerable speculation among English and Spanish speakers alike. A few people believe that the correct name is "chivichanga." Several individuals and restaurants claim, or are given, credit for this culinary innovation, but regardless of where and when the chimichanga originated, it is now a fixture in local cuisine—a large flour tortilla, wrapped around a filling of meat or beans, and deep fried. And chimichangas have changed over the years. There are now even sweet fruit changas, which may be the result of a meeting between the chimichanga and the fried pie of the American South.

Along with wheat, beef provides the other distinctively Sonoran staple. Cooked in a stew with red or green chile, grilled as carne asada, or made into stock for one of the great regional soups that are often meals in themselves, beef is omnipresent in our region. The milk ducts of the cow are grilled to become *tripas de leche*, popular at picnics. Tripe is cooked with stock, hominy, and pigs' feet to become *menudo*, a classic hangover remedy as well as a tasty dish. The reputed curative properties of menudo are celebrated in commercially printed T-shirts that are occasionally seen bearing the legend "Menudo—Breakfast of Champions." The dependence on cattle doesn't stop there. Although milk is not an important part of the local Mexican diet, locally made white cheese is omnipresent, whether crumbled over almost any dish or melted on a tortilla to form a *quesadilla*. There are families in Tucson who are not averse to making a 100-mile round-trip simply to buy some particularly good cheese.

There are other regional specialties. These include *sopa de albón-*

digas (a beef broth containing seasoned meatballs) and *caldo de queso* (cheese soup—a broth containing potato chunks, green chiles, and melted cheese). So-called flat enchiladas are not really enchiladas at all, but small cakes of corn masa flavored with cheese and chile and fried. Chiltepines, the fiery local wild chile peppers, add a special degree of heat and flavor to almost any dish. Tamales, a traditional food all over Mexico, have achieved a certain degree of local character. (The name is not Spanish but Aztec, and tamales of many different kinds have been fiesta foods in Mexico for centuries.) The basic tamal, consisting of meat in red chile surrounded by corn meal masa or dough, is steamed in a wrapping of corn husks, and served in restaurants year-round. It is also prepared and devoured by the tens of dozens in many Mexican-American homes at Christmastime. In summer green corn tamales are made of freshly picked white corn, which is ground, mixed with a little cheese and chile, and steamed in its own husks. Tamal making is an arduous procedure, and families will often spend a day at it, turning out several dozen tamales in one sitting. If green-corn tamales are being made, the men will often work the hand grinder (the tough kernels will burn out most electric blenders) while the women assemble the tamales. Tamal-making sessions often amount to family get-togethers, where food preparation takes place amidst a lot of gossiping and visiting. Yaquis and others make a delicious sweet tamal with a filling of refried beans mixed with brown cane sugar and cinnamon. These tamales dulces are occasionally sold at religious fiestas.

Not all local Mexican food is regional to the Sonoran Desert. Several Mexican bakeries provide a traditional selection of rolls and cookies which is similar to what can be found in many parts of Mexico and the American Southwest. Baking is often passed on as a family profession, and it is a commonly accepted fact that no two bakers' products are exactly alike. Each shape of cookie has its traditional name, and these names themselves can be regional. Thus a flat, lozenge-shaped cookie called *una lengua* (a tongue) in Tucson is called *un huarache* (a sandal) in other parts of Mexico. Tucson in the early 1980s has seen the establishment of restaurants specializing in regional foods from Jalisco and Mexico City. Anglo Americans have started manufacturing salsa especially as a dip for chips and have imported the ritual of the chile cook-off from Texas. But the regional

flavors of Mexican cookery in south-central Arizona remain firmly tied to the ecology and history of the region, and especially to wheat and cattle, Father Kino's two great imports.

Music and Dance

Music is another art form that is best enjoyed in company. This is especially true in Mexican-American society, where the *ambiente* of any social occasion is of the utmost importance. An older Mexican-American friend once attended an Anglo-American cocktail party in Tucson's foothills. To him it was a depressing occasion because there was no music or high spirits, and everyone stood about the room looking serious and talking in low voices. Mexican Americans planning a celebration will often include some sort of music to produce a beautiful ambiente, and make everyone feel that a party is going on.

The best known form of Mexican traditional music in southern Arizona is mariachi music. The word, whose origin is lost in the mists of time and legend, applies equally to the musical style, to the ensemble, and to the individual musician. The typical mariachi wears a version of the charro costume of the gentleman horseman of central Mexico, with tight trousers and jacket which have been embroidered and set with rows of silver buttons; a high-crowned, broad-brimmed hat; and elegant accessories. Melody and harmony are supplied by violins and trumpets, while three members of the guitar family set down rhythmic patterns, sometimes quite complex. The Spanish guitar and the vihuela, a tiny, keel-bottomed, five-stringed guitar, are chorded on the off-beat, while a bass line is supplied by the *guitarrón*, a huge, six-stringed, fretless instrument which is held face up across the body and plucked. The violins, trumpets, and six-stringed guitars are standard instruments and may be purchased anywhere. Vihuelas and *guitarrones* must be imported from Mexico.

Mariachi music is a relatively recent arrival in our region, Tucson's first mariachi band having been established after World War II. The style itself originated in the west central Mexican State of Jalisco and arrived at its present eminence as the artistic symbol of Mexican popular culture in the 1930s and 1940s. Although a good mariachi group will play a wide range of songs and instrumentals old and new, the core of the mariachi repertoire is the *son jaliciense*. This is the traditional dance music of rural Jalisco and is characterized by short

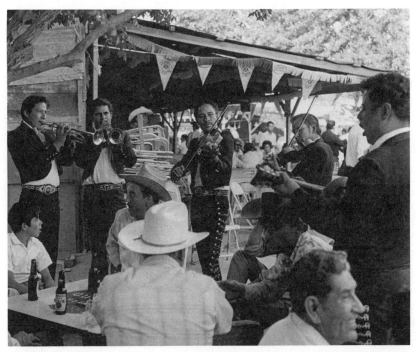

Music in context—mariachis playing at the Fiesta de San Francisco, Magdalena, Sonora, 1967. The men in the foreground have hired this band to play for them and are continuing their social gathering in an *ambiente* of music and festivity. The short jackets and silver-decked trousers are typical of mariachi costume. The man at the right is playing a *vihuela*.

repeated figures and complex rhythms, often with a call-and-response pattern set up between the solo singer and a chorus of band members. Such typical *sones* (tunes) as "La Negra," "La Culebra," and "Camino Real de Colima" provide the basis of the distinctive mariachi sound.

Mariachi concerts are becoming more and more common, and mariachis are hired to perform at an increasing variety of public places and events in southern Arizona. Music is such an important part of the ambiente of any Mexican celebration that it is not uncommon for small parties in bars and restaurants to hire mariachis to provide background for their festivities. A musician who is being paid by the song in a public place is said to be *cascareando*. The only close English equivalent is the archaic word *busking*. Cascareando as a constant activity for a musician assures a repertoire of awesome dimensions— a repertoire of perhaps as many as 2,000 songs, all learned by ear and committed to memory.

The Tucson area is particularly rich in mariachis. This is in great part due to the existence since 1963 of a youth mariachi group called Los Changuitos Feos (The Ugly Little Monkeys). Started by Father Charles Rourke as a means of maintaining cultural awareness and pride among some of his young parishioners, the group has maintained itself for more than twenty years, earning college scholarship money for its constantly changing members and serving incidentally as a training ground for local mariachi musicians. One group of Changuitos alumni formed El Mariachi Cobre, which in 1982 was awarded a contract at Disney World's Epcot Center in Florida. There are currently several tightly rehearsed, concert-quality mariachi groups playing in the Tucson area. Since May 1983, Tucson has been the site of the annual International Mariachi Conference, an event which draws participants from as far away as Washington, D.C., to hear and learn from some of the greatest musicians in the field, many of whom come from Mexico City to teach and appear at the festival.

Mariachi bands may have as few as three and as many as fifteen musicians. A common number is five or six—one or two violins, a trumpet, a guitar, a vihuela, and a guitarrón. Although the more elegant restaurants in Tucson, Nogales, and elsewhere hire mariachis to play for their patrons, many of the musicians one encounters in bars or restaurants, especially in Mexico, keep to the old cascareando custom of charging a fixed sum for each tune played. It is wise to find out which system is in effect before making requests; many Americans enjoying an evening in a Mexican restaurant have ended up with an unexpected music bill as a result of failing to do so.

Another popular style of music among southern Arizona's Mexican community is *la musica norteña*—"northern style music." Originating on the Texas-Mexico border, norteña (or norteño as it is usually called in English) has taken hold in our region in the past twenty years. The standard norteño melody instrument is the diatonic accordion, an instrument played by means of buttons rather than the more common piano keyboard. Each row of buttons represents a single key, and the instrument is rather like a hand-held harmonica in that a different tone results from pulling out or pushing in. Rhythm is provided by a *bajo sexto*, or twelve-stringed bass guitar. Additional instruments may include the saxophone; a three-quarter size, three-stringed, stand-up bass fiddle called a *tololoche*; and drums (or

Music in context—a norteño band performing on an impromptu stage at a horse race just south of Tucson, May 1983. The instruments from left to right are: *tololoche, bajo sexto,* and button accordion. Match races, like other Mexican-American social gatherings, are settings in which traditional musicians often provide the *ambiente* necessary for a good time.

occasionally a single snare or a woodblock). Once in a while an electric organ substitutes for the button accordion. One finds five-piece norteño groups (or *conjuntos*) playing in nightclubs and dance halls as well as norteño trios and duets cascareando in bars and restaurants. While the mariachi image is that of the charro of central Mexico, the norteño's outfit is tied to the *vaquero* (cowboy) tradition of the northern borderlands: Stetson, western pants and shirt, and cowboy boots.

The norteño repertoire includes both instrumentals and songs. The ubiquitous polka is a major feature of the instrumental repertoire, along with the less common Eastern European redova and the Latin rhythms of the bolero and cumbia. Waltzes are not as important for norteño groups as they were for the violin-led orchestras fifty years ago, but they are still played and danced in the region. Two important kinds of songs are the *canción ranchera* and the *corrido*. Canciones

rancheras are sung both by norteño conjuntos and by mariachis. They are the songs of the newly urbanized Mexican working class, similar to American country music in content as well as in the segment of the population to whom it appeals. As is the case with American country music, a major theme involves unrequited love and the temporary solution that can be found in a bottle. Corridos are simply Mexican ballads—narrative poems in Spanish set to music. One of the most important verbal folk art forms of twentieth-century Mexico, the corrido reflects the point of view of the working people in a special way. Corridos have been—and still are—written about almost any subject: an incident in the Mexican Revolution, social injustice in the United States, violence and tragedy along the international border.

For many Anglo Americans in southern Arizona, the border is of little importance. Low prices attract the adventurous, and the seaside towns of Sonora are good vacation spots, but the border itself has little day-to-day impact for most of us. Many Mexican Americans, on the other hand, have family as well as cultural and linguistic ties in Sonora. Visiting "across the line" is common, and the border with its restrictions and inspections is always present in the mind as a potential barrier. As events connected with the border take place that touch the hearts of the local Spanish-speaking population, local poets are inspired to write corridos about them. Some of these corridos find their way into the repertoires of local singers, and a few even get recorded. "El Contrabando de Nogales" tells of heroin smuggling in the border town of Nogales, followed by a shoot-out on the highway just south of Tucson. While this particular story may be fictional, similar events frequently take place. "Tragedia en el Desierto" commemorates the tragic death from exposure of a group of El Salvadoran refugees who attempted to cross the border near Organpipe Cactus National Monument in July 1982. "Los Tres Mojados" comments on a 1970s incident involving the beating of three undocumented aliens near Douglas, Arizona. These three corridos made it onto 45 RPM singles aimed at a local audience; countless others exist only in the memory of their composers or a few singers. All go together to form a rich documentary on the social history of the international border.

Another popular local corrido subject is the horse race. Match races have been a feature of Mexican and Mexican-American vaquero culture for at least a hundred years. Often backed by large sums of money, two favorite horses will be matched on a straight course.

The event can become a party in itself, with men betting, drinking, and discussing previous races of note. Musicians often appear, cascareando for the crowd. Since at least 1892, when a horse named El Merino was beaten by El Pochi just south and west of Tucson, corridos about races have been composed and sung in this region. Perhaps the best known is "El Moro de Cumpas," which tells of a race that took place on March 17, 1957, along the then unpaved main street of Agua Prieta, Sonora, just across the border from Douglas. Composed by Leonardo Yañez ("El Nano"), now a respected senior musician living in Douglas, Arizona, the song tells the story of the race in a series of sharply drawn images. It has entered the repertoire of nearly every traditional singer of Mexican songs in the region, and was even the subject of a movie.

Relámpago, the horse that won the race, later participated in what may well have been a unique contest. He was challenged by the owners of Chiltepín, an American horse named after the fiery local wild chile. However, quarantine regulations prevented either horse from crossing the border to race against the other. The solution to this impasse is said to have been suggested by a United States customs official. The straightaway course was laid out along the border fence. Relámpago ran in Sonora and Chiltepín on the American side. The winner? Relámpago.

Whatever the song, norteño singing is characterized by two-part harmony in an intense, slightly nasal vocal style. This contrasts strongly with the equally intense but classically influenced, full-throated style with which the mariachi solo singer performs his corridos and rancheras. Harmony is a feature of mariachi singing as well, but it usually features several voices, and often serves as a chorus against which the soloist performs.

Older styles of Mexican music can still be found in the region, but to a great extent they have been eclipsed by the immensely popular imported mariachi and norteño styles. Guitar-playing solo singers still appear at family parties and picnics, and one can also hear the occasional instrumentalist who plays the older, nineteenth-century repertoire of polkas, marches, and waltzes. Such a man was the late Ramón Machado, who left his home in Gila County in the early years of this century to join a circus orchestra. Returning to Arizona a few years later, he was a well-known musician in the Santa Cruz Valley until he moved to southern California in the 1980s. My introduction

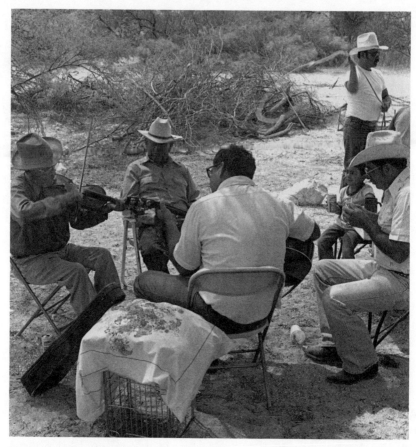

Music in context—Ramón Machado, the Mexican-American fiddler mentioned in the text, plays at a family picnic near Marana in 1980. Richard Morales accompanies him on guitar, while Pete Castillo and Tony Morales listen. The man in the background is about to throw his loop at a roping dummy.

to the older instrumentals came from hearing "Maestro," as he was affectionately known, performing at family picnics near Marana.

Guitar-playing, singing musicians can still be found who perform duets in a style that was popular in the 1920s and 1930s, in which one singing guitarist maintains a bass and chording rhythm line on his instrument while the other plays the melody, fingering high on the neck. This sometimes involves the use of a special, small guitar called a *requinta*. One such duet could be heard in the mid-1980s casca-reando in the Mexican restaurants along Tucson's South Fourth Ave-

nue. Occasionally, one also finds guitar and vocal trios, often called *trios románticos*. Although these groups also feature melody picked out on the requinta, their harmonies are gentler than those of the older style duets. The bolero is a popular form for trios románticos, who usually model their style and repertoire after such popular Mexican groups of the 1940s and 1950s as the Trio Los Panchos and Los Tres Diamantes.

On the more popular, contemporary end of the scale are the Latin bands who play a basically Caribbean style of music, as well as the rock bands who maintain a Latin or Mexican flavor to their youth-oriented music. With both these genres we are moving into the realm of national, popular music. Even within this realm, however, one finds groups like the New Mexico–based Little Joe y la Familia, or the Los Angeles group, Los Lobos, both of which owe a good deal to the norteño accordion tradition. Closer to home, there are local bands all over southern Arizona who play norteño, contemporary country and western, and even rock music with a wonderful impartiality. I once heard such a group in Tumacacori move from a canción ranchera to a Willie Nelson song to an old Chuck Berry rhythm-and-blues classic without batting an eye. The accordion part was played on an electric piano. It was all dance music, and all part of the cultural resources available to this particular group of young Mexican-American musicians.

One special context for music in Mexican-American culture is the *serenata* or serenade. It is considered a lovely compliment to honor someone on his or her birthday, for example, or on Mother's Day or Father's Day, by waking that person up with music. Traditionally, this should happen before sunrise. The musicians cluster around the bedroom window of the sleeping honoree and suddenly burst into music and song, first singing one or another version of the traditional "Las Mañanitas," and then singing any other songs they feel suitable. Serenatas can take place at any time of the day or night, but the pre-dawn *serenata de gallo*—the cockcrow serenade—is felt to be the most traditional and most exciting. I once was invited to join a group of musician friends for a series of Mother's Day serenatas. We started about 1:30 in the morning of Mother's Day and carried on until 7:45 the same morning, singing outside eleven windows. We were invited in for coffee, snacks, or breakfast at several houses. It was a fascinating and lovely experience.

This custom underscores a big difference between Anglo-American and Mexican-American cultural traditions. In many Anglo neighborhoods, music and song outside a window at 4 A.M. might well result in a visit from the police. The only reactions we received were warm and enthusiastic ones. One culture's noise is another culture's beautiful, sentimental tradition.

Mexican Americans in Los Angeles tell a sad but funny story about a group of mariachis who were performing in a bar and decided to play "El Niño Perdido," or "The Lost Child." In this novelty instrumental, one trumpeter goes outside and plays a short bit of melody on his horn. The band answers him with a similar melody. As band and soloist play back and forth to each other, the "lost" musician makes his way into the room and rejoins his fellows. In this story, which is believed to have actually happened, the soloist went into the street and played his phrase. The band answered him. Nothing happened. After waiting for several minutes, a band member went out to look for him, and he was nowhere to be found. Three days later, he showed up again and explained that as he played his initial solo, a police car had driven by. Seeing a lone man playing the trumpet in the street, they had promptly arrested him! The moral is simple: if you hear the trumpets start up next door at 3 A.M., do not call the cops. Enjoy it. This is one of the things that makes southern Arizona such a special place in which to live.

Music can, of course, be danced to, and dancing is a popular activity in the Mexican-American community. By far, the most important traditional regional dance is the polka. Just how polkas arrived in the border country is not known for certain. Possibly, they were introduced by forty-niners, possibly by French immigrants to Sonora in the mid-nineteenth century, or perhaps the fashion spread from the Sonoran cities of Guaymas and Hermosillo. However the polka arrived, it was popular enough by the 1860s that it had been taken up by Mexicans, Americans, and the Tohono O'odham, and it has remained important locally ever since. The regional polka style, however, differs from that familiar in other parts of the country. It is done from the waltz position and involves a smooth walking step which may be embellished with turns or with short bursts of side-by-side marching. The dancers usually move about the floor in a counterclockwise direction. The overriding aesthetic seems to involve smoothness, with the back kept straight and the feet seldom raised far off the ground.

In addition to the polka, waltzes and *cumbias* are also popular, along with other more contemporary dances. (The cumbia is a Carribean dance rhythm which originated in Colombia.) Vaqueros on both sides of the border will occasionally perform energetic solo dances involving complex footwork, and it is not uncommon at a party to see men express their appreciation of the music and *ambiente* (atmosphere) by breaking into a few impromptu polka steps.

Quite different in appearance and context is *folclórico* dancing. Increasingly popular in recent years in southern Arizona, folclórico involves the costumed performance of choreographed versions of regional Mexican traditional dances. These highly stylized and heavily arranged dances are for purposes of public display and exhibition rather than for social dancing at dance halls and parties. While much of the folclórico repertoire is from Jalisco, homeland of the mariachi style, dances from Veracruz, Chihuahua, and other regions of Mexico are also performed in the appropriate costumes. Carried on in several schools as well as by adult groups, folclórico seems to be an important way for Mexican Americans here and elsewhere to give public expression to their cultural heritage. Popular among performers and spectators alike, it seems to have created for itself an important niche on the local scene. Folclórico can be seen at all sorts of public festivals, but especially during the great Mexican holidays of el Cinco de Mayo (May 5) and el Dieciseis de Septiembre (September 16). These patriotic holidays have become for many Mexican Americans occasions for celebrating their cultural heritage. In addition to the huge traditional celebrations in Tucson's Kennedy Park, many shopping centers and malls join in the festivities with mariachis and folclórico groups.

Another context involving traditional music is the religious procession. On saint's days and other important occasions in the Catholic calendar, some congregations will remove the holy images from the church and carry them around the church and back in again or, in the case of Yaqui Indians, to the place of the ceremony. Such a procession is often accompanied by musicians playing traditional religious songs or popular Mexican songs with religious words. At the annual Tumacacori Fiesta, held on the first Sunday of December at Tumacacori National Monument, such a procession takes place before and after mass. Many Catholic churches in areas of heavy Mexican-American population (including Tucson's St. Augustine Cathedral) have mariachi groups attached to them. These groups play at special weekly

mariachi masses and also participate in religious processions. Many of the most popular contemporary religious songs originated with the Cursillo Movement, a revitalization of the Catholic church which started in Spain in the 1940s and has become very important in many parts of the New World. When the Second Vatican Council encouraged the use of local, vernacular music in mass in the 1960s, the cursillistas provided both the repertoire and the energy to launch what has since become an important feature of regional Hispanic Catholic ceremonialism.

Las Posadas is a special, seasonal procession cycle with its own songs. In many parishes, groups of parishioners walk in procession on nine evenings preceding Christmas Eve. They represent Joseph and Mary in their search for posadas, or lodgings. Carrying statues of the holy couple and accompanied by musicians, the procession sings its way through the neighborhood, stopping at several houses each evening to sing a request for lodging for the Holy Family. At each house they are turned away in song, until the household at the final stop sings their welcome. They enter, set the statues in a place that has been prepared for them, and enjoy light refreshments before going home. At the final stop on the last night, a party traditionally ensues at which a piñata in the shape of the Star of Bethlehem is broken. This custom is well established in many Tucson parishes and neighborhoods. It is a curious fact that the organizer of one of the first Las Posadas processions in Tucson was an Anglo-American teacher named Marguerite Collier. Beginning in the 1930s, she taught the songs to her students at Carrillo Elementary School where they are still performed some sixty years later. Nor was this Ms. Collier's only involvement with local Mexican-American culture; she also played a major role in the introduction of the folclórico movement into southern Arizona.

Parties, serenatas, processions—all these provide the outsider with opportunities to hear local musicians playing their traditional music. Exactly who are these musicians? Some of them, of course, are professionals who count on their musical activities for a certain percentage of their income. But quite a few are simply talented individuals who choose this means of serving their community, like a group of musicians I know well on Tucson's southwest side. These men, all in their fifties or sixties, get together each week to play at mass. This activity has made them locally known , and they have been in-

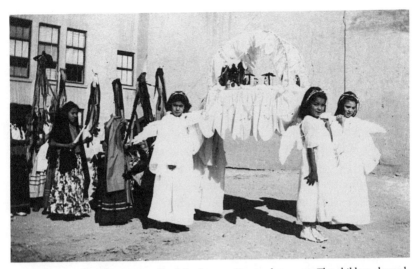

A Las Posadas procession at Carrillo School some time in the 1930s. The children dressed as angels are carrying figures of the Holy Family. *Courtesy of the Southwest Folklore Center, Marguerite Collier Collection.*

vited to play at masses at other churches and at private houses. They play at weddings, wakes, funerals, and graveside services on request. On Mother's Day they sometimes play early morning serenatas to family members and friends. On the evening of December 11, the night before the Day of Our Lady of Guadalupe, they may "serenade the Virgin," visiting altars in homes and churches. On this occasion, they might also sing outside the windows of any close friends named Guadalupe, for this is their day, too. If a relative of any member of the group has a birthday or a retirement or anniversary party, they may well get together for that occasion. Church fund-raising bazaars and office or shop parties, too, are times for making music.

And much of the music is provided, not in exchange for pay, but in a spirit of helping out. To be sure, the musicians often get fed and even paid. But that is not really the point. What is really going on is a kind of ethic of service left over from the days when the communities were much smaller and self-contained, and when entertainment, when it happened, was usually provided by friends, neighbors, or family members. Those were the days that an elderly Mexican-American woman recently (and longingly) recalled as "those times when folks would go around with guitars."

Piñatas and Cascarones

Traditionally a feature of the party following the Las Posadas processions, the piñata is also an important part of birthday parties and other celebrations where children are entertained. Piñatas are hollow, hanging papier-mâché figures covered with fringed strips of brightly colored tissue paper. The piñata is filled with candy or other goodies and suspended by a rope from a convenient branch or beam. Each child (or adult) is blindfolded in turn and handed a stick or bat. The player is then spun around three times and given three tries at breaking the piñata, while an older family member jerks on the rope, intentionally making the task harder. When the smash finally occurs, the goodies cascade out and a mad scramble ensues.

Piñatas have been a part of Mexican popular life for a long time and seem always to have been made in a variety of shapes. An 1897 description mentions birds, animals, fruits, flowers, humans, boats, fish, cornucopias, and devils on bicycles. Contemporary shapes include burros with little carts, bulls, seasonal figures like pumpkins, Santas and Christmas trees, and figures from the popular media such as Big Bird, Michael Jackson, E.T., and Wonder Woman. This timeliness seems to be itself a part of the tradition. After all, piñatas are for kids, and children are acutely aware of what is new and currently fashionable. In Mexico, piñatas are made as they always have been, using a clay pot as a foundation. It is only along the border and in the United States that the papier-mâché piñata, which is harder to break than those of pottery, has taken over. This is believed by many to be in response to laws in the United States which prohibit pottery piñatas for reasons of safety.

Piñatas are not always filled with candies and small toys. I have been at parties in California where there were several piñatas, some of which contained candy and others ashes. Breaking any one of them was a suspense-filled occasion. Some piñatas in Mexico in the 1890s are supposed to have contained perfume. And then there was the Bishop of Morelia in central Mexico, who is said to have hosted a posada at which all the piñatas were filled with the black, sticky, staining, over-ripe fruit of the zapote tree. That's one party I'm glad to have missed.

Piñatas, which can be elaborate works of art in their own right, are used not only by Mexican Americans but by many Anglo-American

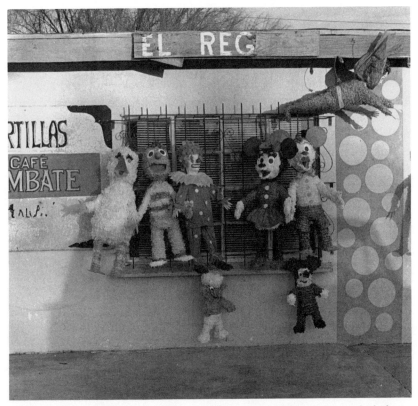

Piñatas outside El Regalo, a store on South 12th Avenue, Tucson 1983, most of which are locally made. Piñatas change with the times; by now, Superman, Mickey, Minnie, and their pals have probably been replaced by more contemporary figures. During a six-month period in the early 1980s, 2,000 piñatas were sold from this tiny store, which also advertises tortillas and Mexican coffee.

families who have adopted this custom for their children's parties. They are available in markets and gift and specialty stores throughout southern Arizona, as well as in Nogales, Sonora. Although most are made in Mexico, there is at least one couple in the Tucson area who make piñatas professionally, on a full-time basis. Numerous other individuals know how to do the work and can make or repair a piñata when the need arises; however, most piñatas are purchased. It is an interesting commentary on comparative standards of living that it's cheaper for a merchant to buy piñatas in Mexico and truck them to Tucson for sale than it is to pay a barely living wage to local crafts-people.

There is another kind of art object that is painstakingly created, only to be broken at parties. *Cascarones* are eggshells that have been filled with confetti and decorated, to be broken over someone's head at a fiesta or party. They have been part of Mexican folklife for at least a hundred years. In many parts of Mexico they were, and are, associated with Easter in the same way that piñatas are associated with the Christmastime Las Posadas processions. They used to be made within the context of the family, and there are still families in our region who make and break cascarones as a regular fiesta activity. In recent years, however, they have evolved into a commercial art form and are commonly sold as craft items at church bazaars and other festive occasions.

There are many styles of cascarones. The most rudimentary cascarón is a blown eggshell which has been filled with confetti and perhaps decorated with paints or dye. Most local cascarones go quite a bit beyond this basic form, however. The eggshell is usually placed on the end of a long paper cone. This is then glued with rows of cut, fringed tissue paper. Sometimes the paper will be green, turning the cone into the stem of a flower with the eggshell in the middle of paper petals. Sometimes short streamers or even colored feathers dangle from the pointed end of the cone. The eggshell can be decorated with paints, felt-tipped marking pens, sequins or glitter applied with glue, or any combination of the above. Flowers, geometric designs, faces of people or animals, and even landscapes are painted or drawn on cascarones. I have found scenes of Monument Valley, clown faces, and accurate renderings of the facade of San Xavier—all done on eggshells! In nineteenth-century Mexico, they could be even more elaborate, with wax added to the eggshells to create sculptures of faces, animals, or people. These were more for gifts than for breaking over people's heads, although they were still filled with either colored paper or perfume.

Cascarones are among the Mexican folk arts that have been adopted by local Indians, and both Yaquis and O'odham frequently make and sell them. In fact, there has developed a Yaqui style of cascarón in which the eggshell is embellished with verbal and artistic statements of Yaqui identity. This style often involves complex, fine-line drawing with multicolored marking pens, and it features such themes as the Yaqui flag, pascola masks, and phrases in the Yaqui language.

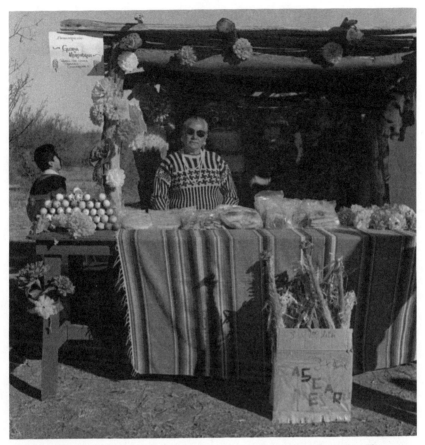

Paper flowers and *cascarones* for sale at the Tumacacori Fiesta, December 1987. The artist, Gloria Moroyoqui of Nogales, Sonora, stands behind the counter. Sra. Moroyoqui reproduces sixteen kinds of flowers in colored paper.

Both piñatas and cascarones are made with colored tissue paper, or *papel de china* (Chinese paper) as it is locally called in Spanish. This name reflects the probable origin of this particular craft. The idea of building three-dimensional shapes from colored paper seems to have been brought originally to the New World from Asia via the famed Manila galleons. Of course, nothing in the history of Mexican culture is ever as simple as it seems. Indians in the mountains east of Mexico City make cutout figurines of bark paper in a tradition that probably has its origins in preconquest times. But piñatas and cascarones, as

well as the paper flowers which are our next subject, all appear to owe at least some of their existence to traditions of the Far East. And that's a nice, romantic thought to have around Eastertime as the bits of eggshell and colored paper dribble down under your shirt collar!

RELIGIOUS FOLK ART

Artificial flowers appear in many contexts—as decorations for food booths at fiestas and as coverings for arches and bowers at wedding receptions and anniversaries, for example—but their most important use is on altars and graves. Flowers are important in Christian symbolism and doubly so among many of the Indian peoples of Mexico for whom they had religious meaning long before the Spaniards arrived in the New World.

Yaquis and Tohono O'odham as well as Mexican Americans in southern Arizona use artificial flowers on both altars and graves. These flowers may be homemade of paper, ribbon, yarn, or bits of discarded plastic, or they may be commercially produced plastic or silk blossoms. By far the most common homemade flowers are of papel de china or colored tissue paper. Some are merely generalized flowers. One young woman told me that the paper flowers with which she decorates the family graves on All Souls' Day are the same as those she used to make for floats when she was in high school. But some craftspeople go far beyond these stereotypical blossoms to create exact reproductions of roses, chrysanthemums, carnations, and other flowers . . . all out of colored paper. One woman in Nogales, Sonora, makes sixteen distinct types of flowers, while a neighbor creates five different kinds of roses alone! Some Yaqui women in the Tucson area brush the petals of their paper flowers with glue and then sprinkle glitter on them.

Flowers are also formed of ribbon or crocheted from colored yarn. Soda straws and the pop-tops from beverage cans are also used, as are the thin, flexible rings from six-packs. Currently, very popular for recycling into artificial flowers are the plastic cups from egg cartons. The cartons come in a variety of pastel colors and may be cut into pieces and recombined to create several different kinds of blossoms. No matter where this craft originated—and it reminds one of the sort of thing that is often taught in senior citizens' crafts classes—it is

currently being used by Mexican-Americans and other families for a very traditional purpose: to decorate the graves on November 2—All Souls' Day.

Nowadays, homemade flowers are being replaced to a great extent with commercially produced plastic and silk blooms, many of which are imported from Southeast Asia. These come in an extremely wide range of shapes and colors. One reason for the great popularity of these manufactured flowers is that they last much longer than the paper ones, which do not survive the first good rainstorm. They are purchased in quantity by florist shops, which then hire women to combine them into wreaths, crosses, and other arrangements. It is in this combining process that the manufactured silk and plastic flowers move from mass production to folk art. They are arranged by members of the community that will use them, in accordance with the aesthetic standards of that community. In fact, a careful observer visiting the florist shops in Nogales, Arizona, and Nogales, Sonora, for instance, in late October can learn to identify the work of each store when it is encountered later on in the cemeteries.

Cut flowers also appear on the graves at All Souls' Day. By far the most popular flowers, especially just across the border in Sonora, are marigolds, fields of which are grown just for this purpose. They may appear on the graves in bunches, as individual blossoms, or as loose petals, and are used in a great variety of decorative ways. The marigold is the traditional Mexican flower of the dead, and is called *cempazuchil* in Spanish. The word is of Aztec derivation. The cempazuchil's use is not confined to the border country, but is spread all over Mexico.

While many cemeteries in southern Arizona are heavily decorated on All Souls' Day, the most spectacular decorations are just across the border in Nogales, Sonora. During the first two days of November, hundreds of people flock to Nogales's three public cemeteries to take care of their family graves. All day long people can be seen cleaning, repainting, scrubbing, and placing flowers and wreaths. If one is planning to buy a new marker for some beloved family member, it will be done at that time. The blacksmith shops are busy turning out crosses, fences, and even little roofed, openwork houses to cover the graves. Vendors of real and artificial flowers and flower arrangements line the roads leading to the cemeteries, along with other people selling sugar cane, corn on the cob, ice cream, tacos, and sodas. Small boys run

up to each new arrival, offering to clean their graves for a small sum of money. Balloon vendors stroll through the cemetery, for children must play even though the adults are at work. Families can be seen by their graves, busily working, or perhaps just sitting quietly and remembering.

The results of this activity are truly astonishing. On November 3, the cemeteries are relatively empty of the living, but filled with the evidence of their visits. Graves have been weeded, raked, swept, and cleaned. Markers have been straightened, repaired, repainted, or even replaced. Crosses and fences glisten with new black, white, and even bright blue or pink paint. Holy statues have been repainted in vivid, lifelike colors. Cut flowers are all over. Some stand on the tombs in built-in containers, while others are in cans or bottles and still others are strewn on the grave itself. Here a grave is completely covered with yellow marigold petals with a cross of white blossoms in their midst. There a single yellow marigold has been thrust into each end of a simple cross formed of four pieces of pipe. At yet another grave the bare earth has been mounded, raked, and sprinkled as a background for the occupant's initials, picked out in yellow marigolds. And in contrast with the natural flowers are the brilliant colors of the paper, plastic, silk, and ribbon flowers on the wreaths and crosses that adorn most of the graves. Most graves have not one but several wreaths, each with a different color scheme. The total effect is breathtaking—a riot of color and form that truly must be seen to be believed.

The All Souls' Day decorations in the cemeteries will soon be faded by fall weather; the locally made grave markers add their special touch all year round. Produced within the family or by a local craftsman, they reflect the taste, talents, and values of the communities in which they are made and used. The medium varies from cemetery to cemetery. In one place there is a preponderance of wrought iron; in another there is a cluster of strap-metal crosses; while in still another community, wood or cast cement or tile mosaic will be preferred. What does not change is the presence of certain basic themes and approaches which appear consistently throughout a region far wider than southern Arizona.

Most locally made Mexican-American grave markers are in the form of either a cross or a niche. Crosses may be made of a variety of materials, sometimes recycled for the purpose. Many are simply four

short lengths of pipe with a four-way joint in the center. Sometimes the arms of such crosses end in old porcelain doorknobs. The choice of material often is determined by the resources of the community in question. One tends to find wrought iron used in mining communities where metal workers were sure to be present, and sawn lumber in railroad towns. Plumbing pipe and ready-made metal scrolls of the sort used nowadays to decorate screen doors are found everywhere. Crosses and other markers which have been cast from cement are also widespread and popular. Niches (*nichos* in Spanish) may be cast from cement or built of rocks or bricks; one or more religious statues often stand within. These little shrines can be in the form of tiny grottoes, open-faced boxes, or miniature churches. The two basic forms, the cross and the nicho, are repeated throughout southern Arizona in almost endless variety.

One does not have to spend much time looking at traditional Mexican-American cemeteries to realize that the grave marker is only part of a larger artistic ensemble. In the first place, the grave itself is often emphasized. This can be done by means of a dirt mound, a cement slab, an encircling row of rocks or other objects, a fence, or a combination of two or more of the above methods. I have seen a grave in Yuma entirely surrounded by empty tequila bottles, set nose down in the dirt. Sometimes a family plot is provided with some sort of boundary, but more often it is the single grave that is so marked. Needless to say these boundaries play their role in the aesthetic impact of the cemetery. As was true in the case of the crosses, the boundary fences tend to reflect the human and artistic resources of the community.

In Nogales, Arizona, for example, there is an active metalworking tradition reflected in the wrought-iron fencing that surrounds so many of the plots in the Nogales cemetery. Wrought iron is a very old artistic medium in these parts; there is a lovely eighteenth-century cross on the dome of Mission San Xavier. There are wrought-iron crosses in many cemeteries; wrought-iron fences around the yards of houses; and wrought-iron gratings covering windows all through southern Arizona. A good deal of this work is decorative as well as useful, and much of it is made by Mexican and Mexican-American smiths. The Aristocrat Ornamental Iron Company in Nogales, Arizona, for instance, makes a substantial amount of the wrought iron

A gallery of Mexican-American grave markers:

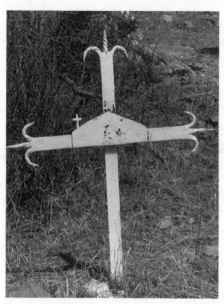

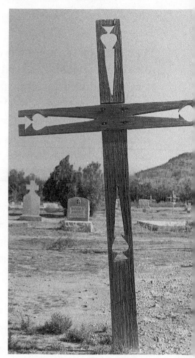

A strap-metal cross at the old mining town of
Harshaw-Duraznos;

A wooden cross at Casa Grande;

A wooden nicho at Tubac,
holding the head of Christ;

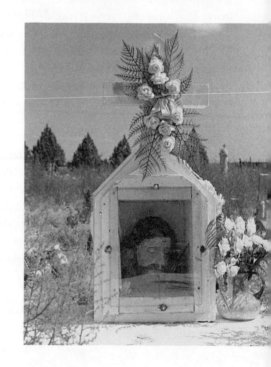

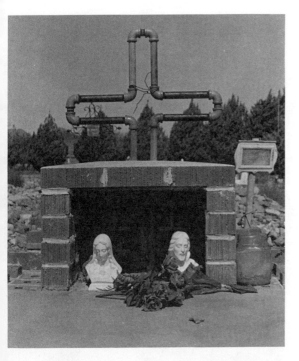

A brick nicho, also at Tubac, containing busts of Christ and the Virgin and surmounted by a cross made of plumber's pipe;

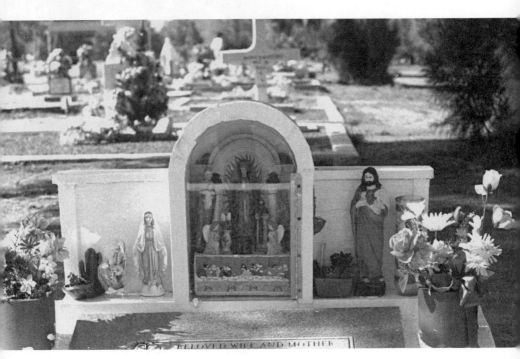

An extremely complex nicho assembly at Casa Grande.

The snake handle on the main door to Mission San Xavier del Bac. This remarkable piece of traditional ironwork was created by the late Raúl Vazquez, a talented local blacksmith whose work appears in several churches in southern Arizona.

seen in the local cemetery. A visit to their headquarters just east of Nogales can be rewarding. The name of the firm appears in wrought-iron letters on the facade of the brick building, and all the doors and windows are covered with elegant and complex grating. A small, portable welding rig on wheels often stands outside the shop when it is not in use. It is encased in a framework of filigree wrought iron and embellished with the word "Aristocrat" on its roof. It serves as a movable advertisement for the firm.

In addition to the grave marker and boundary fence or wall, one often finds religious statuary, whether or not there is a niche to hold it. More than one holy personage is frequently represented at a single grave. The favorite saints, and even the actual statues owned by the deceased, are sometimes placed on the graves. Flower vases are set upon or built into the grave slab or rim. When to all this is added the floral tributes of All Souls' Day, the results can be quite over-powering. The total effect becomes that of a multiplicity of small details adding up to an extremely complex whole. This "principle of accumulation" is an important aesthetic feature of much Mexican and Mexican-American folk art.

This same principle plays an important role in another kind of religious art—the yard shrine. Houses occupied by Mexican-Americans may have nichos or shrines in the front or side yard and be fully visible from the street. Such a shrine may be in the form of a simple arch, a miniature grotto or rustic cave, or even a tiny church complete with towers. It may be of brick or cast cement, or it may be recycled from an old bathtub or refrigerator. Companies that make or sell outdoor yard sculpture will often carry ready-made shrines, complete with statues of popular religious personages. More common than these manufactured shrines, however, are the ones created within the community. Often a family member or neighbor will be called upon to use his building skills. In addition, there are part-time professional craftspeople such as the maker of nichos whose work I discussed in the Introduction.

A typical yard shrine may contain one or more statues inside, frequently set about with candles, flowers, and strings of small, colored electric lights. Here accumulation of detail is joined by another important aesthetic principle: miniaturization. Tiny chapels and other miniature buildings appear on graves as well, but they seem most noticeable in southern Arizona as yard shrines. Shrines may also be built into the walls of the house itself. Some of these shrines seem to have served a secular purpose as well as a sacred one; at least three Tucson houses are said to have once been occupied by bootleggers who signaled the availability of merchandise either by lighting or extinguishing the lights on their house shrine.

If the shrine is a miniature replica of a church, it is usually in the style of the baroque churches of eighteenth-century Mexico. The twin towers, twisted columns, and other features of these tiny build-

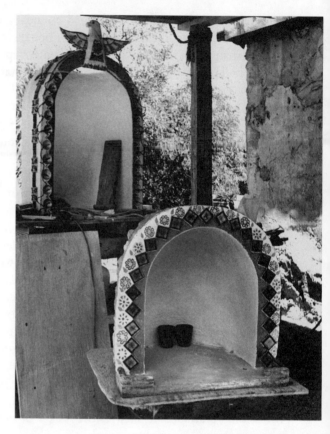

Two unfinished nichos in a Tucson workshop, 1984. The craftsman, who wishes to remain anonymous, is the Yaqui man mentioned in the introduction. Another example of his work appears on p. 8.

ings are the most direct evidence of the baroque legacy mentioned in the Introduction. It is in their religious art that the Mexican-American people show most plainly that they have not abandoned the heritage of the baroque style that was so important in the colonial years. Dramatic use of color, light and shadow, and richness of surface decoration and detail all bear witness to the aesthetic conservatism of the people who create the art under discussion.

While the funerary art is motivated by the need to express respect to deceased family members, many front-yard shrines and other forms of public religious art are made for slightly different reasons. Sometimes a family member has a strong devotion to a certain saint or member of the Holy Family and erects a shrine for that reason. More often, shrines are built as a result of a manda or promise to God or one of the saints in return for a miraculous intercession such as the

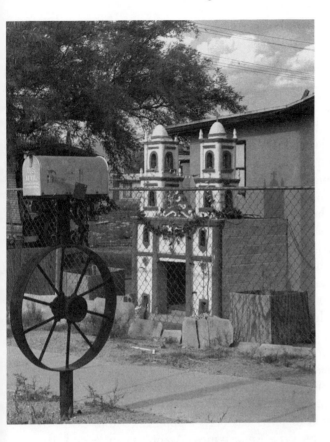

A nicho on Tucson's south side, 1982. The towers of this scaled-down baroque church stand about six feet tall. Tiny silver bells, a string of artificial evergreen needles, and colored lights decorate the front, which is painted white with orange trim. The shrine contains an image of Nuestra Señora de San Juan de los Lagos.

curing of a stricken family member. In one case I know of, a family had possessed a crucifix for several generations, during which time it was believed to have facilitated several miraculous cures and deliverances from danger on their behalf. The decision was made by the crucifix's current custodian to make it available to the general public, and a front-yard shrine was constructed to house it.

Two religious images appear over and over in shrines and on altars in southern Arizona. One, the reclining likeness of Saint Francis Xavier, will be discussed in the next chapter. The other is Our Lady of Guadalupe. In this manifestation the Virgin Mary appears as a young, dark-skinned woman with downcast eyes and hands folded in prayer. Her blue robe is strewn with stars, and she stands on a crescent moon supported by tiny angels. The whole apparition is surrounded by multicolored rays of light and bunches of roses. This representation

of the Virgin is found all over the Mexican and Mexican-American world. La Guadalupana, as she is affectionately called, appears in churches, on cars, in murals, and in a myriad of other settings. This is her story.

In the year 1531, just ten years after the Conquest of Mexico, an Indian named Juan Diego was on his way to Mexico City when a beautiful woman called him over to a hill named Tepeyac, a hill which in Aztec times had been sacred to the Aztec Goddess Tonantzin, "Our Mother." The woman told Juan Diego to ask Bishop Zumarraga in Mexico City to build her a church on this spot. Juan relayed the request to the bishop, who paid little attention. After a second request had been denied, the woman told Juan Diego to gather roses from the hill in his *tilma*, or native cloak, and take them to the bishop as a sign. Juan Diego did so, and when he opened his cloak to lay the flowers at the bishop's feet all were amazed to find a likeness of Our Lady of Guadalupe imprinted on the cloth of the garment. This likeness, still on its original tilma, hangs today in the Basilica of Our Lady of Guadalupe, surrounded by Mexico City's urban sprawl. Reproductions of it are to be found all over the Mexican world, and the dark-skinned Virgin who appeared to Juan Diego in the early days of New Spain is considered the special Protectress of the Americas.

One form of public religious sculpture is seen only at Christmastime. This is the *nacimiento*, or nativity scene. Making replicas of the scene of the birth of Jesus has been a popular custom in European Christendom since the Renaissance. According to legend, the practice of erecting a Christmas crib, as nacimientos are also called, was started in Italy by Saint Francis of Assisi. This is probably not the case, although he did have a good deal to do with the spread of the custom of venerating the Infant Christ. Whatever the origin of the tradition may be, Christians of many cultural backgrounds erect nativities at the appropriate time of year.

Although many Mexican families erect nativities in the privacy of their homes, some nacimientos are presented as public displays. A marvelous example is erected annually in La Casa Cordoba, a small nineteenth-century adobe house preserved as a part of the Tucson Museum of Art complex. Here, each December, a local woman named Maria Luisa Tena assembles a remarkable scene in memory of her mother in Guadalajara, who enlivened her childhood with similar, but more elaborate, constructions. A sloping platform is built to occupy

half of a room measuring about fifteen by thirty feet. Down the center flows a river of fine-spun gossamer fiber. Rich natural and artificial foliage flanks the stream, and rocky outcrops are visible here and there. At the top of the scene, on the left-hand side, is the stable in Bethlehem containing the Holy Family, attended by angels and surrounded by adoring shepherds. The Three Kings travel toward them from their castle, which represents the city of Cartagena and stands on the right. But this is only the beginning. Worked into the landscape are several scenes from the New Testament: the Annunciation, the confrontation by Jesus of the woman at the well, the baptism of Christ, and Jesus and Joseph working together in the carpentry shop in Nazareth. There is also a Mexican market, several craftspeople, a man slaughtering a pig, and workers extracting the juice of the maguey cactus.

The scene grows each year as Ms. Tena finds new figures in Mexico to add to the whole. With its endless details and activities, it is both a wonderful reflection of the legacy of the baroque age and a statement about a concern with the totality of life on the part of the culture whose tradition this is. It seems to tell us that the message of the Bible is only relevant in the context of everyday living, and that no activity is too humble or mundane to be included in the same scene as the Redemption of Mankind.

While this is the most elaborate public Mexican nacimiento of which I am aware in Arizona, it is certainly not the only one. Others can be found in churches and in front of houses during the Christmas season. That is why visits to Catholic churches in Mexican-American neighborhoods during December can be rewarding. It also is rewarding to drive slowly up and down streets in the same neighborhoods, especially just before important feast days.

The most important feast in the Roman Catholic calendar is Easter. However, it is not the focus for traditional art in Mexican-American communities that it is, for instance, among Yaquis and Ukrainians, both of whom are discussed later. To be sure, Easter is a traditional time for making and using cascarones, but nowadays these can be found at almost any Mexican-American public celebration. Front-yard shrines and home altars will be specially decorated or set up on specific days to honor whatever individuals they are dedicated to. Musicians will serenade their favorite saints or members of the Holy Family on their respective days; Our Lady of Guadalupe in particular

is "awakened with song" on her day, December 12. But Christmas gathers to it Las Posadas and nacimientos, as well as special songs, special foods, and even special piñata shapes. This may well be due to the fact that, while Easter is vital for individual redemption, Christmas is by its very nature tied to that most important of all traditional Mexican social institutions, the family.

Publicly visible religious art within the Mexican-American community does not stop with grave markers, front-yard shrines, and nacimientos. The Garden of Gethsemane in Tucson, where Congress Street crosses the Santa Cruz River, is another special example. Felix Lucero was in the United States Army in France during the First World War. Alone and wounded in no-man's-land, he made a promise to the Virgin that, were his life spared, he would devote his remaining years to religious works. This he did, creating sculptures at various sites until he finally came to Tucson. Here, in the 1940s and 1950s, he lived with his wife under the Congress Street bridge and worked on his final offering. The large statues were cast of cement in the river bottom and then moved into place on the west bank of the river. They include the Crucifix, the Last Supper, the Entombed Christ, and the Holy Family. There is also a shrine in the form of a turreted castle containing a miniature scene of Christ Brought Before Pilate. The statues have had a checkered history of alternating care and vandalism. In 1982 they were enclosed within the walls of a new, protected Felix Lucero City Park near their original site.

Not only is the site visited by tourists and those interested in art, it also serves as a focus for devotions by local residents. Visitors frequently find flowers and other offerings placed on the body of the entombed Christ or tucked behind the figure of the Holy Child. Passersby will stop, pray briefly, and move on. It is also a regular site for weddings, and at least one Mexican-American politician has announced his political campaign there. Still more evidence of the garden's incorporation into the local Mexican-American community lies in a series of stories concerning Felix Lucero and the creation of the statues—stories one still hears in the neighborhoods on the west side of the Santa Cruz. It seems that one day, while Lucero was in the riverbed working on the Crucifix, a drunken man rode up on his horse and verbally abused Lucero, making fun of him and his work. He even caused the horse to trample on part of the sculpture. Having done this, he rode on. Before he had gone far, a snake came out from

Tucson's Felix Lucero Park, better known as The Garden of Gethsemane, 1984. Judas stands at the table of the Last Supper in the foreground, clutching a bag of coins in his left hand. The wounds of the crucifix in the background are often touched up with red paint.

under a rock and scared the horse, which reared and threw him. He died instantly of a broken neck.

This is an old story, of course, and one which is told with different details concerning holy places and things all over the world. It does not really matter whether it actually happened in the bed of the Santa Cruz River. What is important is the fact that the story is told— and believed—among the community that lives in the neighborhood of the Garden of Gethsemane. The garden and its statues are legally the property of the City of Tucson, but in a real sense they and the process of their creation belong to the community. Lucero was a talented individual, but his actions in making and fulfilling his vow place him firmly within his community, and the community shows this in the ways outlined above. This, to my mind, is what makes the

The driftwood crucifix that stood during the late 1970s on the landfill on the west bank of the Santa Cruz River, looking toward downtown Tucson, March 1979.

Garden of Gethsemane a work of folk art and what separates it from the environments created by so many talented, visionary, and often alienated artists across the country. These men and women who have created highly individualistic environments for themselves, were and are artists, to be sure, but not folk artists in the sense in which the term is used here.

Others within the Mexican-American community express their faith in highly individual ways. At some time in the 1970s a large and powerfully conceived crucifix was erected of scrap wood on the landfill on the west bank of the Santa Cruz River, just south of downtown Tucson. It remained for a few years, during which time it was apparently used as a place of prayer, to judge from the number of candles at its base. By the early 1980s it had been removed.

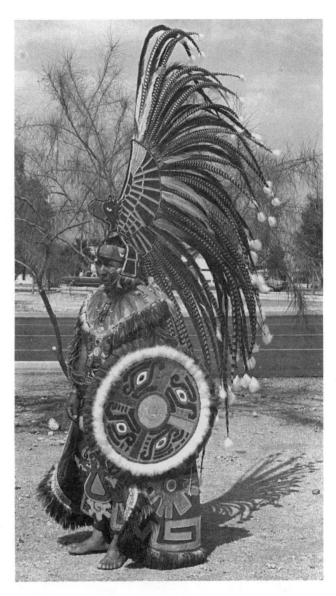

Rogelio Valdovín wearing one of his Aztec costumes. The occasion was a celebration of Yaqui art and traditional culture at Old Pascua village, May 1981. The brilliantly colored costume is adorned with feathers, embroidery, rhinestones and sequins, and took approximately a year to create. Like all his Aztec costumes, it bears an image of Our Lady of Guadalupe—this one on the cloak. Señor Valdovín makes his costumes to fulfill strongly felt religious and cultural obligations.

A different but still personal artistic response is that of Tucsonan Rogelio Valdovín, who for the past decade or more has been creating elaborate Aztec costumes in response to an intense religious experience. As is so often the case, his acts of creation have been undertaken, not as the exercise of a sort of personal option, but because of a feeling

of obligation to do so. By creating and wearing his Aztec costumes, Sr. Valdovín is honoring God, the Virgin of Guadalupe, and the Indian aspect of Mexico's cultural heritage. He wears the costumes in religious processions, at Native American cultural events, and in a few civic events such as Tucson's annual Rodeo Parade.

<div align="center">SECULAR PUBLIC ART</div>

Murals and Automobiles

The outside walls of public buildings are the sites of yet more Mexican-American public art, art of a secular nature. Neighborhood gangs announce their territory by means of graffiti; businesses of various kinds advertise their wares and services through wall paintings; murals serve as proud statements of cultural identity and aspirations. I am not going to say much concerning the first and second of these categories. Graffiti are individually done, unsanctioned wall

The facade of Martínez and Sons wrought iron shop in Tucson, May 1987. The Martínez family, now training its fourth generation of ironworkers, is one of several southern Arizona Mexican-American families who maintain this decorative tradition. Their work can be seen in cemeteries, on fences, and on window gratings all over the region. With the increasing popularity of metal gratings over windows and doors, the Martínez family and others are now advertising themselves as "security specialists" as well as ironworkers.

Graffiti—the antiestablishment end of the mural tradition. This is the wall of an empty laundry company on South Fourth Avenue in South Tucson. A remarkable range of decorated walls can be seen within a few blocks of the corner of South Fourth Avenue and 29th Street. Photo taken in June 1987.

decorations. While most are limited to stylized lettering announcing barrio or neighborhood boundaries, a few figurative graffiti do occur. Most common of these is the picture of a man's face with narrow-brimmed hat, "shades" (dark glasses), and thin, drooping mustaches —a kind of symbol of young Chicano identity. I have also seen a recognizable picture of Our Lady of Guadalupe spray-painted on the boarded-up window of an old house. Commercial advertisements painted on walls seem more common in such Mexican-American commercial districts as South 4th, 6th, and 12th avenues than they do elsewhere. These can run from elegantly rendered business names to symbols such as barber poles, plates of food, tires, and the like. These paintings change constantly as businesses come and go, and they provide much of the distinctive atmosphere of Tucson's south and west sides.

Since the late 1960s there has been a national mural movement among minority peoples in the United States, and especially among Chicanos. Inspired in part by the work of the great revolutionary muralists of Mexico, the movement turns urban walls into vivid state-

ments of cultural identity and aspirations. These cultural-identity murals have proliferated in the last twenty years in Tucson and in the neighboring enclave community of South Tucson, appearing on government buildings, schools, community centers, apartment complexes, and private businesses. Sponsorship and financing have come from both the public and the private sectors. Some murals have been regarded by their sponsors as a way of forestalling graffiti. Some murals are the creations of artists working alone, but frequently a locally known artist will be hired to design and lay out the mural and supervise a crew of neighborhood children or teenagers who actually apply the paints.

A particularly rich mural on the former Perfection Plumbing building at 950 South Park Avenue, for example, was done in the 1970s by a group of Tucson High School students under the supervision of Antonio Pazos. It mixed the historical and the contemporary, portraying an Aztec temple, a Yaqui Deer Dancer, Mexican revolutionary soldiers, Our Lady of Guadalupe, zoot-suit-clad pachucos, a priest marrying a Chicano couple in front of a baroque church, and two low riders (cus-

Perfection Plumbing's mural created by Tucson High School students under the direction of Antonio Pazos. The photo was taken in 1981; the mural has since been painted out. Among the images of Mexican-American identity, reading the central portion from left to right, one may see a Pachuco, the Mexican flag, a Catholic chapel, a Yaqui deer dancer, revolutionary horsemen, a low-rider truck hopping, Our Lady of Guadalupe, more Pachucos, graffiti, the American flag, a "classic" postwar coupe, Emiliano Zapata, symbols of revolutionary struggle, the banner of the United Farm Workers, and a prickly pear cactus.

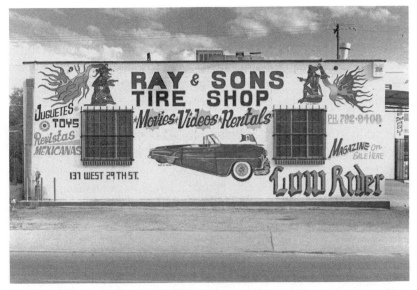

Ray and Sons Tire Shop, West 29th Street, Tucson, May 1987. This mural was painted by Luis Mena several years ago, subsequently covered by racks of tires, and later uncovered and retouched. The Aztec gods and the low-rider convertible remain from the older mural; the list of items for sale and rent has changed to reflect the changing times.

tomized cars). This privately commissioned mural was obliterated in the early 1980s after the building changed hands.

The combination of traditional and modern images is reflected in many local murals. One particularly interesting assemblage is on the front and side of Ray & Sons Tire Shop on West 29th Street. These paintings, by Luis Mena, combine the Mexican tricolor, Aztec deities, and low rider. (In addition to automobile tires, Ray & Sons carries *Low Rider* magazine and a selection of videotapes.) Mena has done other murals that seem to hover, as does this one, somewhere between straight advertising and cultural-identity statements. Among his most spectacular recent works are ranch cooking scenes on the side of a van that serves as a rolling taco stand and a series of delicate representations of sea animals on the walls of the Los Siete Mares Restaurant on South 4th Avenue.

There are many other murals in the Tucson area. South Tucson boasts several excellent ones on its city hall and community center. On the north wall of a beauty parlor on South 12th Avenue is a

portrait of Benito Juarez, the great Mexican lawgiver, created by the prolific Mena. The El Rio Neighborhood Center on West Speedway has a wide variety of cultural and political mural statements. Yaquis have painted murals as well. Both Old and New Pascua have depictions of Yaqui Indian ceremonial life on their public buildings. But murals are transitory. Old ones fade, are defaced, and then painted over. By the same token, artists are constantly being hired to paint new walls. On the same day in 1984 that I discovered the loss of the Perfection Plumbing paintings, I came across a new mural being laid out on a nearby apartment building. Any list of Tucson murals would probably be out-of-date before it could be published. As with so many of the arts described in this book, murals are best discovered for oneself.

The rather startling combination of the ancient and the contemporary in many murals provides a fitting transition to the last category of Mexican folk art to be discussed here: vehicle decoration. The hand-decorating of personal and commercial vehicles is an important artistic activity in many parts of the world. Afghan trucks, Maltese fishing boats, Sicilian carts and pickups are well known Old World examples. Closer to home, trucks and taxis in Mexico have long been known for their painted mottoes, their windshield decorations, and for the fringes and religious motifs which embellish their interiors.

One of the most important modes of transportation in rural Arizona and Sonora is the pickup truck. If one wishes to haul any kind of livestock in a pickup, it is necessary to raise the sides of the bed by means of a wood or metal stock rack. Contemporary stock racks are usually simple arrangements of welded metal pipes that fit into holes in the sides of a pickup bed. It is only in the Mexican and Mexican-American community that stock racks take on elaborate decorative features. By far the most common of these features is a circular metal mount for the spare wheel, high up in the front quarter of one or both sides of the rack. Only rarely do these have wheels mounted in them; their function appears to be primarily decorative. Purely ornamental as well were the metal cultivator wheels that I saw included in the sides of one stock rack south of Tucson. Patterns of pipes and wooden strips, welded-on horseshoes and metal scrolls are just a few things that appear on other racks, common sights in southern Arizona with its strong vaquero tradition.

Fancy metalwork appears on the racks that many carpenters and contractors attach to their pickups to carry pipe, lumber, and other long objects. Many of the region's Mexican-American blacksmiths and ironworkers advertise their skills on their trucks. I have already mentioned the highly decorated, portable welding rig belonging to the Aristocrat Ornamental Iron Company in Nogales, Arizona. In Tucson, the pickup belonging to Martínez and Sons' Wrought Iron Company has a fancy iron rack, and in addition its doors are painted to depict a burglar breaking through a window—something that would never happen, it is implied, if the window had an iron grating over it!

If one sees a custom-painted, elaborately chromed automobile that has been lowered till it almost scrapes the ground, chances are it is a low rider. The paint job is usually several coats and perhaps with a metal fleck in it, or a subtle shading of color from dark to light. Interiors are frequently customized, with options such as thick pile fabrics, swivel seats, chandeliers, and even built-in TV sets. The steering wheel on many low riders is a tiny affair of chrome-plated chain. Hydraulic lifts are often installed at all four wheels, so that either or both ends can be raised or lowered at will.

Owners of low riders (they're called "low riders," too) have a phrase they use to define their ideal of automotive beauty—"low and slow, mean and clean." First off, all the cars are built low, some actually being equipped with scraper bars that can be dragged on the ground to produce a dramatic trail of sparks. One drives one's low rider slowly out of necessity to keep from hanging up the bottom of the car. But slowness is actually a part of the style—one wants to see and be seen in one's car, and one of the messages of the low rider is that the speed with which one travels is much less important than the style in which one gets there. "Mean and clean" also refers to the style and luxuriousness of the car's decoration. It is almost impossible to explain, but after you have seen some of the cars, you will understand the phrase.

Low-rider show cars are often unbelievably elaborate, with mural paintings on all possible surfaces and a mass of chrome plating. Street cars—those used for everyday transportation—are of necessity less opulent, but they may still represent large investments on the part of the owners. Low riders may be pickups or "classics" of the period between 1936 and 1950. Classics are often restored to a greater degree of

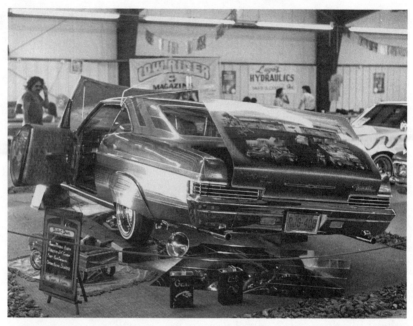

A low-rider car display at the Pima County Fairgrounds, August 1982. The plaque at the left gives credits to the painters and upholsterers who worked on the car; behind it is a miniature pickup truck painted a metallic flake green to match the larger car. The mirror beneath the car reflects a painting of Cheech and Chong on the bottom of the gas tank; the mural on the trunk cover shows the scene at a local car wash. Not only is the interior fully upholstered in deep pile, but the inside of the hood is also, and the edges of the doors are painted with figures. A frog wearing a zoot suit graces the door edge on this side of the car. Not visible in the photo are the built-in TV set below the instrument panel and the picture of Miss Piggy on the door to the glove compartment.

richness than they originally possessed. The basic low-rider emphasis is on luxury, even opulence. Low-rider owners share with the great princes of the Renaissance the experience of being patrons of the arts. When the cars are placed on display, the names of paint, bodywork, chrome, and upholstery specialists are included on the signs bearing the car owners' names.

The art of the low rider is basically a social art. Owners gather in clubs, at competitions, and at conventions to see and be seen and to enjoy the company of their peers. Cars are judged and trophies are awarded. Some owners dress especially for the occasion, often in versions of the classic 1940s zoot suit. Special hopping competitions are held in which the hydraulic lifters actually cause the front end of the cars to jump off the ground vertically. It is not unusual to see

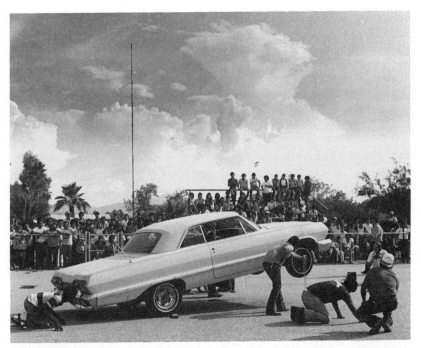

Hopping contest at a low-rider show, 1982. The owner kneels at the left, activating the battery-powered hydraulic lifters; judges on either side of the car are measuring the height of the hop, which in this case was around two feet.

heights of twenty inches or more measured between the bottom of the front wheels and the ground. Hopper cars are frequently different from show cars, being lighter and not customized to the same degree of elegance.

Low-rider car clubs have received considerable publicity in Arizona in recent years, only some of it positive. Newspaper articles in the late 1970s and early 1980s occasionally used the term "low rider" to mean much the same as "street gang." Many of the low-rider groups have recently devoted themselves to improving their image to the outside world. One Tucson club provides its cars for wedding processions. Another group transported the Catholic Bishop of Tucson to mass on the day of Our Lady of Guadalupe; and still others engage in a variety of community services. In 1982, the Tucson Museum of Art began organizing low rider shows in its parking lot in conjunction with the annual Tucson Meet Yourself festival. The project was later taken over by the Tucson Festival Society, which also features a low-rider

show at its annual La Fiesta del Presidio each spring. All this activity has helped create an attitude of public acceptance for this important form of contemporary Chicano folk art.

General Themes

Mexican-American and Chicano art forms seem to have certain unifying themes and motifs. The heritage of Spanish colonial times can be traced in Father Kino's legacy of beef and wheat, and in the contemporary importance of the baroque style in religious art. Another aspect of this colonial heritage is the Catholic religion. The majority of Mexican Americans are Catholic, and the images of Catholicism pervade the art. Much of the art we have discussed is religious in nature. The arts of celebration—food, music and dance, piñatas and cascarones—are frequently practiced in a religious context. However, religious images have a way of cropping up in secular contexts, as shown earlier in the discussion linking household shrines with bootlegging activity. Another example is the image of Our Lady of Guadalupe, which appears on murals, is spray-painted on boarded-up windows and on the cars and regalia belonging to low riders. In these and other ways, Catholicism, itself a part of the legacy of the Spanish empire, is felt in the contemporary reality of Mexican-American and Chicano folk art.

The baroque aesthetic of richness of color and form, of miniaturization, dramatic impact, and accumulation of vast numbers of tiny details which are complete in and of themselves are all reflected over and over in the arts we have looked at. From grave markers to low riders to the very organization of public celebrations, we are constantly reminded that the contemporary Mexican American is heir to the rich legacy of the baroque age of colonial Mexico.

Above all, I feel in this art a sense of community, and I see in it respect owed and obligations fulfilled to members of that community. In its smallest, most intense form, community equates with family. The arts of celebration and the cemetery markers all function to strengthen bonds between living family members or to reaffirm ties with and respect for departed relatives. Community extends beyond the family as well. The murals, the acts of service on the part of low-rider clubs, and the fact that so many of the art forms occupy a highly social context attest to the importance of a broad human community. And in the

religious art—grave markers, yard shrines, and public religious sites —the obligation and respect are extended to an even broader community, this time a sacred one made up of departed ancestors, the saints, the Holy Family, and God. It is in the context of community service and obligation that the traditional arts of the Mexican Americans of southern Arizona seem to make the most sense. For they are public arts, performed on a broad stage, benefiting as wide as possible a segment of the community. They tie artist, family, saints, and spectators together in a system of interaction. Their presence, like the presence of the culture that produces them, goes far in making our region the special place that it is.

2

* * *

The Traditional Arts of
Native Americans

TOHONO O'ODHAM TRADITIONAL ARTS

The people who have lived in our region the longest are those whom we used to call the Papagos. Their name for themselves is O'odham—the People—or Tohono O'odham (the Desert People, to distinguish themselves from their cultural and linguistic relatives, the River People or Pimas, who live farther north in the Salt and Gila valleys). Their reservation stretches from near Kitt Peak on the east almost to Ajo, and from the Mexican border to just below Interstate 8, with detached districts near Gila Bend and at San Xavier, a few miles south of Tucson. Many Tohono O'odham live in Tucson, Casa Grande, and other nearby cities and towns. Their still-living oral traditions make it clear that in a real sense this is their land.

Older O'odham can point out the place where, in the legendary past, four children were sent to the Underworld in order to avert a flood, or the place where I'itoi, or Elder Brother, killed the Ho'ok monster who was eating the People. For the Tohono O'odham, this desert country is the Garden of Eden and the Holy Land rolled into one. Here they came out of the Underworld, here their legends took place, and here it is they still live. Their land is alive with a history in

which the arrival of Father Eusebio Kino with his wheat, cattle, and Catholicism is a relatively recent interruption.

This does not mean that the O'odham are highly visible in today's Tucson. Far from it. As the threat of Apache wars faded in the nineteenth century, Anglo-American Tucsonans, who had welcomed the Tohono O'odham as valuable allies, became less interested in their Indian neighbors. Most O'odham have never really been integrated into any of the dominant societies of Tucson, although they have frequently served in important economic as well as military roles. In the earlier years of this century, San Xavier O'odham provided labor, mesquite firewood, and pottery vessels for domestic use to the growing city of Tucson. But the labor pool is flooded now with people more in tune with the modern world: the mesquite stands on the reservation are dwindling, and the O'odham potter's art is a dying one. The fact that the second largest reservation in the United States lies partly within Pima County, with a district at San Xavier just south of Tucson, means less to many Tucsonans and visitors than does the presence of Old Tucson, an artificial environment which was created as a movie set and is maintained as a tourist attraction at an equal distance from town.

Given this situation, it should not be surprising that most Tucsonans probably know the O'odham best, not through any of the social arts, but through the relatively impersonal medium of their baskets. Originally made as objects for household use, most Papago baskets nowadays are created for export to Anglo-American communities. They are one of the most regular and meaningful ties to a money economy for many O'odham households. This is not to imply that O'odham families do not have baskets. Many do, but they are increasingly used in the same way they are in Anglo households, as objects of interior decor rather than as kitchen utensils. In an O'odham context, however, the statement they make is subtly different from what it would be in an Anglo-American home. In the one case, the basket is "a part of our heritage," and in the other, a piece of Indian art.

All contemporary Tohono O'odham baskets are made by the coiling technique. A bundle of grasses (usually beargrass) is wound into a spiral and then wrapped and stitched together with more fiber. An awl is used to poke holes in the coil for the stitching process. The most common stitching material is yucca leaves, bleached white.

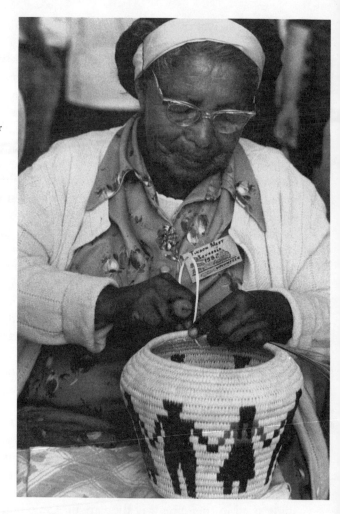

Tohono O'odham basket maker Anita Antone demonstrating her skills at Tucson Meet Yourself, October 1982. The basket Ms. Antone is making shows a ring of men and women dancing the *keihina,* or O'odham circle dance. *Helga Teiwes photo, courtesy of the Southwest Folklore Center.*

Black is provided by the outer skin of the seed pod of the devil's claw (Martynia). Green comes from unbleached yucca leaves, while red is the yucca root. Most baskets are of the traditional close-coiled type; that is, the stitches are so close that one cannot see the bundle beneath them. However, open-coiled baskets, often called "lazy weave" or "split stitch," are increasing in popularity. In these baskets the coil is left visible and the bleached stitching material is split so as to form a pattern against the darker grass of the bundle.

Close-coiled baskets are usually decorated with natural or geomet-

ric forms. One finds spirals, clusters and rows of geometric motifs, stars, and representations of animals such as snakes and owls. Some basket makers will even weave such scenes as circle dances or saguaro picking into the walls of larger close-coiled baskets. The designs on split-stitch baskets are always geometric. O'odham baskets are most commonly found in the shape of flat plaques and deep or shallow bowls. Figurine baskets are also made, most often in the form of people, owls, and dogs. Miniature baskets may be of the normal materials or they may be made of horsehair. These latter may be tiny indeed, and it is not unusual to find a perfect miniature basket, complete with design, measuring one inch or less in diameter. Horsehair is also used for the occasional braided ropes and hatbands still made by a few older men.

One basket design deserves special mention. Although the Man-in-the-Maze design (also called the I'itoi ki or "I'itoi's House") has been a popular basketry design for fewer than fifty years, it is similar to designs on prehistoric rock art found in many parts of O'odham country. It is said by some O'odham to be one of their ancient designs, and it is endowed with several layers of meaning. I'itoi, for whom it is named, is the Elder Brother and Creator of the O'odham. After setting things in this world in motion, he retired to his house, a cave on the west slope of Baboquivari Mountain, where many believe he still lives. At different times in Tohono O'odham history, the People have called on him for help and he has responded. In the legendary past, he killed the Ho'ok monster that was eating children near the present-day town of Sasabe and another huge beast that was sucking people into its maw near what is now Organpipe Cactus National Monument. In more recent years, when a railroad was being built across the Papago lands, I'itoi led the wild animals to a place of safety.

Some say the basket design shows the path that I'itoi made to his dwelling place on Baboquivari so that he could not be followed. Others say I'itoi made the maze, but at a dwelling up north, in the Pima country. Another, possibly more recent explanation is that it is the path each person must follow in his or her lifetime, or the path that the Tohono O'odham must follow in order to reach a deeper meaning of life. Some relate it to a maze design that appears at the prehistoric site of Casa Grande, near Chandler. Whatever its age and traditional meaning, it has become much more than a basket design,

This outstanding Tohono O'odham basket featuring the I'itoi ki design was being raffled off at the Papago Culture Day celebration at San Xavier in May 1984. It is instructive to note that the basket was the first prize, followed (in probable value as well as in importance) by a seven-day trip to Hawaii and a portable TV set.

being incorporated into the official seal of the Tohono O'odham tribe and becoming a symbol of their identity. One finds it on T-shirts, on bumper stickers, on stationery, and even as a part of the decoration of Catholic churches.

A question often asked concerning Tohono O'odham baskets is: "How long does it take to make one?" That question is almost impossible to answer. Larger baskets and more complex designs naturally

take longer. Close-coiled baskets are more time-consuming to make than split-stitch ones. Time for gathering and preparation of the raw materials must be considered as well. Basket makers do not work at their craft on a full-time, eight-to-five basis, but rather every now and then between other tasks around the house. Depending on all these factors, as well as on the ability of the craftswoman, a given basket may take almost any amount of time to make. Perhaps the best answer is that given by Bernard Fontana in a leaflet distributed by Tumacacori National Monument: "Until it is finished."

Occasionally, in stores and trading posts one sees Tohono O'odham openwork baskets made of baling wire. A common assumption is that these baskets were invented in response to the tourist trade. This is not the case. These baskets—which are made by men, in contrast to the regular baskets, which are made by women—have a very practical use. They are hung in ramadas which provide shelter for traditional outdoor kitchens and serve to keep food away from small animals. Another remembered use was that of hanging perishable foods down a well where it was relatively cool.

O'odham pottery was once common in many southern Arizona homes, both as cooking ware and in the form of large, porous water jars. Drinking water would stay cool in these ollas through evaporation. A decline in the number of Papago potters coincided with the availability of piped water, refrigerators, and ice machines, as well as inexpensive and unbreakable cooking and storage vessels. Today, only one or two women still know how to make these larger vessels, and their price is accordingly prohibitive to all save collectors. A few men and women make and sell smaller vessels. These are primarily for decoration, rather than for domestic use.

Here's how traditional O'odham pottery was—and is—made. The potter (almost always a woman) goes to a favorite clay-gathering place and digs up clay suitable to the job at hand. She then crushes it by beating it with a stout stick, and sifts the coarser particles out with a screen. This is the time when she adds any additional materials needed to bring the clay to the proper consistency. Back home, she adds water, works the clay into a ball, and lets it sit for three to five days. She is then ready to form her pot. She takes a fistful of wet clay and pats it until it is round and flat. Laying it over the bottom of an inverted pot, she pats it thin with a flat stone and then uses a flat

wooden paddle to get it still thinner. She removes her partly finished vessel from its mold, sets it upright, lets it dry slightly, and smooths its inside surface with her moistened hand. Placing the flat stone anvil on its inner surface, she strikes the outside with her wooden paddle, thinning and raising the walls still more. Finally, she adds coils of clay to the rim and works them in with her paddle and anvil until the pot wall is raised to its desired shape.

The potter then lets the vessel dry slightly and rubs its entire surface with a water-worn pebble. The pot can then be painted with a slip made from red or white clay and polished again. It is then put up to dry for two or more days, at the end of which time it is placed in a shallow pit and covered with mesquite or palo verde wood. The potter sets fire to the wood, adding fuel when needed until the pot seems "done." If the pot is to have painted decoration, a paint is prepared from the bark and gum of the mesquite tree and the painted vessel is lightly cooked over coals to blacken the paint.

Occasionally, Tohono O'odham craftspeople make figurines of clay, wood, and even twisted electrical wire. Genre scenes, including nativities, are made of wood and clay. A large nativity is displayed annually at Mission San Xavier. It was carved of wood by Tom Franko, son of the late Chepa and Domingo Franko, both of whom had attained international fame for their carvings. The Holy Family is shown as though they were Tohono O'odham, under a ramada plentifully stocked with traditional baskets and pottery and with the Baby Jesus in an old-fashioned, swinging hammock-cradle. A string runs from the cradle to the edge of the display so visitors can rock the Holy Child.

Older wood-carving traditions are also maintained by a few men who still whittle ladles and bowls of mesquite wood. Although the ladles, bowls, and trays so produced are no longer as commonly found in O'odham kitchens as they once were, they nevertheless find ready sales in crafts stores throughout the area.

Other craft and art forms are derived from the non-Papago world. Some Papagos do beadwork, never an important Papago craft, to sell to Indians and non-Indians alike. A few Papago men do silverwork, mostly using the overlay technique. Many older Papago women quilt, having probably learned to do so from Catholic and Protestant missionaries in the earlier years of this century. There are also a few Papago painters doing genre scenes in watercolors. All these art forms, while they have a decided O'odham flavor, are fairly recent arrivals,

and none of them, except quilting, is followed by more than a handful of people.

THE TOHONO O'ODHAM ARTS OF CELEBRATION

The visual arts described above constitute the most accessible of Tohono O'odham traditional arts. They have been selected by the O'odham and by outsiders for export beyond their original context, are well described in public and scientific literature, and are available through a number of retail outlets. It is not necessary to meet a Tohono O'odham in order to acquire an O'odham basket, or even a collection of such baskets. There are other forms of traditional O'odham expression which, though they are readily accessible in the Tucson area, require a little effort to find. These are perhaps best grouped as the arts of celebration, as they are usually practiced at festive occasions in and outside the O'odham community. Of these arts, the one most commonly found is cooking.

Although there are no restaurants in the Tucson area which specialize in Tohono O'odham cuisine, the food is available in a number of settings. The most consistent source is at Mission San Xavier, just south of Tucson, where on weekends local families and organizations operate food stands. Other settings include such public festivals as the Fourth Avenue Street Fair, the Tucson Festival Society's San Xavier Fiesta, and Tucson Meet Yourself. The most popular food sold on such occasions is the local variety of Indian fry bread, commonly called "Papago popovers."

These are made from wheat flour, baking powder, salt, powdered milk, and water. After being rolled into balls, the dough is formed into flat, round cakes about ten inches across and fried in deep fat. The resulting bread may be eaten plain or with honey or it can be made into a sort of burrito with beans or red chile as a filling. Similar fried breads are prepared by Hispanic and Indian peoples in many parts of the Southwest. The closest traditional, local Mexican parallel to Papago popovers are the large, deep-fried buñuelos which are served with a raw sugar syrup on New Year's Day in many households. Pima women also make popovers, frequently with whole-wheat flour. The sopaipillas of northern New Mexico are a related food, as is Navajo fry bread, which is similar in shape and size to the Papago popover.

"Indian tacos" have recently become popular at public festivals in Arizona; they are rounds of crisp fry bread piled with ground meat, cheese, lettuce, and taco sauce.

Much of the rest of the publicly available O'odham foods show our region's debt to Mexican culture. Red-chile stews, menudo, flat "Sonoran-style" enchiladas, and wheat bread baked in wood-fired ovens bear witness to the continued presence in O'odham country first of Spaniards and then Mexicans. Such other staples of contemporary O'odham feasts as potato salad and Kool-Aid reflect the fact that the People share their desert with contemporary American culture. As a matter of fact, the combination of potato salad and fiery red chile is a highly regional taste sensation and a real contribution to our local culinary traditions.

There is an older body of Tohono O'odham cooking as well. It utilizes such native wild foods as cholla buds, mesquite beans, and the fruit of the giant saguaro cactus. This latter is boiled down into a wonderful syrup. Also still in existence are some ancient, traditional crops like corn, squash ("Papago Pumpkins," sold in northern Sonora under the local Spanish name *pezcuesuras*), and the tiny tepary beans that have evolved on the Sonoran Desert. The non-O'odham individual may occasionally come in contact with these foods at special, educational events, or as guests at O'odham feasts.

Music and dance have long been important elements of Tohono O'odham culture. Old-style O'odham dancing was, and still is, performed to music provided by a vocal chorus accompanied by one or more rattles and an inverted basket beaten as a drum. The basket may also serve as a resonator for a wooden rasping stick. As large coiled baskets get more and more expensive to replace, a molded drum of rawhide or some such other stiff material is substituted increasingly.

The singers perform in unison. Tohono O'odham songs, in common with the songs of many other Southwestern Indians, possess what scholars call a "terraced melody." That is, the musical verses tend to start on a relatively high note and gradually descend, pausing along the way at intermediate notes. Unlike some Native American song traditions, Tohono O'odham song texts usually are composed of meaningful words. Some of the short poems have striking images, often associated with rain and the resulting plant growth and enhancement of life. These O'odham live, after all, in a desert, even though their name for it, tohono, translates as something like "stony

place," or even "shining place," in contrast to our concept of the desert as a place not really suitable for human occupation.

Here are translations of two Tohono O'odham songs from the repertoire of a contemporary singer:

> Dove person, you came and sat on top of my head
> You drink the juice from my fruit
> From this, every time you breathe out
> Your breath forms clouds.
>
> There is a pond of water
> And on the edge of the water is
> Someone running with his head tilted up
> Why, it's the killdeer bird.

Both these songs are used for one of the most important of the surviving Tohono O'odham traditional dances: the *chelkona* or "skipping and scraping" dance. This dance, which is performed by boys and girls (or young men and women) in two long lines, used to be an important part of traditional intervillage celebrations. Nowadays, the dance is taught to children, and abbreviated versions are performed at all sorts of public gatherings.

Tucson's chelkona team is an independent group called the Desert Indian Dancers; reservation teams are usually sponsored by schools. The details of costume and performance vary in different parts of O'odham country. The Desert Indian Dancers are clothed in white: long white dresses for the girls and white kilts for the boys. Faces are daubed white with clay and the boys have rain and other symbols painted on their naked torsos. The boys carry images of white birds, while the girls bear triangular cloud, rain, and lightning symbols. Thus dressed and equipped, they move onto the dance area while the adult singers, who usually wear western clothes and long dresses, begin their song. The two lines of silent dancers cross each other, turn into facing rows, and perform other figures, all to the accompaniment of singing. This general pattern of dress and movement holds true for all the chelkona groups I have seen, even though details of costume and equipment, especially color, vary from group to group.

Various explanations of the chelkona relate to one of the best known of all Tohono O'odham legends: that concerning the four children who were sacrificed in the distant past to prevent a great flood in what is now the center of the reservation. As is the case with so much

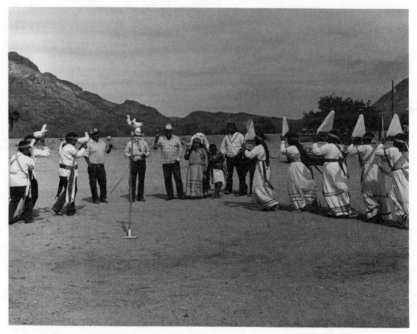

The *chelkona* dance on its home territory. Members of the Desert Indian Dancers perform the *chelkona*, or skipping and scraping dance at San Pedro Village, June 1980. A standard with a bird effigy stands in the center, in front of the four singers. The man directly behind the bird is scraping on a molded cowhide drum, a modern-day substitute for the traditional, but now extremely valuable, large inverted basket. The other singers play gourd rattles. A row of girls approaches from the right carrying triangular rain cloud symbols made of cotton; the boys carry white birds. The multicolored ribbons hanging from the dancers' waists represent rainbows. This is the same dance that is shown on p. 2, performed by the same group almost ten years later. As members grow up and graduate from high school, they are replaced by younger children who in their turn get the opportunity to learn something about their traditional music, dance, and beliefs from the elders of the organization.

of Tohono O'odham ritual, one of the chelkona's major purposes is to bring down the rain. The birds represent those that appear on the desert just before rains; the cloud, rain, and lightning symbols are self-explanatory. The chelkona's function within Tohono O'odham culture has shifted, however; now it is both a vehicle for passing some of the old ways on to the younger generation, as well as a suitable symbol of O'odham identity to present at festivals and intertribal get-togethers. The dance cycle, which is traditionally repeated four times and takes a couple of hours to complete, has been shortened to fit the tastes of non-O'odham audiences.

Another traditional Tohono O'odham dance that one might encounter at festivals and public programs is the *keihina,* or round dance. This is a social dance, but with religious overtones. As they move in a counterclockwise circle, dancers are sometimes urged to stamp their feet down hard on the ground, so as to "bring in the rain clouds." This blending of sacred purpose with social pleasure is not uncommon in O'odham culture, nor in our own, if we pause to think about it.

The Tohono O'odham have borrowed music and dances from their Mexican and Anglo-American neighbors. One such dance is the *kwariya,* an O'odham version of the Spanish *cuadrilla,* or *quadrille,* a popular dance of the last century. Still performed as an exhibition dance in at least two Papago communities, the kwariya involves three or more sets, each of which is comprised of two couples. Dancing to fiddle and guitar music in $\frac{6}{8}$ or jig time, the couples form stars, swing their partners, "duck for the oyster," and execute other figures which belong to the same general tradition as the Anglo-American square dance.

The most popular form of O'odham music and dance comes as a surprise to many outsiders. Called "waila" or "chicken scratch," it consists of polkas, two-steps, and other European rhythms played on a variety of European-derived instruments. In contemporary waila bands, melody is provided by a button accordion, one or more saxophones, or a combination of the two instruments. Rhythm is supplied by a regular, dance-style drum set and an electric guitar and electric bass guitar. One also occasionally encounters the bajo sexto of the Mexican *norteño* tradition instead of a guitar. The music is almost exclusively instrumental. One man, Virgil Molina, sings in O'odham, Spanish, and English. His group, the Molinas, is to my knowledge the only one to feature vocals.

Although it is not clear exactly how and when polka music arrived among the O'odham, it was apparently well established at San Xavier by 1869 when pioneer educator John Spring observed a San Xavier band playing polkas, waltzes, and schottisches at a San Agustín fiesta in downtown Tucson. Spring does not mention specific instruments, but the band—all of whose members are by tradition male—probably played violins and guitars, with perhaps one drummer on the snare drum and another on the bass drum. Such was certainly the typical Tohono O'odham orchestra until well after World War II. While the tunes and dances probably arrived in southern Arizona in the 1850s,

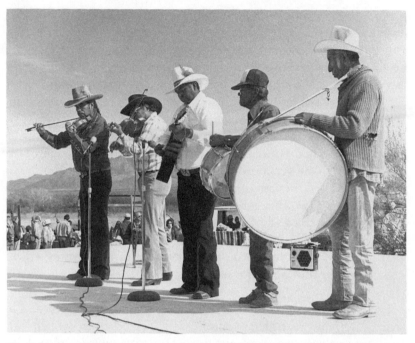

The San Simon Good Old Time Band performing at Tumacacori Fiesta, December 1984. This is the traditional O'odham line-up of two violins, guitar, snare drum, and bass drum. This group was the winner of the First Annual O'odham Old Time Fiddle Band Contest at the Wa:k Pow Wow, March 1984. The Tumacacori Fiesta, held each year on the first Sunday in December, includes Mass at Tumacacori Mission and traditional music, dance, crafts, and food from many of the traditional native and immigrant peoples of southern Arizona.

it is likely that all the instruments had already been introduced to O'odham culture by the Jesuit and Franciscan missionaries in the eighteenth and early nineteenth centuries. The older fiddle bands still play occasionally, but for the most part they have been replaced by groups playing accordions and saxophones. These achieved popularity in the 1950s and 1960s. The saxophone seems to have been introduced to Papagos by way of marching bands, first at mission day schools and Indian boarding schools and later in the public school system. Thus the two great institutional attempts at changing Tohono O'odham culture—the Spanish mission system and the Indian schools—are reflected in, of all things, the organization of O'odham popular dance bands!

O'odham musicians marching in procession at the Feast of Saint Francis Xavier, December 1981. The accordion player is Henry Juan, leader of the Papago Indians, a well-known local *waila* band. The guitar and *guitarrón* players to the left are Yaquis. The procession is marching from San Xavier church to the outdoor dance floor nearby, as part of a ceremony that will result in the transferring of responsibility for the annual feast from the old committee to the new one.

The most popular rhythms for *waila* music are polkas, two-steps (locally called *chotis*), and the Caribbean cumbia. Other imported European rhythms such as the waltz, the redowa and the mazurka can occasionally be heard as well. Tunes come into Papago repertoires in a variety of ways. Some are traditional waila pieces that have

been handed down for generations, since the days of the fiddle or-
chestras. O'odham musicians learn others from listening to Mexican
norteño bands in person or on records. Still others come from both the
traditional and the contemporary American mainstreams. "Rudolph
the Red-Nosed Reindeer," "Una Paloma Blanca," "Oh My Darling
Clementine," "Turkey in the Straw," and "Twelfth Street Rag" have
all been played by waila bands. The waila tradition is oral rather than
written. The tunes are learned by ear and often exist independently of
their titles. Persons requesting a particular song of a waila band must
often be prepared to hum a few bars.

Waila is very popular among both the Desert (Papago) and the
River (Pima) people, and at any given time there may be more than
twenty of the bands in southern Arizona, constantly organizing,
changing personnel, and regrouping. Some groups play only for cele-
brations in their own villages, while others have cut records and are
in considerable demand for dances all over the region. Although the
music is unique to the tribes living south of the Salt River, it is begin-
ning to be heard by a wider audience as waila bands are invited to
appear at regional and even national festivals. One group, the Joaquin
Brothers, has played at a dance in Buffalo, New York. Another way
the music has spread is through recordings. Starting in the early
1970s, Canyon Records of Phoenix, the largest record company in
the United States devoted exclusively to Native American music, has
been issuing waila records and tapes to an appreciative audience.

Although many Whites and Indians use "chicken scratch" to refer
to this southern Arizona Indian polka music, I prefer "waila." A main
reason for this is geographic. Pimas—the River People—seem to call
the whole musical genre "chicken scratch." For many older Desert
People, however, the term is properly used only for a particular kind
of dance, probably performed to the mazurka rhythm. The origin
of the name is simple: the dancers kicked their feet back the way a
chicken does scratching the ground for food. By whatever name it is
called, waila is unique to our southern Arizona desert—the tohono—
and to the O'odham who have lived here since time immemorial.

Food, dance, and music—the traditional Tohono O'odham arts of
celebration—are all to be found in the Tucson area at multicultural
events such as festivals, powwows, and "Indian Days" celebrations.
In such contexts, however, we see only selected aspects of culture
presented to outsiders. To understand the various arts of celebration

within the context of their own culture, it becomes necessary to leave the city with its diversity of peoples and travel west to the Tohono O'odham Reservation where they are integral parts of the living, dynamic cultural tradition of Tohono O'odham Catholicism.

TOHONO O'ODHAM FOLK CATHOLICISM
AND ITS ARCHITECTURE

The main Tohono O'odham Reservation occupies 2.77 million acres in southern Arizona—slightly less land than that of the Commonwealth of Connecticut. Unlike Connecticut, however, the reservation supports a relatively small, scattered population, fewer than 8,000 people. In aboriginal times, in order to grow crops in a land without permanent running water, the Tohono O'odham developed a system whereby each family lived in two villages over the course of a single year. During the winter, when rains are few and light, the people made their homes in the hills near some source of permanent water, often a dripping spring. In the summer, the villagers moved down to the floodplains where they could irrigate their crops by diverting the runoff from the heavy seasonal rains. The rainy season over and the crops harvested, they returned to the winter village or went on distant trading trips.

Traces of this way of life can still be seen in the location of the villages. Each village now has a permanent well, but some are old mountain villages and some are summer farming sites in the intermontane valleys. Few of the sixty-odd villages on the main reservation have more than one hundred residents; only Santa Rosa and the administrative capital of Sells can be called towns. Most of the others have from one to twenty occupied houses scattered in typical O'odham fashion just within sight of each other. One thing most villages have in common is a small Catholic church or chapel. Some were built by Franciscan priests for their congregations; others were built by the villagers for their own folk Catholicism. But even the mission churches are different from the Catholic churches found elsewhere in that they reflect to some extent the needs of Tohono O'odham folk Catholicism—a religious blending unique to this region.

Although Catholic missionaries had occasionally visited the Tohono O'odham since Father Kino's day, it was not until the present

century that a permanent mission program was established among the people of the desert villages to the west of Tucson. When the Franciscans arrived in the 1900s to continue the work that had been started so many years before, they discovered that many Papagos were already Catholics of a sort. From their neighbors at San Xavier and in northern Sonora they had learned to say certain prayers, walk in processions, acquire and venerate religious images, and make the important annual pilgrimage to Magdalena, Sonora. They integrated these customs into their own culture in a distinctively O'odham way.

The annual pilgrimage to Magdalena is important to Mexicans and Mexican Americans as well as to O'odham Catholics. In order to understand it, we must know a little history. Father Kino, who did so much to open this region to European evangelism and settlement, died in 1711 and was buried in Magdalena, some sixty miles south of the present international border. His patron saint, and the patron of missionaries in general, was Saint Francis Xavier, a remarkable sixteenth-century Jesuit who did intensive missionary work in both Japan and India, died off the coast of China in 1552, and found his last resting place in the then Portuguese colony of Goa on the east coast of India. His body was preserved in lime for his final journey. That it arrived and remained in excellent condition was a sign to some of St. Francis's followers of his intensely spiritual nature. For this reason, one of the standard representations of this saint is as a corpse, reclining and dressed in a cassock or vestments. Such a statue is the focus of pilgrimages to Magdalena.

However, San Francisco has undergone some remarkable transformations in northern Sonora. In the first place, many of those who attend the annual fiesta held in his name now feel San Francisco and Father Kino to be one and the same. Both, after all, were famous missionaries; both are dead. Why shouldn't the statue of the dead man in the church be a representation of the dead man whose bones have been on public view in the middle of the plaza since 1966, when Father Kino's grave was discovered and opened? As a result of this discovery, which followed an intensive investigation sponsored by the Mexican government, Magdalena was officially renamed Magdalena de Kino. In addition, a small dome was built over Father Kino's excavated grave, which is on permanent view in the plaza renovated in his honor.

Nor is that the only way in which Magdalena's cult of San Francisco is unusual. While the feast of Saint Francis Xavier in the Catholic calendar is December 3, the fiesta in Magdalena is celebrated on October 4, the feast day of Saint Francis of Assisi. This further confusion is probably a result of the historical fact that in 1767 the Jesuit order, of which Father Kino was a member, was expelled from all the Spanish dominions and was replaced in northern Sonora by the Franciscans. The members of this totally different organization had as their patron saint another Francis—Saint Francis of Assisi. The ensuing confusion in the dates of the Magdalena fiesta is easy to understand. Another result of these historical circumstances is that the statues of Saint Francis Xavier sold in Magdalena are unique in the Catholic world. The famous Jesuit is reclining, to be sure, but he is wearing the brown robes of the Order of Friars Minor—the Franciscans!

The typical Papago folk Catholic altar contains holy pictures and statues, acquired at Magdalena during the feast of San Francisco on October 4. There are statues of the saint dressed in his brown Franciscan robes and encased in little glass boxes. There are holy pictures as well—often commercially produced, postcard-sized pictures of San Francisco and a number of other popular sacred personages. Our Lady of Guadalupe, the Guardian Angel, Saint Joseph, and various manifestations of the Christ Child are especially popular. Many of these holy pictures are framed and set behind glass which has been painted on the reverse with geometric or floral designs and perhaps the Spanish word *recuerdo* (souvenir). Under the painted glass, a layer of crumpled aluminum foil gives a glittering, dynamic quality to the whole painting. These frames are made by about five families of Mexican craftspeople in the Magdalena area, primarily for sale to Tohono O'odham pilgrims. They add color and beauty to the interiors of the chapels where they are placed.

After the holy objects are purchased in Magdalena, they are usually held for a time next to the statue of San Francisco. Thus charged with power, they are brought back home. Their final destiny is placement on an altar, either in a private home or the village chapel. The typical chapel altar is built against the end wall of the building, much as altars were in Catholic churches in the days before the 1967 Vatican II reforms changed the liturgy so that the priest faced the people during mass. The images are placed on the altar or arranged in rows on the

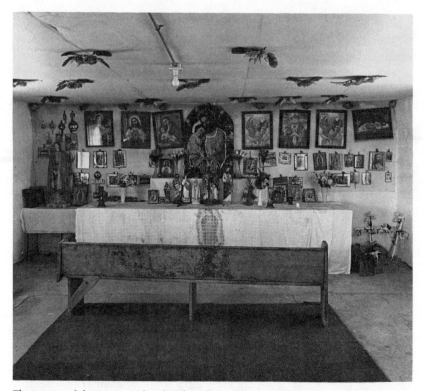

The interior of the San Jose Chapel, Kaka Village, Tohono O'odham Nation, July, 1982. The altar cloth is embroidered with a representation of Our Lady of Guadalupe; artificial flowers decorate the ceiling. Several of the pictures are in painted glass frames, purchased at Magdalena, Sonora, at the time of the annual Fiesta de San Francisco.

wall behind it, often with paper or plastic flowers alternating with the pictures. The wall is usually hung with a white sheet before the pictures are put up. The resulting profusion of detail is very much unlike what one finds in a contemporary Catholic church or chapel. It is, however, reminiscent of the eighteenth-century baroque altarpieces or retablos that still survive in Mission San Xavier and in the church at Tubutama, Sonora. Thus in yet another way the heritage of the powerful baroque style can be seen to live on in southern Arizona.

Tohono O'odham folk chapels serve as safe places to keep sacred objects and as the focal points for various outdoor activities. Therefore, most are a good deal smaller than the missionary-built Catholic churches, which must accommodate a priest and his congregation

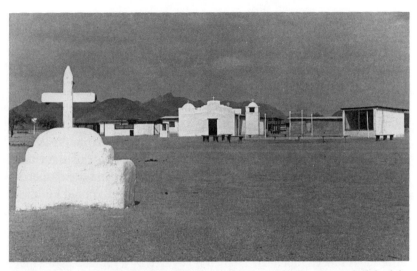

The chapel complex at Kohatk Village, Tohono O'odham Nation, July 1982. To the left of the centrally located chapel is the outdoor kitchen and indoor dining room; to the right is the bandstand and open-air dance floor. In the foreground is the field cross, the focal point of the procession that starts the Saints' Day celebration at most villages.

during the celebration of mass. Churches and chapels alike are rectangular, boxlike structures with a door at one end and an altar at the other. Additional transepts or rooms may be added as they are needed. Many of the buildings are decorated with scalloped gables over their doors; this again is an echo of the baroque, but one which has come to the desert after a roundabout journey. In the late nineteenth century, California architects were searching for a style which expressed the special cultural heritage of their state. What they developed, later called the Mission Revival style, was heavily influenced by the simplified late baroque architecture of the California missions. The plain plaster walls, scalloped gable ends, long arcades and tiled roofs of the Mission Revival were soon found adorning hundreds of public and private buildings all over southern California. By 1910, the style was well established in both Phoenix and Tucson. In 1913, when Father Tiburtius Wand built the second permanent church in what would later become the main Tohono O'odham Reservation, he selected Mission Revival as a suitable style. Father Junipero Serra, founder of most of the California missions, had been a Franciscan, and the twentieth-century missionaries considered themselves to be

following in his footsteps. What architectural style could be more suitable for these new Indian missions than one which referred back to the great days of Franciscan California? Other Mission Revival churches followed in other villages, and soon the O'odham were remodeling their small chapels to reflect the popular new style. To this day the reservation is dotted with small Mission Revival churches and chapels, each with its baroque gable and tiny bell tower.

The chapels do not stand alone in their villages. Around each is a cleared area, often surrounded by a fence. To the east of the chapel door stands a cross on a pedestal. Between the cross and the chapel is a cement dance floor, usually flanked by a three-sided, roofed building. Typically, this has a tall pole in its center from which overhead wires run to other poles set around the edge. Behind or to one side of the chapel is the feast house devoted to the preparation and consumption of food. A fenced, open-air kitchen is covered by a ramada. The stoves are raised adobe platforms with a sort of built-up, three-sided trough in which there are hot coals and on which sit the huge, enameled cooking pots. Usually there is a large, wood-burning outdoor oven in or just outside the kitchen area. Attached to the kitchen is a small house containing a dining table. Cross, dance floor, feast house—all these are used for saint's day feasts, wakes, wedding celebrations, and other festive religious occasions when the people come together to pray, dance, eat, and socialize.

Popular feast days for O'odham Catholics include Christmas, New Year's, Easter, the Finding of the Holy Cross (May 3), San Jose's Day (March 19), San Juan's Day (June 24), and San Francisco's Day (October 4). The whole village sponsors a huge feast once every year or two on its patronal feast day; smaller ones are put on by individual families.

Preparations for a village feast begin long before the day itself, and often include the repainting or even rebuilding of the chapel. This is another way in which the O'odham chapels differ from the missionary-built churches. Churches were built in a single campaign and tend to be simply maintained, like most other buildings in Western European-derived mainstream tradition. O'odham chapels, on the other hand, are constantly being altered and rebuilt as a part of the preparation for the annual feasts. This may well be a reflection of an older Indian custom of renewing shrines and temples on a regular,

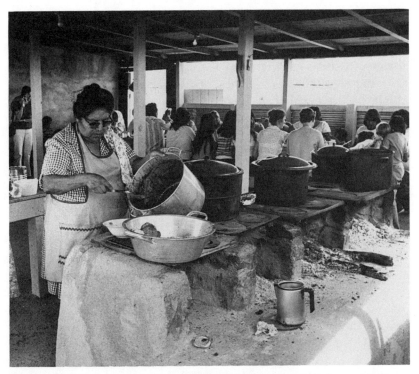

Preparing food for an O'odham feast in the San Pedro Village public kitchen, 1980. Frances Manuel in the foreground is ladling from a large pot, while serious eating goes on in the background. This picture shows the traditional, wood-fired stoves of the outdoor kitchen.

ritualized basis. Just in this way did the Aztecs of Mexico, distant linguistic relatives to the O'odham, rebuild their temples every fifty-two years.

Even if the chapel is not to be heavily reconstructed, it will at least be swept, dusted, and decorated with paper flowers and multicolored paper streamers. Streamers and flowers are also festooned on the wires above the dance floor. Loads of mesquite wood are hauled in from the desert for cooking and warming fires. The appropriate number of beeves are slaughtered, and food is bought. Word of the feast is sent out, often by way of an announcement on "Desert Voices," a weekly radio program in O'odham and English aired on Tucson radio station KUAT-AM. Finally, all is ready for the feast.

The first event is the procession, which usually takes place some-time in the afternoon. It forms just outside the church and consists of men, women, and children of the village carrying the various saints' images. If there is a statue of the saint being honored that day, it will lead the procession. Arches, said by some O'odham to represent rainbows, are made of cane or long sticks and decorated with sheets, colored ribbons, and paper flowers, and are carried over the images of the saints and their bearers. A group of women often walks along singing hymns in Spanish, and an accordion or fiddle band also ac-companies the marchers, playing polkas. The procession makes its way counterclockwise from the church door to the cross, pauses for prayer and devotion, and then continues on a circuit of the plaza, returning to its starting point. If a priest is present, mass will be said.

At this point the feasting begins. Guests will be invited into the dining room in shifts and served with red-chile stew, one or more other stews (such as beef and vegetable, or menudo), beans, potato salad, tortillas, fresh-baked rolls, and Kool-Aid and coffee. Dessert may be J-ello or cake or both. As one shift is finished, its members leave the table, which is then cleared, wiped off, and set for the next shift. This process goes on all night, often until well after dawn the next day.

In the meantime, the waila band will start warming up in the small, three-sided house beside the newly decorated dance floor in front of the chapel. By late afternoon, the band will start playing polkas, two-steps, and cumbias. Some couples will dance; spectators will sit on benches around the dance floor. If it is a cold night, there will be a mesquite fire off to one side, from which shovelsful of coals will be brought over and dumped beneath the benches to keep the spectators warm. Like the feeding of the multitudes, the dancing will continue all night. It is not unusual for two or three hundred people to come to a feast held in a village whose normal population is two or three families. In some villages, especially in the western part of the reservation, a solo ritual dancer and clown, called the *pascola*, performs off and on during the course of the feast. The pascola dance and its accompanying music was learned by the O'odham from the Yaquis.

Many people are surprised that the Tohono O'odham are so little known by the outsiders who have moved into their country. A good

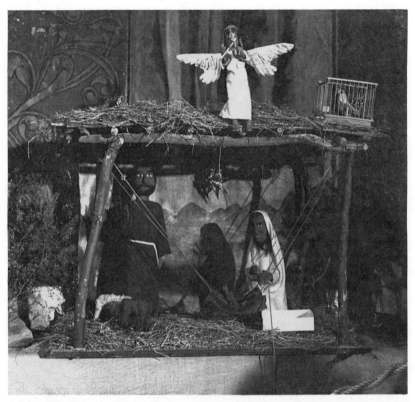

A Tohono O'odham *nacimiento*, Mission San Xavier, January 1987. The figures were carved by Tom Franko of San Xavier village. A string hangs from the swinging cradle; children and others will pause, say a prayer, and then pull the string and rock the Christ Child. I have seen a similar arrangement in the Spanish colonial mission at Oquitoa, Sonora, a day's drive from Tucson. The rooster in its cage was an addition of a Franciscan priest who was stationed at the mission a few years ago.

deal of this is due to traditional O'odham culture. O'odham are not self-advertisers. They go their own way, maintaining and adapting their traditions without worrying much about presenting them to the outside world. Theirs is not an obvious presence, either as creators or consumers, to make an impact on our commerce-oriented society. And the scattered, isolated nature of O'odham villages must also be a contributing factor. But for whatever reasons, the Tohono O'odham have been, until recently, an invisible people in their own homeland. Happily, due in part to increased interest and responsibility on the part of the public media, this state of affairs seems to be changing.

That is fortunate for the rest of us, for the Tohono O'odham have much to offer their more recently arrived neighbors.

YAQUI TRADITIONAL ARTS

Yaqui Indians came to southern Arizona as political refugees. They had been defending their Sonoran homeland in the lower valley of the Río Yaqui about three hundred miles south of the present international border ever since they turned back Diego de Guzman's slave-raiding expedition in 1533. So well did they maintain the integrity of their sacred homeland against Spanish and, later, Mexican invaders that it was not until the late nineteenth century that their position finally became desperate. By then they were facing the full economic and military power of Porfirio Díaz's Mexico. Yaqui territory was rich farmland, and the Yaquis were standing in the way of economic progress. A program of Yaqui extermination was proposed and attempted, and hundreds of Yaquis were captured and deported to other parts of Mexico as slave laborers. Hundreds more responded to this crisis by fleeing to the United States between 1890 and 1915. This is the origin of Arizona's Yaqui communities.

Not all interactions between Yaquis and Europeans involved attempted invasion and Yaqui resistance. Shortly after defeating an expedition sent against them in 1610, the Yaquis requested Christian missionaries. In response to this request, two Jesuits arrived in Yaqui country in 1617. For more than one hundred and fifty years after that peaceful entry, Jesuit missionaries lived among the Yaquis, introducing new crops, new kinds of political organization, and a new religion. The result of this presence was the creation of a completely new entity —Yaqui Christian ceremonialism—with deep roots in both Christian theology and native Yaqui tradition. By the nineteenth century, this Yaqui Christianity was a potent symbol of Yaqui identity maintained and defended with the same fierce dedication with which the Yaquis resisted incursions into their sacred territory. After the immigrant Yaquis in Arizona realized they were safe from persecution, they started their ceremonial life in their new land.

Yaqui ceremonies, which have an intricate and complex set of meanings for Yaquis, lie at the center of most of the traditional arts that survive in Arizona's Yaqui communities. That these ceremonies

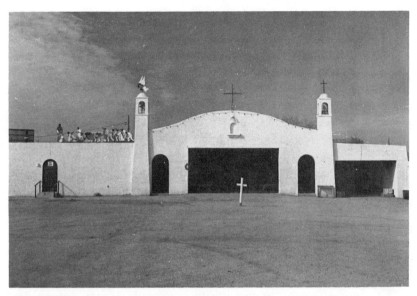

Traditional Yaqui religious architecture. The San Ignacio chapel at Old Pascua Village, December 1982. The *nacimiento* barely visible at left is the same one featured on p. 91. A row of colored electric lights frames the roofline; filigree ironwork crosses decorate roof and towers. The wide entrance accommodates processions and rows of dancing matachinis.

are open to the public—that the art forms clustered about them are public arts—is due entirely to the generosity of the Yaquis, who ask only that visitors behave in a respectful manner and abide by the Yaqui rules of proper conduct. The beauty and intricacy of Yaqui ritual are well described in publications addressed to every level of audience, and they take a variety of approaches. Here, I have tried to give only enough of the shape and meaning of the ceremonies to provide a general introduction to a person seeing them for the first time.

Traditional Yaqui religion is a complex blend of native Yaqui and Catholic beliefs and practices. Yaquis place great importance on the public fulfillment by individuals of obligations incurred towards God and the saints. One of the ways in which such obligations may be fulfilled is by putting on a ceremony or religious fiesta. Usually taking place on the eve or vigil of the saint's day involved, a fiesta includes a procession, public praying and singing, and public feasting. In addition, it involves the contributions of certain specialized ritual performers. Most important of these is the *pascola*.

The *pascola* (pahkola, or "old man of the fiesta" in Yaqui) is one of the most distinctive and best known of the Yaqui ceremonial dancers. He wears a distinctive costume for his work. Rattles made of strings of the dried cocoons of the giant silk moth are tied around his legs just above the ankles. Wrapped about his loins is a breechcloth of patterned flannel blanket material, secured by several hand-woven wool sashes. Around his waist is a leather belt from which several metal bells are suspended. A slotted wooden hand rattle containing metal discs strung on stiff wire is thrust into his belt. Around his neck he wears a bead necklace from which is suspended a large, mother-of-pearl cross with four splayed arms of equal length. This distinctively Yaqui cross is believed by some Yaquis to be an ancient symbol of Our Father the Sun, whom they formerly worshiped. It is also said to represent the four sacred directions. The pascola's hair is tied into a topknot and embellished with a paper flower. On the side or back of his head he wears a small wooden mask.

This mask is one of the best-known objects of Yaqui traditional art. Carved of soft wood such as cottonwood, it is small in size, usually about six inches long by five inches wide, and just covers the dancer's face. It is usually painted black and carved to represent a human, goat, monkey, or dog face. Tufts of white horsehair form beard and eyebrows. Facial features, a border, and such special elements as a Yaqui cross on the forehead may be painted or incised onto the surface of the mask. The cross functions to protect the pascola from harm while he is performing his sacred tasks.

The pascola is the ritual host of any religious ceremony. Without at least one pascola, one cannot have a fiesta. Attired in his special costume, with his rattle thrust into his belt and his mask on the back or side of his head, he opens and closes the fiesta, makes public prayers, gives religious orations, and also acts as a clown and dancer. His function seems to be to keep the attention of the people focused on the sacred ceremonies that are taking place. To this end he engages in humorous monologues, indulges in pantomime with other fiesta performers, and performs two distinct kinds of dances.

To the music of the violin and the harp the pascola performs a complex step dance, with the dried cocoon rattles on his lower legs accentuating the complex rhythms of the music. If there is more than one pascola (three is a common number), they dance in turn, starting

Yaqui pascola dancing to the music of the harp and violin, while the deer dancer and deer singers await their turn. The fiddle held against the player's chest in an archaic playing position is an indication that we are probably dealing with a musical style introduced into this community from the European mainstream sometime before the nineteenth century, when the modern style of holding the violin became popular. Yaquis probably learned to fiddle in the early or mid-seventeenth century. Photo taken in November 1976.

with the youngest and finishing with the oldest. After all have danced, another musician, the *tampaleo*, gives a few tentative taps on a thin drum he holds in his lap. He then plays a melody on a three-holed flute, accompanying himself on the drum. To dance to this music, the pascola pulls his mask over his face, goes into a slight crouch, takes his rattle out of his waistband and proceeds to gesture with his head and feet, accompanying the music with complex rattle play. It is now that the deer dancer begins to dance.

The deer dancer occupies an ancient part of the Yaqui ceremonial world. While all religious fiestas must have at least one pascola, only the larger ones need have a deer dancer. A reminder of the time when the Yoemem, or the People, as the Yaquis call themselves, hunted as a means of livelihood, the deer dancer impersonates a young

A Yaqui deer dancer. The three singers, playing rasps and water drum, are in the background; the flute-and-drum player is at right. This and the preceding photo were taken at a ramada specially erected for the purpose of making a film, off Yaqui territory. Were this a Yaqui religious fiesta, there would be an altar on the left side of the ramada, and the construction would be more solid. Photo taken in November 1976.

fawn in the Enchanted World of the dawn. He dances to music and song provided by three men who play on rasps and a water drum. The songs, which are in a very old form of the Yaqui language, contain images of the dawn, of flowers, and of enchantment. The deer dancer moves in a fluid, deerlike fashion; between dances he stands silent and aloof from the other activity, arms folded and eyes downcast.

The music of the pascola and deer dances is neither improvised nor selected at random. The *sones*, or dance pieces, along with the appropriate techniques for playing the instruments, have been passed down through untold generations of Yaquis and constitute an important part of the Yaqui artistic heritage. The deer songs are in archaic Yaqui and are possibly the oldest intact body of Yaqui literature. Here are two examples of Yaqui deer songs.

Wilderness World

You are an enchanted flower wilderness world
You are an enchanted wilderness world
You lie with see through freshness
You are an enchanted wilderness world
You lie with see through freshness
Over yonder in the *seyewailo* in the middle of the wilderness
 in the enchanted wilderness world
Beautiful with the dawn wind beautifully
You lie with see through freshness wilderness world
You are an enchanted wilderness world
You lie with see through freshness wilderness world

Coyote

Let us go little brother to where the coyote is sounding
Let us go little brother to where the coyote is sounding
Let us go little brother to where the coyote is sounding

Over here in the bottom of the *seyewailo* dawn
There under the enchantment he is sounding enchanting
Let us go little brother to where the coyote is sounding.

(Both songs translated by Felipe S. Molina, a Yaqui deer singer from
Yoem Pueblo, Marana, Arizona.)

In addition to the songs, tunes, and techniques, Yaqui ceremonial
musicians must know the appropriate piece of music for each part of
the ceremony. A Yaqui fiesta is divided into three parts: from the start
of the ceremony till midnight; from midnight till dawn; and from
dawn till the end of the fiesta. Each segment has its traditional body
of music as well as its special tunings for the instruments. The violin
and harp players choose a particular *son* from their repertoire—one
which is appropriate to the portion of the ceremony they are then in.
The tampaleo must then answer with the appropriate flute-and-drum
version of the same son, and the deer singers respond in a similar
manner.

All the time that the pascolas are not actively dancing, they are
pursuing their other duties. They pass out water and cigarettes to the
people at the fiesta; they indulge in humorous monologues, dialogues,
and pantomimes. They can become animals, such as coyotes, and hunt

the deer. If this takes place, it is usually around dawn, just before the end of the fiesta. Pascola performances can be hilarious, even for spectators who do not understand the Yaqui language. But however funny the clowning may be, and however spectacular the dancing, both are merely a part of something infinitely more important: the religious ceremony.

Pascolas and deer dancers sometimes appear outside of the Yaqui community. Although they are religious performers, they are permitted to appear on secular occasions and may be seen at such annual cultural events as the San Xavier and Tumacacori fiestas and Tucson Meet Yourself. Their performance at such events, however, is usually limited to a half-hour presentation and is only a sample of what the visitor sees at an all-night fiesta with a Yaqui audience and in a Yaqui cultural context.

Other tribes besides the Yaquis have pascolas. Tohono O'odham pascolas appear at many traditional Catholic feasts. The O'odham may have learned pascola music, dance, and ritual from the Yaquis during the latter tribe's period of flight from Mexico, at the time when some of the most used Yaqui routes into the United States passed through O'odham country. O'odham pascolas resemble those of the Yaquis in many ways. They are sacred clowns and step dancers who entertain the people at feasts. The usual O'odham pascola costume, however, consists simply of regular street clothes and a set of leg rattles. O'odham pascolas do not usually dance with masks, nor do they use the wood and metal hand rattle. Their music is commonly provided by a violin and a guitar and is subtly different from that of the Yaquis. Other tribes in Sonora and Chihuahua—Mayos (close cultural relatives of the Yaquis), Warihios, and Tarahumaras among them—also have the pascola dance.

The matachinis, also ritual Yaqui performers, are a group of religious dancers who perform a Yaqui version of a seventeenth-century European contradance. This dance is found in many parts of Mexico and in New Mexico as well, but the Yaquis are the only group in Arizona to follow the tradition. Formed into two (sometimes three) lines, they perform figures similar to those of such dances as the Virginia reel, but with a serious religious purpose. They are the soldiers of Our Lady of Guadalupe, and each movement they make to the music of the fiddles and guitars is in itself an act of devotion and prayer. These

A Yaqui deer, pascola, and matachinis dance before the Holy Family in a *nacimiento* set up at Old Pascua Village by the late Arturo Montoya. The figures are of plywood, cut out and painted. The scene changes every year; in 1987 it was a painted panel rather than cut-out figures. Photo taken in December 1982.

men and boys keep alive a sacred tradition of great beauty. They do not perform at secular occasions. In fact, what they do is not a performance at all in our sense, as it is not done for a human audience or even for the satisfaction of "art for art's sake," but rather to fulfill an obligation to God and Our Lady. Photographs of matachinis and other highly sacred Yaqui performers do not appear in this book out of respect for Yaqui traditions.

By far the most famous Yaqui ceremonial occasion is the Lenten and Easter ceremony. Originally introduced to the Yaquis by Jesuit missionaries as a means of teaching them the stories and concepts of Christianity, the ceremony has been transformed over the centuries until it is now uniquely Yaqui. It is a Passion Play—a reenactment of the suffering, death, and resurrection of Jesus Christ—and has been performed on an annual basis for about as long as has the more famous Passion Play at Oberammergau in Germany. It is the ceremonial

high point of the Yaqui calendar, lasting all through Lent and culminating on Holy Saturday and Easter Sunday. Unlike similar dramas in the European tradition, it relies on formal, symbolic movements on the part of groups of participants, rather than on words and gestures of individual actors, to depict the action.

Briefly, the events are as follows. Beginning on the first Friday of Lent, the members of several religious organizations within the Yaqui community take certain sacred images out of the church and carry them along the Way of the Cross, visiting each of fourteen wooden crosses placed in a circle around the church plaza. They are accompanied by masked beings called chapayekas—the word means "sharp-nosed ones"—who are soldiers searching for Christ in order to kill him. Each Friday evening during Lent, these chapayekas and their allies, the unmasked Fariseos (Pharisees) and Knights of Rome, grow in number and boldness. The chapayekas are menacing, but at the same time, they are clowns, pantomiming evil behavior. Each one wears a huge, white, horned mask and carries a wooden sword and dagger with which he communicates to his fellows. Each one also has a wooden rosary around his neck and holds the cross between his teeth, maintaining contact with Good during his impersonation of Evil.

On Thursday of Holy Week, the forces of Evil capture Christ, who is represented by a small crucifix. On Friday, they crucify him, once again in a restrained set of symbolic actions. On Saturday morning, the chapayekas and Fariseos line up with Judas, their leader, in front of the church. At some time after midday, they charge the church, the only territory in the village that is not under their control. Three times they charge, and three times they are beaten back by the members of the various church organizations, as well as by the deer dancer, pascolas, and matachinis, who pelt them with green leaves and confetti "flowers," symbols of God's grace and goodness. After their third retreat the chapayekas remove their masks and run with the Fariseos into the church, where they are blessed with holy water and brought back into the world of Good. At this point, the fiesta celebration begins. Matachinis, deer dancer, and pascolas lead a procession carrying the sacred images to a ramada where an altar is set up to receive them. Ritual dancing, singing of prayers, and feasting continue until well after dawn on Easter Sunday. Later on Easter Day, three young

women run across the plaza with the news that Christ is risen, and all the villagers join in a circle to hear a formal sermon in Yaqui and thank one another for their participation in this beautiful ceremony.

This Easter ceremony takes place at four Yaqui communities in southern Arizona. These are Guadalupe village just south of Tempe, Old Pascua in Tucson just off Grant Road, the Thirty-Ninth Street community in South Tucson, and New Pascua to the south and west of Tucson. Respectful visitors are welcome at all four locations. The only restrictions are that photography, sketching, recording, and note-taking are strictly prohibited. No admission is charged, although all those attending the ceremonies are given opportunities to help defray the considerable cost involved.

As outsiders, we cannot hope to comprehend the deep and complex meanings that these acts of faith and beauty have for Yaquis; thanks to Yaqui generosity, we can share to some extent in an ancient complex of ceremonies that are carried out, not for an audience or the tourist trade, but as a fulfillment of the Yaquis' obligations to God. It should be noted that the ceremonies operate on a Yaqui timetable. Spectators who arrive at the time announced in the newspaper may find themselves waiting for an hour or more in the warm Arizona sun. On the other hand, they may find that the ceremony has already started and is partially over. On such occasions it is helpful to remember that the ceremonies are in no way being staged for spectators, who are indeed privileged in being permitted to view them.

The setting for the traditional Yaqui religious arts is a Yaqui church and its surrounding plaza. Just as the Tohono O'odham have developed their own form of Catholic religious architecture, so have the Yaquis created churches that fill their specific ceremonial needs. All are extremely wide buildings, with openings in front that extend almost the entire width of the building. This is to allow processions and dancing matachinis to leave and enter the church. On occasion, the matachinis will dance right up to the altar, which in some churches stretches all across the wall opposite the entrance.

Either directly in front of the church or in front and off to one side is a ramada with walls on three sides. This is the fiesta ramada where the saints' images are taken during religious ceremonies and where the pascola and deer dancer hold forth. As one faces this ramada, the left side is for the altar, and the right for the fiesta

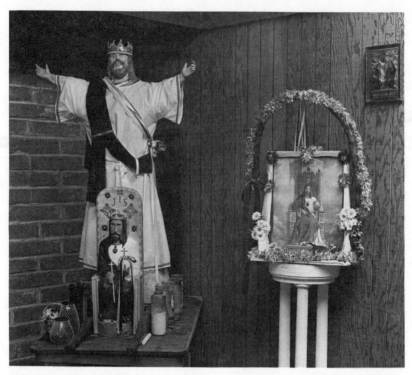

Cristo Rey—Christ the King—in two variations, carved by a member of the Tucson Yaqui community sometime in the 1960s or 1970s. A commercial print of Cristo Rey is at right, flanked by paper and plastic flowers and surmounted by a tinsel arch. Photo taken at Cristo Rey Chapel, New Pascua Village, July 1980.

dancers. White wooden crosses are stuck in the ground in front of the ramada and church during ceremonies. Somewhere nearby is a kitchen and dining area where all the ceremonial performers are fed. Visitors to the ceremony can usually buy food at stalls located on the periphery of the plaza.

There are other Yaqui art forms which the non-Yaqui might encounter. Some men paint pictures and create sculpture illustrating various aspects of Yaqui ceremonialism. Two of Tucson's Yaqui communities have murals dealing with the same subject. In addition, Yaquis have adopted (and adapted) some traditional Mexican folk arts as their own. Yaqui altars are decorated with artificial flowers. Yaqui-made cascarones are mentioned in the chapter on Mexican folk art. Both the mariachi and norteño traditions have taken hold among

Yaquis as well. But the most important of the traditional Yaqui arts are tied in one way or another to Yaqui religious observances.

The Tohono O'odham and the Yaquis are not the only Native Americans in southern Arizona. Tucson is a large city, with a climate, a university, and industries that attract people from all over the country. Some of these people are Native Americans who have brought traditional skills and knowledge with them from their homelands. As I write this, Tucson is (at least temporarily) home to Hopi carvers and potters, Navajo, Hopi, and Hualapai silversmiths, Apache and Sioux quilters, and Sioux and Delaware beadworkers. Occasionally, some of their work appears in stores or at craft markets in the area. In addition there is an organization, the Tucson Native American Intertribal Dancers, which is dedicated to the performance of traditional Indian dances. They put on public programs throughout the year and serve as an important local artistic resource.

An intertribal Native American institution which is gaining popularity in our region is the powwow. Although the word originally meant "medicine man" or "healer" in the Algonquian language of northeastern North America, it has come to describe a special sort of social gathering. Powwows are occasions at which Native Americans from different tribes get together to enjoy traditional Indian music, dance, and food, and simply "to be Indians" together. They originated on the Great Plains toward the end of the past century in response to the need for a new kind of secular social gathering that could be attended by members of more than one tribe. Although regional styles of powwow are developing, it still retains much of the character of that part of North America which gave it birth—the Great Plains. This can be seen clearly in the dress and music that are associated with powwows.

There are two basic costumes for male powwow dancers, each associated with a specific dance style. The "traditional" or "straight" dancer dresses in a style borrowed from the Earth Lodge peoples of the American Midwest: leggings, breechcloth, an "Indian shirt," and often some sort of turban as a head covering. The "Indian shirt," also

called a ribbon shirt, has spread into the Southwest as well as an item of clothing for important social occasions. It has long sleeves and is usually cut quite full, from a flower-patterned cloth. Horizontal strips of brightly colored ribbons are sewn to the chest and back. Other ribbons dangle vertically from the ends of these. An alternative costume of traditional dancers involves leggings and breechcloth and a bare torso with a breastplate of thin, tubular white beads called hair pipes. These were made of buffalo or beef bones until recent years, when plastics have moved onto the scene. The traditional dancer uses the basic powwow double step, in which the ball of the foot touches the ground on the first beat, and the whole foot on the second.

This step is also the basis for the "fancy dance," but with increased speed and the addition of more complex footwork and a lot of body movement. Some say that the fancy dance developed in the 1920s, influenced by such active mainstream dances as the Charleston. The fancy dancer's costume is an elaboration of Plains Indian costumes of the nineteenth century. He wears a breechcloth, often highly decorated, and is naked to the waist. Attached to his head is a horsehair roach, often colored red. On his back he wears a pair of large, round feather bustles. Smaller bustles can be attached to his elbows and knees. Angora wool leggings and beaded moccasins complete the fancy dancer's finery.

Women's dances are roughly similar. For the traditional dance, women wear the traditional costume of their tribes. The dance consists of bending the knees and subtly shifting the feet, torso, and arms while remaining basically stationary. The shawl dance is a fairly recent development similar to the fancy dance and is danced by girls and young women. A shawl dancer wears a short skirt along with high, beaded leggings and a fringed shawl around the shoulders. She grips the shawl with each hand, her elbows slightly bent, her back straight, and her body upright. Shawl dance footwork is extremely active and complex.

Powwow music is provided by a group of men seated around a large drum who sing to the rhythm of their drumming. Such a group is called a "drum," taking its name from the instrument. There are two styles of powwow singing—northern (which originated with such groups as the Sioux and Blackfoot), and southern (showing the influence of Oklahoma tribes like the Kiowa and Comanche). Northern singing is extremely high-pitched and intense, often breaking into a

Powwow-style dancers at Tucson Meet Yourself. The traditional dancer to the left is Leslie Smith, a Tohono O'odham; the fancy dancer to the right is Tony Poseyesva, a Hopi. Seated around the drum in the background are the Wa:k Singers. They are, from left, George Thomas (O'odham), Dave Begay (Navajo), Ralph Corella (O'odham), and Tyrone Head (Sioux). *Photo by David Burckhalter, 1987, courtesy of the Southwest Folklore Center.*

falsetto, while the southern style is a bit slower, more relaxed, and lower in pitch. Both styles use a fairly short, descending melody, which is repeated many times in the course of a single song. A typical drum will have a leader who sings a few syllables alone before being joined by the others. Although powwow singing may well sound all the same to the untutored ear of the visitor, there are really several different kinds of song at any given powwow. Furthermore, powwow singing has its own standards of excellence. A good singer is judged on the range, volume, and expressive quality of his voice, as well as on the clarity with which he sings the words. While many of the songs have words, some are composed entirely of vocables—that is, meaningless syllables like "he ye he ya he yo." This is a poetry of pure sound, a specialized art form with its own rules and aesthetic. Although many tribes have vocable songs, they are particularly useful in the case of an intertribal drum, many of whose members may not share the same Indian language.

Most powwows are held out-of-doors, often on a school athletic field. In case of inclement weather, they can be held in some large

indoor space such as a gym or a convention hall. On arriving at an outdoor powwow in southern Arizona, the visitor encounters a circular arena surrounded by benches or bleachers. In the center or to one side, often under shade of some sort, the musicians sit gathered around their various drums. It is common to have both a northern and a southern host drum as well as any number of guest drums who may also perform. A master of ceremonies will announce the various events and dances and urge the dancers to participate. Announcements may well be in a local tribal language as well as in English. The announcer will also introduce special individuals such as the head man and head woman dancer and the powwow queen and her princesses.

Around the outside of the arena, one usually finds stands selling Indian crafts and traditional Indian foods, and often such mainstream American delicacies as hot dogs. The fact that the crafts are for sale to Indians from many tribes and regions of the country makes for a rather different selection from that found in Indian craft stores that cater to the Anglo-American tourist or collector. There may well be such costume accessories as hair pipes and women's shawls. A good deal of beadwork will probably be in evidence, even though southern Arizona has no really strong native beading tradition. Also for sale will be such non-craft items as records and tapes of Indian music, baseball caps with the powwow logo or name on them, and powwow T-shirts. These last two are popular fund-raising items for the powwow committee, which must at least break even. Bumper stickers for sale can have mottoes ranging from "Indian (or "Sioux" or "Navajo" or "Papago") and Proud" to "Fry Bread Power" and "Custer Wore Arrow Shirts." In addition, there are usually jewelry and other craft items that will appeal to visitors and Indians alike.

Before the powwow formally begins there may be a Gourd Dance, in which participation is limited to veterans. Dancers will move slowly from the edges of the arena toward the center. They usually wear ordinary street clothes with the addition of a red and blue blanket, a sash, and sometimes a bandolier. Service ribbons or medals may be pinned to the sash. Gourd dancers hold a special rattle made of a gourd filled with pebbles and mounted on a stick. A large metal salt shaker is sometimes substituted for the gourd. Following the gourd dance the powwow proper begins with a grand entry in which all the costumed participants parade onto the arena. They are preceded by an American flag, the appropriate tribal flag if the powwow takes place on

Navajo-Ute musician R. Carlos Nakai posing for his portrait, June 1987. Nakai wears a ribbon shirt and a choker and breastplate made of the tubular beads called "hair pipes." Around his neck dangles an eagle-bone whistle. He holds two Plains Indian-style flutes cradled in his arm and wears a beaded belt of Plains style. An excellent musician and lecturer who moved to Tucson in 1986, Nakai plays flute music from a number of tribal traditions as well as his own compositions in a contemporary style.

a reservation, and a staff decked with eagle feathers. This last is often called "the Indian Flag" by powwow participants. It is customary for spectators to stand and for men to take off hats during the Grand Entry and the prayer and Flag Song which follow. After the Grand Entry the master of ceremonies will usually announce a round dance, in which everyone can participate, or an Intertribal. The latter consists of simultaneous solo performances by all costumed participants. Later on there may be fancy and traditional dance contests for men and similar competitions for women. Besides the participatory dancing and the contests, there may be giveaways. These are occasions on

which a family or individual publicly presents gifts to people whom they wish to honor. It is common, for instance, for the families of the head man and woman dancer to hold giveaways to show their appreciation for the honor bestowed upon them.

Powwows are just starting to become popular in southern Arizona. Many regions of the United States have their own styles of powwow; it will be interesting to see what develops here. One unusual feature of some local powwows is the inclusion of exhibition tribal dances. This can be seen at the Wa:k Pow Wow held annually at San Xavier Village near the old mission. The purpose of this event is to raise funds for the San Xavier O'odham feast committees who are responsible for providing food, dance music, fireworks, and other necessities for the annual round of folk Catholic feasts at Mission San Xavier. In addition to the usual powwow dancing and events, the Wa:k Pow wow features traditional dance groups from many southern Arizona tribes. Here one can see Apache Crown Dancers, Yaqui and Tohono O'odham pascolas, and O'odham dances and games of several kinds. In addition, there is an annual all-O'odham old-time fiddle orchestra competition, which provides a rare opportunity to hear the older styles of O'odham polka music.

This is not the only regular powwow held in southern Arizona. The Tucson Intertribal Dancers often hold one as do the Tohono O'odham and Yaqui tribes. A large powwow is held each winter as part of Casa Grande's annual O'odham Tash festival, which also features an intertribal parade, traditional dance exhibitions, a polka, large craft sales, and an all-Indian rodeo. In addition, there are several large powwows in the Phoenix area, as well as many small ones, often staged by local college or high school Indian student groups. The custom is truly taking hold, and we shall doubtless see an increase in powwows in southern Arizona over the next few years.

Most powwows welcome visitors. Photography is usually permitted, but it is considered polite to ask permission before taking close-ups of dancers or spectators. Some powwow participants may not wish to have their pictures taken, not necessarily because of any religious prohibition but simply because they prefer it that way. Scheduled events may not take place exactly when a printed program or advertisement says they will. The internal timetable some call "Indian time" operates here just as it does at the Yaqui ceremonies. Nor is every event in the powwow guaranteed to be an exciting

spectacle for onlookers. Powwows are Indian affairs, staged by Indians for their own benefit. Few are produced to entertain the outsider. But if the program in the arena gets too monotonous, one can always do as Indians do in a similar situation: get up, stroll through the grounds, enjoy the costumes, sample some food, look at the crafts, and then wander back.

These are the traditional arts of the Indians of southern Arizona. Some are ancient, with roots deep in the Sonoran Desert. Others, with equally deep roots, are more recent arrivals, along with their owners. Still others are modern developments, created and evolved to meet contemporary needs. Certain themes emerge, however, even though each group is distinct in its culture, its history, and its arts.

In the first place, even the oldest of the art forms we have mentioned is not as it was before the Europeans came to the region. That would, of course, be impossible. Culture changes, and even if a certain aspect of culture remains much the same as it was, it is sure to change, if only in subtle ways, along with the rest of its cultural context. For example, the Tohono O'odham still make baskets, but the techniques and appearance of the baskets have changed since the last century, as has their use. Even in O'odham families, they are now more often items of household decoration, symbolic decoration, if you will, than pieces of everyday kitchen equipment. One reason for this is economic. It is impractical to parch seeds by shaking them with coals in an inflammable container worth several hundred dollars on today's market if some other method will work just as well. It makes more sense to spend the time and effort making a basket that can be sold, using the money to buy suitable, modern kitchen utensils. Besides which, very little wheat gets parched in O'odham country anymore. Baskets are still made, but for different reasons that accommodate a changed world. In much the same way, I'itoi's last recorded act was to save wildlife from the encroachments of a railroad. But his presence on Baboquivari was felt strongly enough a few years ago to cause a delegation of Tohono O'odham to make strong protests against a federal proposal to open up the slopes of that mountain for mineral exploration.

One of the themes implicit in this chapter has been the Indian pattern of drawing upon tradition to form artistic responses to new situations. Another theme has been the sense of community, which

is similar in importance to that found in Mexican-American culture. So many of the art forms discussed, from Yaqui pascola masks to O'odham polka music to contemporary powwow dancing, make sense only in terms of the community involved. The celebration of community—of common identity—is an important theme not only of the Native American traditional arts associated with particular events but also of the more recent art forms such as murals, genre paintings, and sculpture, and even of such crafts as silversmithing and beadwork.

One often hears comments to the effect that Indians are "losing their culture," and are becoming "just like everyone else." This is not exactly the case. Indians, of course, occupy precisely the same corner of the twentieth century as do the rest of us. In many ways their lives appear similar to ours, and in many ways this is indeed the case. And yet, when one looks beyond the modern clothes and contemporary jobs, beyond the polkas and the Catholic religion, beyond the preoccupation with intertribal identity, one finds some very old processes and ways of doing things. It is these ancient tribal attitudes and customs which contribute so much of what is rich and wonderful in southern Arizona's cultural environment.

3

✳ ✳ ✳

Other Regional Arts

In the first two chapters, we have been looking at the traditional arts of some of southern Arizona's long-term ethnic communities. The Tohono O'odham have been in this desert country for centuries; Hispanics, as well, have a long history here. Each of these groups is an ethnic community, held together by a distinct cultural heritage that often includes language, world view, and values, as well as behavior, etiquette, and art. But there are in our region other traditional arts that cannot be explained by linking them to a particular ethnic tradition. Some are shared by members of a common occupation, as is the case with the songs, stories, sports, and arts of the cowboy world. Some are the direct expression of a shared religion. The Mormon church and its traditional arts and lore give an example of this. And some, like western swing music, are best thought of as regional—influenced by occupation, ethnicity, and religion, but also tied to the area in which they are found.

Cowboys and cowboy culture are an indelible part of our national myth. Cowboys today are pretty much what they were a hundred years ago: the laboring force of the cattle industry. However, things

have gotten a bit complicated with the passage of time. Today's cowboys have open to them a series of options that are specifically of the last half of the twentieth century. In addition to working with cattle, they can become "dude wranglers," interpreting the West to visitors, or they can become rodeo cowboys—professional athletes competing in a sport derived from traditional ranch contests of skill. That these latter occupations exist at all is due to the fact that over the past century the American cowboy has become more than the regional follower of a specific occupation. He has become the focus of a set of popular concepts, beliefs, and attitudes that permeate our national society. The cowboy has become, in fact, a mythic figure and a symbol of American identity.

Modified to suit the needs of each generation, the popular image of the cowboy provides a model of the lone worker for justice, the independent man who puts things right on the troubled frontier. Not only does this mythic cowboy not spend much time at his craft of working range cattle, but he is somehow connected in much of the popular imagery with western towns rather than the open range where his work actually lay and to some extent still lies. The concept "cowboy"

A statement of place and occupation. Part of the mural decorating the Farmer John Meatpacking offices on West Grant Road near Interstate 10, Tucson. Created in the 1960s by former Hollywood set painter Leslie Allen Grimes, this huge mural of cattle raising in southern Arizona is one of a set of four on Farmer John buildings. The other three are in California, and they depict pigs rather than cattle. All the murals have become local landmarks and are maintained by the company.

is for many a part of a package that includes tinhorn gamblers, dance-hall girls, violent death in dusty towns with false-front buildings, and much else which has only peripherally to do with the working of range cattle. Likewise, many elements of traditional cowboy dress and behavior have been modified and adopted by westerners and would-be westerners as symbols of their regional identity.

This chapter will deal with both sides of the western coin—the reality of the working cowboy and the myth of the West—as they are expressed through the traditional arts. Some of the arts are those of real, working cowboys. Some are regional; they are found here because southern Arizona is part of the American West. Some are used by individuals and communities to express their identity as western-ers. A lot of what we will see has been touched in one way or another by our western mythology. Finally, we will look at an occupation and a religion—mining and Mormonism—that are still important in our region, but which have been rather left out of the myth and its images. Let's start again with food.

BEEF, BEANS, AND BISCUITS

Traditional cowboy camp cookery is difficult to find in public. The regional preference for steak, nevertheless, gives us a clear signal that we are in cattle country, and a number of local restaurants feature at least two of the classic "three B's" of ranch cooking—beef, beans, and biscuits. However, if you want to savor an old-time roundup delight such as SOB (the initials stand for just what you suspect) Stew, you'll probably have to make it yourself.

An SOB stew is created just after butchering and consists of mar-row guts, sweetbreads, and other inside parts of the beef critter. Reti-cence about using even a suggestion of strong language in mixed company is a long-standing cattle country tradition that is only now disappearing. In typical western fashion, this has been turned into a straight-faced joke by the use of such additional euphemisms as For-est Ranger Stew and Loan Officer Stew. Or you can substitute your boss's name.

Another delicately named dish is Mountain Oysters—barbecued beef testicles. Even though they have given their name to an exclusive Tucson club founded by local ranchers, they are hard to come by

unless you happen to be helping out at an old-fashioned branding. In Nevada the same dish is called calf fries. There is a totally improbable but popular joke about a rancher who was told that French cowboys made the best hands, but that they insisted on rich, high-quality food. He served them calf fries the first day, then sheep fries. The third day they all quit and left the ranch without saying a word to anyone. He asked the cook if he knew what the trouble might be. "I dunno," replied Cookie, "but I know it ain't the food. I let 'em know what I was fixin', and everbody likes french fries."

But back to the three B's of cow-country cooking. The first and most important is beef. Mesquite cooking, a recent food fad in other parts of the country, has always been locally important for the simple reason that mesquite is our local hardwood. For some expatriate Arizonans, the surest reminder of home can be a heart-stopping whiff of pungent mesquite smoke from a cooking or warming fire. There's nothing else like it in the world.

In the old days, steaks were often fried, and fried well. Cowboys and cattlemen, unlike many suburban Americans, tend to like their steak well done. Putting your seasoned beef in a sack and burying it in a pit to barbecue slowly and thoroughly is another favorite way of "feeding the multitudes." A lot of the pit barbecue specialists I know are Mexican Americans who are a generation removed from the ranch. I am an insatiable gatherer of information about traditional ways of doing things, but I've learned not to ask for any details of sauce recipes or cooking times and techniques. All too often, they are closely guarded family secrets.

Beans are usually pinto, and in former times they could be placed in a pot with some water, salt, pork or bacon, onion, and garlic and buried all day under the coals of the campfire. The results were ambrosial. Nowadays, they are cooked up on the stove with some onion and salt, and maybe a little bacon. But no molasses, please. That's an East Coast perversion.

Biscuits aren't served much in public, but they were, and still can be, a mainstay of ranch cooking. Out-of-doors, they are made in a Dutch oven—a cast-iron cooking pot with a rimmed lid. You place the raw biscuits in the pot, put the pot on some coals, put more coals on the lid, and wait. But biscuits also taste good baked in a regular stove, indoors. Here's the late Van Holyoak's favorite biscuit recipe: "You use more flour than you do baking powder, and more baking powder than salt. You use less shortening than you do milk. You stir

it all together, knead the dough, and put it in the oven. It helps if you light the oven. Bake it at 450° for 20 minutes, and then open the oven door real slowly so the biscuits don't float out." It is a Holyoak family legend that one of Van's daughters, finding herself at home and hungry after school, actually followed her dad's recipe. When I asked how it turned out, Van replied, "Perfect, of course."

Van was from Arizona's White Mountains, up by Showlow. That's a bit outside of our region, but some aspects of cowboy culture remain pretty constant throughout Arizona, and indeed the whole West. Cowboying is a regional occupation rather than an ethnic tradition with its roots deep in the soil of one specific place. Furthermore, cowboys are traditionally a very mobile lot. One cowboy singer of my acquaintance used to wrangle dudes in Wyoming in the summer and winter down at Castle Hot Springs in central Arizona, wrangling dudes. Similar work, but in two widely separated and totally different environments. So this chapter will of necessity stray from time to time outside southern Arizona in order to give an illustration or make a point. And Van's recipe leads pretty neatly into the most important, but hard to classify, genre of western Anglo-American folk art: good talking.

WORDS AND WINDIES

Although some Mexican vaqueros and Papago cowboys in southern Arizona speak their own languages, cowboy culture is primarily a culture of English speakers—and some of them are fine talkers indeed. Language is an art form in every one of southern Arizona's living cultures. Mexicans, Papagos, Yaquis, and others all have highly developed traditions of oratory and oral literature. However, English is more accessible to most of us than Yaqui sermons or Mexican wordplay. In this case, it's not completely accessible because a lot of cowboy speech involves the fairly specialized vocabulary of the working cowboy, and it takes some learning and experience before the outsider can follow what's going on. Just as cowboys learned many of their skills from Mexican vaqueros who had been working wild cattle for more than three hundred years in the New World, so a lot of cowboy language is borrowed from the Spanish. Some words like *remuda* (horse herd) have been taken over unchanged. Others, like "chaps" (pronounced "shaps," and taken from *chaparejas*) or "lariat" (from *la reata*—a braided rawhide rope) have been altered a bit.

Sometimes these word changes can be strange and wonderful. *Mecate* is the Spanish word for a twisted horsehair rope. English-speaking cowboys took over the technique, the rope, and its name. However, old-time Texans were apparently more familiar with Irish names than they were with the subtleties of Spanish pronunciation, and to this day cowboys will talk about their "McCarty ropes" or even their "McCarthys." A technique that brought with it an altered vocabulary is the Mexican method of roping calves. The old-time vaquero would rope his critter and then take a couple of turns around the saddle horn with the loose end of his rope. In Spanish, one describes this process with the phrase *dale vuelta*, or "give it a turn." English speakers kept the sounds but altered the grammar, and they talk about "taking their dallies" or even their "dally-welters."

Texans prefer to keep the end of the rope tied "hard and fast" to the saddle horn. This difference in roping styles persists to this day, and I have heard some wonderful arguments between Texas "tie-fast men" and California or Nevada "dally ropers." There are dangers in both methods. Careless dallies can cost you a thumb and tying hard and fast can cost you a saddle. But it does seem that dallying is better suited to working cattle in rough country. By now the issue, which is still hotly argued, may really be a matter of cultural style.

There is a wealth of other regional words in the cowboy vocabulary in addition to those borrowed from the Spanish-speaking vaqueros. You can still hear "chuck" and its derivatives, "chuck wagon" and "chuckbox" all over the West. The word is of unknown origin, but was used in the late 1800s by English criminals as well as American cowboys. Then as now it meant "food."

Nouns can be made into verbs. For instance, cowboys will talk about cattle—or people—"sulling up," or turning sullen and cranky. Some traditional western talkers and users of words seem to have a wonderfully extravagant way with the language. One old cowboy, when I asked him how he was, replied, "Well, Jim, I've got the forked end down, and I can't ask for any better." Another in response to the same question answered, "I never felt better . . . and by God, it's about time I did!"

This sort of playful attitude toward the spoken word is often applied to reality as well. In some cases, it consists of simple exaggeration. An old song describes a famous bucking horse: "He could paw the white out of the moon and buck you half a mile." Another tells of the narrator's experiences while trying to ride a wild bull:

We went around by Jupiter and took a look at Mars.
We met with several comets that were playing with the stars.
I learned some real astronomy on top of that old bull;
Took a drink from the Dipper, and he also took a pull.

This playfulness with words and concepts is often directed at the weather and other natural phenomena. My friend Van Holyoak used to call me occasionally with weather reports from the mountains. One year when the winter had been particularly cold but dry, he informed me that a low humidity storm had swept over his ranch, leaving it covered with a foot of dry ice! Another time he complained about having had "duck troubles." When I obligingly asked what sort of duck troubles he had been experiencing, he told me that, in the haste of getting his house ready for winter, he had installed the draft upside down in his chimney. The first time they lit a roaring fire, the backwards draft had sucked a whole flock of ducks down the chimney and splattered them all over the living room. It took a long time to clean up the mess, and his wife was mad at him.

All this was delivered in a perfectly matter-of-fact tone of voice. It's not that Van really thought I'd believe him; but one of the rules of this particular game is that both narrator and listener behave as though the sober truth were being told. And if the teller can suck his listener into believing, or even halfway believing him until the final "kicker," why so much the better.

This sort of friendly deception can develop into serious business. The story is told of Van's father, Joe Holyoak, that one day when he was a young man he rode over to the store several miles away to buy some supplies. While he was there, some of the local hangers-on caught him out with a particularly plausible lie. Joe didn't say anything, but simply hung around till late in the afternoon, doing odd chores for the storekeeper. Finally, after everyone had relaxed his guard, he got back at them with some of their own coin. After his listeners realized they had been "taken," Joe remarked, "Well, boys, it's time for me to be getting home," and saddled up and rode off, avenged and happy.

The kind of story Joe told was probably a specialized sort of tall tale I call the "hook" story. It starts out as perfectly plausible, building detail on detail, often stretching things out for several minutes of densely packed narration before ending on a note so improbable as to hit the listener between the eyes. Joe Holyoak is said to have told a

bunch of wide-eyed boys in Clay Springs about the day in his early youth when he was riding in Apache country and saw a nasty-looking bunch of Indians coming after him on horseback. The Apache Wars were officially over even then, he explained, but every now and then the young men got on the prod, and it was always wise to stay away from such groups on general principle. Joe accordingly started drifting north on his horse. The Apaches followed him. When he sped up, so did they, and as they got closer, he saw that they were all armed. Really concerned now, he lit out at a hard gallop, closely followed by the yelling Indians. However, he was in unfamiliar country, and before he knew it, the level ground he was riding on narrowed into a thin neck of land, with a deep canyon on either side. Looking ahead, he realized that he was rimrocked—trapped on the edge of a cliff with no way to go but back, into the arms of the waiting Apaches. At this point, Joe broke off the story and started to walk away from the enthralled youngsters. "What happened then, Joe?" they demanded. "They killed me" was Joe's laconic response.

This story has been around the West for a long time. The famous scout Jim Bridger is said to have used it, and I suspect it didn't start with him. To my mind, it is the classic old-time western hook story. When convincingly told, it would hold the listeners enthralled until they were felled by the last line. There are modern hooks as well. Tom Jennings of Thatcher once held my attention for five minutes with a harrowing story of running out of gas while driving a VW Thing (a small, all-terrain car of the 1970s) along a narrow mining road in the full heat of the summer. There wasn't any spare gas, and no water to sustain them on the twenty-mile hike to the highway. They had a little tequila, but didn't dare drink any even though they were racked by thirst. They tried the tequila in the gas tank, but the Thing's engine only coughed and spluttered. Finally, Tom remembered a bottle of warm coke in the trunk. In desperation they poured it into the tank and the car took off and ran like a charm all the way to the nearest gas station. As Tom then remarked with a perfectly straight face, "Things go better with Coke." Another hook, another sucker.

Plain, old-fashioned tall tales are still told in this country, too. One that has received some attention in the local media concerns that wonderful game fish of southern Arizona, the Santa Cruz River Sand Trout. It seems that as the rivers of southern Arizona dried out, the fish slowly adapted to the changing climate, exchanging their gills for lungs and growing their eyes out on stalks. In time they became Sand

Trout, swimming around in the sands of the dry rivers, breathing air, and looking for their food over the surface of the wash. They were supposed to be fine fighting fish, but extremely wary and hard to catch, partly because of their excellent eyesight. Furthermore, one had to place the bait right next to them because they were reluctant to swim through the hot sand and burn their tender skins. Once caught, they fought furiously. However, if you were extremely hungry, you could use heavy line and simply haul your trout to shore, hand over hand. The friction of the sand would have it skinned and cooked by the time it landed. Unfortunately, all this is now academic, as southern Arizona's entire Sand Trout population was drowned in the floods of October 1983.

These tall tales, or windies as they are sometimes called, are still told informally, with intent to amuse or deceive, all over the West. But they are also found in regional literature and even in the newspapers in a tradition that goes back more than a hundred years. In this century, Dick Wick Hall, writing articles for East Coast magazines from Salome, Arizona ("where she danced"), told of a frog that had to be taught to swim as it had never seen water. And the Tucson dailies still sometimes herald the arrival of 100-degree temperatures by printing long, detailed articles about the breaking of the ice floes on the Santa Cruz River—an occasion always fraught with danger and high excitement.

COWBOY POEMS AND SONGS

Traditional Western verbal skills find expression in poetry and song as well as in the prose of everyday speech. People in the cattle-raising business have been writing verses about their life and work for well over a hundred years. The idea of cowboy poetry may seem a bit strange at first, but the tradition started in the last century at a time when writing verses about almost anything was a much more common activity than it is now. Many working Americans were still familiar with the old ballad traditions that formed such an important part of our heritage from the British Isles. Such immensely popular poets as Rudyard Kipling and Robert Service were writing poems on various aspects of outdoor life, and newspapers often printed poems by locals and others. It was in this atmosphere that cowboy poetry got its start. By the late 1880s, such local papers

as the Miles City (Montana) Stock Growers' Journal were publishing cowboy-composed poems on cowboy life, some of which are still recited today on ranches all over the West. Some acquired tunes and became cowboy songs; others still remain as recitations.

Arizona has produced its share of cowboy poetry. Charles Badger Clark, the South Dakota poet, spent the years between 1906 and 1910 in southern Arizona, and it was over in Cochise County that he wrote some of his best (and best-known) poems. They include the "Cowboy's Prayer," which has become a classic known all over the West and printed on scores of postcards as being by an unknown author. The poem is found in its entirety in Clark's "Sun and Saddle Leather." Here is the famous first verse:

> Lord, I've never lived where churches grow.
> I love Creation better as it stood
> That day You finished it so long ago
> And looked upon Your work, and called it good.
> I know that others find You in the light
> That's sifted down through tinted window panes,
> And yet I seem to feel You near tonight
> In this dim, quiet starlight on the plains.

As a popular celebration of a romantic attachment for the open western spaces, it has been well loved, frequently quoted, often copied, and never surpassed.

Other popular cowboy poems and songs have come out of Arizona over the years. "The Crooked Trail to Holbrook" tells of driving a herd of cattle from near Globe all the way up to the railroad at Holbrook, probably in the 1880s. Gail Gardner, still living in Prescott as these lines are written, composed several poems that have "gotten away from him" and are widely sung and recited by cowboys all over the West. His classic, "The Sierry Petes, or Tying Knots in the Devil's Tail," tells of two drunk cowboys who run into the Old Gentleman himself on their way back from a "little whizzer" in Prescott's Whiskey Row. But all these are really northern Arizona poems, although they are known and performed in southern Arizona as well.

I have heard only one specifically southern Arizona poem recited by cowboys. It is said to have been written by Tucson's pioneer bartender, Charles O. Brown, in July of 1879. It follows the ancient western

convention of bragging about your environment or possessions or whatever you are secretly a little proud of by running it down. It, too, has the Devil as a prominent actor. It has several titles. The oldest one seems to be "Arizona: How It Was Made and Who Made It; or The Land That God Forgot."

The Devil was given permission one day
To select him a land for his own special way;
So he hunted around for a month or more
And fussed and fumed and terribly swore,
But at last was delighted a country to view
Where the prickly pear and the mesquite grew.
With a survey brief, without further excuse,
He took his stand on the Santa Cruz.
He saw there were some improvements to make,
For he felt his own reputation at stake;
And an idea struck him—he swore by his horns,
To make a complete vegetation of thorns.
He studded the land with the prickly pears
And scattered the cactus everywhere,
The Spanish dagger, sharp-pointed and tall,
And at last—the cholla—the worst of all.
He imported the Apaches direct from Hell,
And the ranks of his sweet-scented train to swell,
A legion of skunks, whose loud, loud smell
Perfumed the country he loved so well.
And then for his life he could not see why
The river should carry even water supply,
And he swore if he gave it another drop
You might take his head and his horns for a mop.
He filled the river with sand till it was almost dry,
And poisoned the land with alkali
And promised himself on its slimy brink
The control of all who from it should drink.
He saw there was one more improvement to make,
He imported the scorpion, tarantula and rattlesnake,
That all who might come to his country to dwell
Would be sure to think it was almost hell.
He fixed the heat at one hundred and seven,
And banished forever the moisture from heaven
But remembered as he heard his furnace roar,
That the heat might reach five hundred or more.

And after he fixed things so thorny and well,
He said: "I'll be damned if that don't beat hell."
Then he flapped his wings and away he flew
And vanished from earth in a blaze of blue.
And now, no doubt, in some corner of hell
He gloats over the work he has done so well,
And vows that Arizona cannot be beat
For scorpions, tarantulas, snakes and heat.
For his own realm compares so well
He feels assured it surpasses hell.

A rare tribute, and one that many newcomers to a southern Arizona summer have doubtless echoed. There are other poems comparing various tracts of western land with hell. One of the points of the genre is that it takes a real tough character to put up with whatever country is being described. Although the poem, also called "Hell's Half Acre," has been printed several times in the last hundred years, and occasionally still gets recited, I have never heard it sung. But that is not the case with many others, Gail Gardner's classic among them, which exist both as songs and as recitations. This depends to a great extent on the tastes and abilities of the performer. Cowboy songs are simply cowboy poems that have been set to music. True cowboy poetry, depicting some aspect of cowboy life from inside the culture, is still sung, recited, and composed in southern Arizona as it is all over the cattle-raising West. And it can still be heard in public: at festivals, at dude ranches, and in bars and dance halls, especially if there happens to be a rodeo going on nearby.

WESTERN SONGS, WESTERN SWING,
AND OLD-TIME FIDDLING

More common than cowboy songs are what are often called Western songs—songs written from outside the world of the cattle industry, glorifying the world of the American West, both real and mythic. These reached their heyday in the thirties and forties with the singing cowboy movies. Classics of the genre include Smiley Burnett's "Ridin' Down the Canyon," Gene Autry and Ray Whitley's "Back in the Saddle Again," and "Tumbling Tumbleweeds" by Bob

Nolan of the Sons of the Pioneers. The last named group has probably done more than any other to set styles of western song, and for many listeners their romantic lyrics and close harmonies *are* the American West.

This influential singing group began in Hollywood, California, in 1933, when Tim Spencer, Bob Nolan, and Len Slye (later to achieve fame as Roy Rogers) formed a close-harmony singing trio. The next year they were joined by fiddler Hugh Farr and they took the name the group still bears today—the Sons of the Pioneers. Their music was, and is, characterized by extremely close, tight harmonies, lots of yodeling, rhythmic guitar chording, and superlative "hot" fiddling. Hugh Farr, their original fiddler, was one of the great western fiddle technicians of all time and his legacy can still be felt in the Sons' performances. And the Sons' repertoire, consisting of such songs as "Tumbling Tumbleweeds," "Cool Water," and "Happy Roving Cowboy," is still the basis from which such western singing groups as a currently popular Nashville trio, Riders in the Sky, draw most of their material.

The Sons of the Pioneers, with different members, are still going strong some fifty years after their founding and have recently made their winter performing home at a chuck wagon-style restaurant outside of Tucson. Such restaurants are part of an interesting western tradition, and one which has done much to preserve this particular style of music. To understand them, we first need to take a look at another important institution for interpreting of the West: the guest ranch, or "dude" ranch.

Starting long before the turn of the century, easterners became fascinated by life in the cattle-raising West. Some were content to stay at home, read, and dream. Others actually moved west and became cowboys or ranchers. Still others chose a middle road that was to become increasingly popular for those who could afford it: they took western vacations on cattle ranches. Dude ranching, as it became known, appears to have begun in the northwestern cattle states of Montana, Wyoming, and the Dakotas. At first ranches simply took on paying guests as a way of making ends meet a little better and tiding over the inevitable low spots in the roller-coaster economy of stock raising. Then ranches started specializing in entertaining guests. The dudes were allowed to observe, and occasionally participate in, the

routine work of the ranch and were entertained with camping trips, day rides, and chuck wagon suppers of steak, beans, and biscuits, and treated to cowboy songs and stories.

Although dude ranches as vacation spots are no longer as popular as they were in the 1930s and 1940s, Arizona still has its share. (Other factors contributing to their decline include our state's rapid urbanization which has encroached on many ranch sites, and the skyrocketing costs of insurance.) Such well-known outfits as Romaine Loudermilk's Kay-El-Bar near Wickenburg and, closer to home, the Tanque Verde east of Tucson and the La Osa near the border village of Sasabe have provided a taste of cowboy life and lore for a couple of generations of eager easterners. Along with the riding, hunting, fishing, and the constant presence of the Great Outdoors, cowboy songs, stories, and recitations played their part in setting the tone for the vacation stay. Sometimes it was the working cowboys or the ranch owner or manager who supplied the entertainment. Sometimes musicians were hired from a nearby town, or one of the West's wandering minstrels dropped in. Such a man is Singin' Sam Agins, currently living near Sedona, Arizona. For forty years Sam has traveled the dude ranch circuit, singing cowboy songs for his supper and plying his regular trades as silversmith and jewelry and musical-instrument salesman among the fascinated guests.

The step from dude ranch to cow-country restaurant/theater came sometime after World War II with the opening of the Flying W Ranch Restaurant near Colorado Springs, Colorado. At the Flying W, still going strong in the mid 1980s with several clones scattered around the western states, visitors stand in line for a hearty supper of barbecued beef, baked potato, biscuits, beans, canned peaches, and coffee. They eat at picnic tables and clear their own plates in the best dude ranch tradition of "pitching in." Following this, they are treated to an hour-long program of cowboy and western songs and tunes. The entire experience is a sort of one-evening dude ranch visit. From the earliest days of the chuck wagon restaurants, as they came to be called, the style and repertoire of the entertainment closely followed those of the Sons of the Pioneers. A typical chuck wagon show consists of several familiar Western songs, a couple of hot fiddle tunes, and a country novelty number or two, all interspersed with traditional rural American comedy routines. Such time-honored vaudeville jokes

as the one about the young man from the city who took up turkey farming, but with a total lack of success, are still alive and well in chuck wagon entertainment circles and have found a whole new generation of happy listeners: "The turkeys all died, but next time he'll plant them a foot apart instead of only eight inches." But it is the music and, above all, the nostalgic, lovely western songs and close harmonies that provide the real attraction of the chuck wagon restaurants, even though for many the nostalgia is for the western movies of their childhood rather than for the open ranges of the real West.

Tucson's chuck wagon restaurant, the Triple C Ranch, was founded by Chuck Camp, the son of an old-time Colorado fiddler and an alumnus of the Flying W. The Ranch has from the start been a family operation, with Chuck, who also teaches at Pima Community College, doing most of the actual construction and the kids pitching in with building, cooking, serving, and musical chores as they grew older. In the late 1970s, the Camp Family band consisted of both parents and four teenaged offspring. More recently the group has been dwindling as daughters marry and leave home, and the Camps are now a quartet. But they still put on a fine meal, and more recently have served as the warm-up band for the Sons of the Pioneers.

About the same time the Sons of the Pioneers were getting their start in California, a group of white jazz and country musicians in Texas and Oklahoma were laying the groundwork for the great western instrumental style of the mid-twentieth century. The hybrid that we call western swing was the work of many musicians, but the band most associated with the origin and perfection of the style was a group called Bob Wills and His Texas Playboys. Wills, the fiddling son of an old-time Texas fiddler, had worked in several dance bands in Texas in the twenties and early thirties, but it was not until 1934 in Tulsa, Oklahoma, that he and his Texas Playboys started creating the music that made them famous. Their first records in 1935 had most of the characteristics that are thought of as typifying their contribution to Western dance music. Saxophone, trombone, and electric steel guitar had joined the fiddle as "voice" instruments; solid dance rhythms were provided by drums, banjo, guitar, bass, and piano. The repertoire borrowed heavily from recorded Afro-American jazz and blues and the band's swinging performance style was interspersed with falsetto cries and vocal chatter on the part of the band leader. Whether or not

these actually were innovations on the part of Wills's band, they were associated with his group and were spread throughout the Southwest by means of their records and personal appearances.

This was the time of the Great Depression, the end of the jazz era, and the beginning of the swing era of American popular music. What Wills's Texas Playboys and other groups created and spread was a sort of southwestern, rural, white man's big band swing. The older, Anglo-Irish-American fiddle tunes still had a place, but even here the fiddling was given a distinctly "hot" flavor. Western swing has had a lasting influence on instrumental dance music all through the West, especially in the border states, and bands echoing some elements of the style can still be found in southern Arizona. An equally important aspect of Bob Wills's influence is the tunes that he introduced into the repertoire of regional musicians. There is hardly an old-time fiddler in the area who can't play such Wills classics as "San Antonio Rose," "Faded Love," and "Maiden's Prayer." They have even crossed cultural lines, with "San Antonio Rose" played by Mexican and O'odham violinists, norteño bands, and O'odham waila groups.

Western swing music was and is dance music. Although it can be played in other contexts, its primary use has always been for dancing, and surviving bands with strong western swing influence can still best be sought in dance halls. Although southern Arizona has no surviving full-sized western swing ensembles, there are a few bands that keep much of the spirit of the genre alive. Perhaps the best known of these is Dean Armstrong and the Dance Hands, who have been playing for dancing in the Tucson area since the late 1940s. Their fiddler, Edd Smith, used to sit in with the Wills band when he was a teenager in Missouri. To hear the group play on a weekend evening at Li'l Abner's Steak House, where they have been the house band for years, is to go back to the early forties and beyond. Most other local bands play in a mixed style, with some bluegrass or perhaps a little modern country rock thrown in. If there are traditional western swing bands in other parts of southern Arizona, and there may well be, I haven't run into them yet. But I keep hoping!

It's a real delight to watch the dancing in an old-fashioned southwestern dance hall. Although the schottische is a thing of the past, waltzes are still extremely popular, and the varsovianna, an intricate waltz done by a couple standing side by side, can still be seen,

especially in rural areas. The same "skaters' waltz" position of the varsovianna is used for the "Texas Shuffle," a complex series of kicks, points and two-steps which has gained in popularity in recent years. The dance is also called the "Cotton-Eyed Joe" after the fiddle tune to which it is most commonly performed. The "Western Swing," a sort of nonaggressive jitterbug dance, had Tucson as at least one of its points of origin in the 1970s. But whatever the rhythm and whatever the steps, western dancing seems to be characterized by an interest in smoothness, complexity, and precision. To my mind, watching a booted couple wearing jeans, and possibly even matching shirts, going through their well-practiced routines on the dance floor is a minor but real regional pleasure.

Another form of music which has long been associated with social dancing is old-time fiddling. The violin or fiddle is the oldest and most important of the traditional Anglo-American dance instruments. Played solo or accompanied by whatever other instruments happened to be available, it has for several centuries provided music for solo and group dancing at all sorts of social occasions. Like all folk artists, fiddlers learn from other members of their communities. It is perfectly common to find excellent fiddlers with wide repertoires who don't read music, and the techniques by which a fiddler makes his music are often very different from the commonly accepted ways of playing the classical violin.

Actually, violins and fiddles are basically the same instrument. Many older fiddlers will tell you that the difference between the two is that a violin lives in a well-crafted leather or wooden case, while a fiddle gets carried about in an old sack. This joking reference to the differing social status of the two kinds of music contains a good deal of truth. A fiddler may use steel strings on his instrument, or he may "set up" the bridge of his instrument differently than a violinist to get a different sound. But for all intents and purposes, fiddles are violins.

The differences in technique between fiddling and violin playing start with the way in which the instrument and the bow are held. Some particularly old-fashioned fiddlers hold their instruments down on their chests rather than tucked up under the chin. All violinists held their instruments this way until the early nineteenth century. The practice has been handed down in some folk communities long after classical violinists switched to the current way of holding the instrument. Unorthodox bowing and fingering techniques employed by

fiddlers achieve effects outside the aesthetic ideals of classical music. Finally, fiddlers frequently tune their instruments in nonstandard tunings, making it easier to achieve certain sounds such as continuous drones.

The common dance tunes played on the fiddle usually have two parts, one pitched higher than the other, which most younger musicians call the A and B parts. Many older fiddlers call them the "coarse" and "fine" parts, referring to the thickness of the strings on which they are played. The fine or thinner strings give off a higher pitch. Each part is usually played through twice. Fiddle tunes are usually classified according to the dance rhythm, with a jig being in $\frac{6}{8}$ time, a reel in $\frac{4}{4}$ time. Breakdowns are simply fast reels. The term "reel" is more commonly found in places like New England, with strong, recent musical ties to the British Isles, while the terms "breakdown" or "hoedown" are commonly used in the southern and western parts of the country. Waltzes, polkas, schottisches, and other nineteenth-century couple dance rhythms are also played by most fiddlers.

The traditional names of fiddle tunes are a form of folk art in themselves. Consider the following: "Soldier's Joy," "The Arkansas Traveller," "Forked Deer," "Hell Among the Yearlings" (sometimes humorously bowdlerized to "Trouble Among the Young Heifers," with the explanation, "I couldn't say 'Hell' in front of you nice folks"), and "Rocky Mountain Goat." Waltz titles tend to be a bit gentler: "Johnny, Don't Go," "Wednesday Night Waltz," and the lovely Texas piece, "Midnight on the Water." Tunes may be named after people, as in "Sally Gooden," or places, as in "The Animas Valley Waltz." Some tunes may go by different names in different places: I have heard the same number called "Wild Horse," "Stoney Point," and "Pigtown Fling."

Some tunes may have stories that go along with them. Many older fiddlers, for instance, know some sort of historical anecdote to explain the tune "Bonaparte's Retreat." Sometimes it is short and sweet: "I've learned the history on that tune, and it's about the retreat of France" was what one fiddler told me. Others may go into more detail. Wild Horse Shorty, a Tennessee fiddler who lived in southern Arizona from the 1930s until his death in 1987, told a long story about the great General Bonaparte training his troops. A young bugler was being examined, and he admitted to playing every call except the command for retreat. "We don't play the Retreat in this army," was the general's

response. Years later, when Bonaparte was on the field of Waterloo, he needed to get what was left of his army to safety as quickly as possible. Turning to his bugler, he commanded him to blow the Retreat. "But General," replied the youth, "you told me that this army didn't have a Retreat." "Well, blow SOMETHING," cried the exasperated commander. And the tune we call "Bonaparte's Retreat" is what he played that day. The common fiddle tune called "Bonaparte's Retreat" is one of several named after the famous nineteenth-century general and seems related to an older Irish piece called "The Eagle's Whistle." It is unlikely that "Bonaparte's Retreat" could ever be played on a bugle; the story tells us more about attitudes concerning Bonaparte than it does about music history.

Fiddle styles and repertoires vary widely in different parts of the United States. Through the public media, Americans have become most familiar with the fast, often wild breakdown styles of the Southeast. Out West, preferences are slightly different. All fiddlers know some breakdowns, but the waltz is very important in this region as well, and polkas are much more common among older fiddlers here than they are in Appalachia. This is probably related to the strong fundamentalist protestant prejudice, so prevalent in the rural South, against couple dancing, contrasting with a more permissive approach in many western communities. The importance of these rhythms among the region's Hispanic population may also be a factor. In any case, some of the finest fiddling in the Southwest is done on waltzes. Some of these have truly haunting melodies evocative of the wide, lonely spaces of the region in which they are so popular.

Old-time fiddling has been with us for at least two centuries, during which time America has shifted from a rural society to an urban one, and from a society in which many families and communities provided their own recreation to one in which all forms of leisure activity are increasingly packaged and controlled on a national basis. The weekly dance at the schoolhouse is a thing of the past, along with such scenes of cooperative neighborhood activity as barn raisings and corn shuckings, all of which provided a setting for the fiddler's art. Yet fiddling is still with us. Why is this so, and what functions do fiddlers play in the 1980s?

There are two major settings in which fiddlers today play their music, get satisfaction from being fiddlers, and make their skills and knowledge available to younger generations. One is the jam session.

Our region seems to be full of small groups comprising members of one or more families who get together on a more or less regular basis to play and enjoy traditional music. These gatherings are often quite informal, involving an evening every week or so in which the musicians play and the non-musicians listen and visit. Refreshments are usually served—often warm or cold non-alcoholic drinks and some sort of dessert. Many of these get-togethers revolve around an old-time fiddler. These regular jam sessions are more common than one might suspect. In the early 1970s, I was astonished to learn that in one sixth grade classroom in a southwest Tucson elementary school there were three students, each of whose family was involved in such a group. Obviously these children were well exposed to the music at a fairly impressionable age. Equally obviously, the older musicians lived in an atmosphere of approval and encouragement for their music, an atmosphere that made it worthwhile to keep up the considerable practice necessary to be an active musician.

The other context for the preservation of old-time fiddling is the Old-Time Fiddle Contest. There is scarcely a weekend on which there isn't some sort of a fiddle contest in Arizona, New Mexico, or Southern California, accessible by automobile to many of the state's fiddlers. Contests provide an opportunity for fiddlers to get together and play music informally with each other as well as compete for prize money and prestige. They can be sponsored by civic and business groups, by local Parks Boards, or by organizations of the fiddlers themselves. In almost every case, the fiddlers appear on stage—often divided into classes on the basis of age or experience—one after the other and play three tunes apiece. The usual rules demand one breakdown, one waltz, and one "tune of choice." The latter may be a ragtime piece, a polka, or a jig; anything, in fact, except another waltz or breakdown. Usually there are other rules governing the permissible number of accompanists, the amount of time spent on stage, and the kinds of tunes played. Judging varies considerably, but in most cases the judges are fiddlers themselves and often play a few tunes before the contest to "prove their qualifications." Points are awarded on the basis of rhythm, intonation, and other criteria. Sometimes the judges sit in the same room as the fiddlers; occasionally they occupy a separate room with the music electronically piped in to avoid obvious favoritism.

All this has had its effect on the music. The musical skills neces-

sary to get and keep couples on the dance floor may be quite different from those needed to please a group of judges listening to an electronic signal. This is, in fact, the case with contemporary contest fiddling. The contests have served to smooth the music out a good deal and eliminate many regional characteristics. In fact, a "contest style" has developed in Texas, where contests have long been common and important. Influenced by such virtuoso Texas fiddlers as Alexander "Eck" Robertson, Major Franklin, and Benny Thomasson, the music has slowed down, smoothed out, and acquired a tendency to include intricate, almost mathematical variations on the tune. This sort of playing, influenced by jazz and the western swing music of the 1930s and 1940s, has been for the past twenty years the style that wins the contest money all over the West.

Instrumental accompaniment or "back-up" has changed to match the fiddling. String bands in the Southeast, where many Texas musicians have their roots, may contain any number of instruments, with fiddle, five-string banjo, and guitar the most common. In the classic Southeastern style, which developed into Bluegrass, all the instruments play melodic lines. These may be unison statements of the melody or they may be in the form of counter melodies, often called runs, played against the lead instrument, usually the fiddle. Back-up in the Southwest is quite different. The five-string banjo is seldom heard, except in Bluegrass bands. The ubiquitous guitar is played "sock" style, with the guitarist strumming chords up and down the neck, rather like a jazz or western swing player. Any linear, single-note accompaniment is provided by the string bass. The other instruments are relegated to the role of providing a rhythmic and chordal back-up in ways that do not in any way interfere with the fiddle's melodic voice. This is not to suggest that the southwestern guitar style is simple. Where a southerner will use three, or at the most, four chords in a given tune, filling in between them with melodic runs on the bass strings, a southwestern guitarist may employ ten or more chords up and down the neck of the instrument to do the same job.

One more instrument remains to be mentioned. In the old days, it was the most important of all the western musical instruments —the lowly and underrated harmonica. There were probably more "mouth harps" or "French harps," as they were called, played by old-time cowboys than all the other instruments combined. Easily transportable in a vest or chaps pocket, virtually unbreakable, and

inexpensive to start with, the "harp" supplied music in cow camps all over this region. It is still played, although not often in public contexts. But its shrill, lonesome sound is probably more common over much of the West than anyone suspects. Mexicans, Anglo cowboys and miners, O'odham, and others all play harmonicas. Fiddle tunes, hymns, marches, popular songs played as instrumentals, polkas, waltzes—the old-timers played them all on the mouth harp. I suspect that much harmonica playing was done to please the musician, or, as one old Texas cowboy put it, "to keep the cattle from stampooding." It certainly has made music in a lot of bunkhouses and around a lot of campfires.

COWBOY CRAFTS AND SCULPTURE

When dealing with the decorative arts and crafts of the cowboy world, it is wise to bear in mind that although they reach heights of luxury and elegance today, all have their origin in the everyday working life of the cowboy. Western saddles, even though stamped and carved and covered with silver ornaments, are really only platforms from which to work while on a horse. Cowboy boots are objects of high fashion in the 1980s and may cost well over $1500 a pair when ordered from custom bootmakers. Nevertheless, they were developed and are still used by working cowboys. Their pointed toes, high heels, and high tops were designed to serve a definite purpose. In much the same way, the sport of rodeo, now the domain of carefully trained professional athletes, originated in informal contests involving skills that were essential to old-style cattle working.

Working cattle from horseback takes equipment, and all that equipment is still handmade to a certain extent. Although most are mass-produced, saddles, bridles, ropes, and even metal bits and spurs are also made by local craftsmen all over the West. There are saddle makers in Tucson, Willcox, Douglas, and elsewhere in our region. From them the working cowboy or weekend horseman may order custom-made saddles in a bewildering variety of styles and decorations. All have a certain ancestry in common, however.

The western saddle is the end product of a long evolutionary process stretching back into Mexico and beyond. Spaniards brought horses to Mexico in 1519, as well as the techniques for working and

fighting from the saddle. As herds of stock spread to the vast grazing lands to the north of the Valley of Mexico, new techniques and equipment were developed. The vaqueros of what later became the U.S.–Mexican borderlands were skilled at roping cattle from horseback—the only way to stop them on the open range. For this work, a special saddle was gradually developed. It had a high horn to which the rope could be attached in order to absorb the shock of the full weight of the cow and a substantial cantle for the rider to lean back against. This Mexican stock saddle, similar to saddles still used in northwest Mexico, was the ancestor of the western stock saddle we know today.

As use of the saddle spread over the North American West, it underwent a series of changes, often in response to variations in working conditions. Indeed, there are still strong regional saddle preferences in some parts of the West. Idaho and northern Nevada cowboys, or buckaroos, as they prefer to call themselves, still use a style of saddle that originated in Spanish California, one with a high cantle and a "slick fork," that is, one with almost no "swell" below the horn. A slick fork is often the choice of cowboys working in flat country. For rough, mountainous terrain, however, a certain amount of "swell" is sometimes necessary because it makes it easier to brace oneself in the saddle on steep slopes. Cowboys in areas where dally roping is popular like their horns fairly high, with a flat, three-inch pommel, which makes it easier to take the dallies quickly and efficiently. Dally ropers will also wrap their saddle horns with old inner tube or a similar substance, to give something for the rope to "bite" on. Texas tie-fast ropers wanted a full, double-rigged saddle with front and back cinches to keep it from standing on end when a heavy animal hit the end of the rope, while dally ropers often used a "center-fire" rig with the cinch directly under the stirrup leathers.

The changing nature of the work—and recreation—also account for differences in saddles. Many cowboys now use a modification of the roping saddle, designed to make it easy to dismount in a hurry after roping a calf. It has a very low cantle with a "Cheyenne roll," or backward curled rim, and not much swell. It was developed as much for competition ropers as for working cowboys.

The old-style cowboys fifty years ago had a different set of problems. They usually had to ride whatever horses were assigned to them, and some of these were pretty rank buckers. So a lot of the older sad-

dles have a high cantle and broad, undercut swell, aids to staying on a bucking horse. The variations are many and complex. Like so many of the topics touched upon in this essay, it would take a good-sized book to cover them all in detail.

Once the basic shape and rigging of the saddle are decided, the decoration is added. The most common decoration is applied by working the leather itself. Many of the saddles one sees have what are called "tooled," "stamped," or "carved" designs on the leather. These terms seem to be regional. Montana saddle makers "stamp" their designs. In southern Arizona craftsmen tend to "carve" them. The techniques, however, remain the same.

The saddle may be stamped or carved all over, or just in certain areas—the corners of the skirts or stirrup fenders, for instance. This is called "corner stamping." There may also be a linear decoration confined to the edges of the different parts of the saddle, "border stamping." Two kinds of pattern are commonly employed: basket-stamped and floral. Basket stamping is done with a single tool and reproduces the over and under weave of wicker basketry. This seemingly simple pattern is, in fact, susceptible to a wide range of variation in shape and size.

The floral designs are frequently clusters of oak leaves and acorns or leafy bunches of flowers such as poppies and roses. These designs are a fascinating aspect of Western folk art. They seem to have become popular with leather workers around 1900 and are almost indistinguishable from the floral designs used by nineteenth-century craftsmen to decorate objects such as presentation firearms and banjo necks. This late nineteenth-century preference for sinuous floral decoration on utilitarian objects seems to come from the same major aesthetic impulse that gave birth to Art Nouveau.

Saddle tooling and stamping is judged on two basic criteria: the evenness and depth of the work itself, and the skill with which the saddle maker adapts the pattern to the surface. Patterns are often highly individualized, and each experienced saddle maker has usually developed one or more of his own. As is often the case with folk art, individuality is combined with a careful following of the basic tradition. Occasionally, one finds an extremely innovative artist like Slim Green of northern New Mexico, who has evolved his own tooling patterns based on local Indian pottery, silverworking, and weaving designs. For the most part, however, saddle makers tend to create variations of the two basic patterns described above.

Retired saddle maker Paul Showalter of Patagonia showing some of his filigree silver work, September 1984. Many of the same floral motifs that appear on western saddles and belts are also found on rifle barrels, trigger guards, and ornamental woodcarving. Showalter built and inlaid the wooden stock for this rifle, engraved the metal parts, and did the silver overlay visible here.

In addition to leather tooling, one sometimes finds silver ornaments applied over the leather. The silver may be engraved with curving floral designs very similar to those used on the leather. These "silver saddles" are luxury items and are intended for public show. Such elegant gear may best be seen at parades such as the annual La Fiesta de los Vaqueros (rodeo week) parade in Tucson.

Designs used on saddles are also applied to spur straps, luxury bridles, and leather belts. Once again, one can buy a leather belt with floral stamping in any western store in southern Arizona, or order

such a belt from a craftsman. Many saddle makers also make custom belts in a variety of patterns. Most custom-made belts have the name or initials of the owner carved into the leather in the middle of the back, while others have silver letters.

Reins, quirts, and bosals can be made of braided leather. A quirt is a short whip about two feet in length; a bosal is the nosepiece for a hackamore, a sort of bitless headstall with reins, which is used for training horses. Craftsmen specializing in this kind of work are scattered throughout ranch country. Once again, these utilitarian objects can have an aesthetic value within their community. Whether or not such braided leather objects are regarded as art depends on the amount of control and evenness the craftsman is able to demonstrate in his work. A large number of small strands, evenly manipulated with woven decorations interspersed, makes for highly regarded work. Some craftspeople only make rough-and-ready bosals. Really fine leather braiders, however, are greatly admired by most working cowboys, and they often create things such as miniature bits of equipment or braided bolo ties as a sideline.

Bosals can also be made of untanned cowhide, or rawhide. Rawhide is harder to work than soft leather, but it wears like iron. In the old days it was used to repair almost anything. The word slipped into cowboy slang to mean a rough-and-ready job. In addition, the verb "to rawhide" means to hassle in a fairly roughshod manner. "Mormon rawhide" is baling wire—a joking reference to the fact that most Mormons in Arizona farmed rather than ranched and therefore had easier access to baling wire than to rawhide. Both were—and still are —indispensable materials for rough repairs. Another item commonly made of rawhide is the reata, or rawhide lasso.

Elsewhere in the West, fancy rawhide working is undergoing a small revival. In southern Arizona, the situation is different, due to the closeness of the Mexican border. Once again, the differences between the two national economies encourage importation of goods and discourage crafting by local artisans. The few southern Arizona rawhide workers I have met have been Mexican or Mexican-American vaqueros, pursuing the craft for their own purposes rather than for economic gain.

Most spurs and bits are purchased from stores or catalogs, but here and there one finds a cowboy or vaquero who crafts and decorates his own. The metal may be engraved or inlaid with silver, or more

Leather braider Verne Dorman of Patagonia at Tucson Meet Yourself in 1983. Dorman learned to braid leather from his father as a boy and took up the craft again after his retirement. In addition to bola ties such as the one he is wearing, he makes reins, bosals, quirts, and other pieces of horse equipment for ranchers and cowboys in Santa Cruz County. *Photo by Bill Doyle, courtesy of the Southwest Folklore Center.*

unusual materials can be used. The late Luis Martinez of Florence, Arizona, was an all-round craftsman who worked in a wide range of materials. In addition to a full repertoire of leather and rawhide work, he made bits and spurs for himself and for neighboring cowboys and vaqueros. Some of his bits were created out of old horseshoes inlaid with silver.

Boots, too, are occasionally crafted by individuals and small companies on a custom basis. Scattered around Arizona are a few old-timers who make their own boots or who make a very few pair just for the fun of it. In addition, there are two important small boot companies in southern Arizona. Stewart Boots in Tucson makes a distinctive boot of soft leather, employing Mexican craftsmen who were for the most part trained in the great Mexican leather working center of Leon, Guanajuato. Paul Bond of Nogales, Arizona, has been in business for years, and he makes a line of extremely ornate custom boots as well

as boots for work. Like Stewart, Bond relies on Mexican craftsmen. Much of his work is done in Nogales, Sonora, as a means of keeping prices down on the intricate stitching and inlay work. Both companies are known all over the West as sources of fine custom-made boots.

With this discussion of boots, we enter the realm of traditional costume. Even though few items of contemporary dress are hand-made, people often deliberately select and wear clothing to indicate their membership in a particular ethnic, occupational, or other group. Western regional dress provides an excellent example of this. Under the influence of the requirements of cowboy work and the dictates of Hollywood-inspired fashion, a distinctive regional costume has evolved in the West. Here again one can see the results of the complex interplay between myth and reality that has been so important in shaping our western culture. The basic components of this regional costume are a wide-brimmed hat, a shirt with a scalloped yoke, and often pearl snap buttons, straight-legged trousers, and cowboy boots.

Working cowboys have always tended to vary their dress according to the region in which they live, and to a certain extent this is still true. In Arizona, for instance, boots tend to have blunt, rounded toes and thick walking heels. Farther north, in Montana, boot toes are much more pointed and the heels are quite undercut. Vaqueros in our neighboring state of Sonora, Mexico, on the other hand, prefer extremely blunt, rounded toes and heels that are undercut by as much as two or three inches. I have heard of boot makers who can correctly identify the region from which their walk-in customers hail simply by their taste in boots.

Hats are a different matter. It used to be that hat creases were regional, but they now seem to be more a matter of generation and status. Older men, especially ranch owners as opposed to cowboys, frequently wear a narrow-brimmed, light grey ("Silverbelly") hat, often called an "LBJ" after the late President Lyndon B. Johnson who wore such a hat and who gave quantities of them away to visitors at his ranch. In some very brushy areas, narrow brims can be functional. A narrow-brimmed hat is less likely to be ripped off your head while you are pursuing a wild cow through heavy, tall brush than is a wide-brimmed one. Many younger cowboys, however, prefer a broad brim, turned down in the front—a fashion adopted from rodeo bull riders. A few years ago, extremely high crowns were fashionable. Current trends, especially among Nevada buckaroos, seem to be toward the

kind of wide-brimmed hat with a single crease down the center of its high crown that is associated with movie stars of the twenties such as Tom Mix.

Many cowboys like to curl up the sides of their hat brims into a "hog trough." An extreme version of this, with the brims going almost straight up from the side of the head, was popular several years ago. The joke went at the time that this was so four men could fit side by side in the front seat of a pickup. In a similar vein, a brim that is curled up at the back is often said to have a "pickup roll"—from being pressed against the rear window of the cab of a pickup truck.

The most distinctive dress in the West is worn by the buckaroos of northern Nevada, Idaho, and southern Oregon. Buckaroos tend to be dandy dressers. In addition to the hats mentioned in the preceding paragraph, they wear "wild rags" (three-foot-square silk scarves) around their necks and tuck their trousers into the legs of their knee-high, elaborately stitched boot tops. None of this is found in southern Arizona. In fact, I had never seen a real buckaroo till 1985, when I took a trip to Elko, Nevada. However, cowboys are extremely mobile people, and the fashion appears to be spreading in southern Arizona.

Another popular cow-country sport has given rise to a fascinating kind of sculpture. Roping is a necessary skill for working cattle on the open range. It is the only way to stop a cow or calf in order to brand, inspect, or doctor it. Roping has also evolved into an extremely popular western sport. Team roping, in particular, in which one partner ropes the head and another the heels of a calf while working against the clock, is a favored pastime in many western localities. It is a sport in which the very old and the very young can compete together. It is not uncommon to see parents and children, or even grandparents and grandchildren, on the same team. There is a kind of roping event called the "Century Roping" in which the age of the two team members must add up to a sum of more than one hundred years. I know team ropers in their eighties who still compete regularly and who occasionally even take home some prize money.

It's a common western belief that roping is one skill one cannot achieve in one's later years. A good roper must have been at it, practicing steadily, from youth. But roping cattle for practice can present a problem. Cattle are economic assets, and too much exercise can run their weight down. Fence posts are the wrong height to rope, and practicing on family members and pets can rapidly lead to resentment.

Team roping in Chino Valley, Arizona, June 1980. The header is to the right, behind the calf. He has built his loop and is about to make his throw, while the heeler awaits developments. This particular team of two old-timers boasts a cumulative age of over 140 years.

And so the roping dummy comes into play. In its most common form, it is simply a plastic calf's head with two long spikes on the neck which are thrust into a bale of hay. One stands behind the "animal," builds a loop, and tries to toss it over the horns.

Many ropers, however, prefer to make their own roping dummies, often sticking them together out of whatever materials are available around the ranch. A small sawhorse with a "head" made of the belt from an old machine of some sort and horns consisting of a set of tricycle handle bars is a common example, as is a plastic calf's head attached to a body made of horseshoes welded together. This latter goes far toward solving a perennial ranch problem: what do you do with all those discarded horseshoes? The dummy might also be a more or less elaborate construction of old pipe, welded and fitted together to

A roping dummy, photographed at the Ropathon north of Phoenix, November 1980. Someone had a bit of time, some pipe, a welding rig, and a fondness for detail.

form a calf effigy. Whatever the materials, homemade roping dummies can be exciting bits of ranch sculpture and frequently provide a touch of pleasing whimsy to a calf roper's household. At the same time they satisfy the "don't buy it if you can make do" rawhide ethic that is still an important part of traditional ranch life.

Another kind of ranch sculpture can be found, not near the ranch buildings themselves, but out by the road. Pat Jasper of Austin, Texas, calls this boundary art. It is erected on the edges of the property, be it a junction of a ranch road with a main road or simply at a driveway exit. Some boundary art takes the form of gates. The most common style is the Ponderosa Ranch gateway with two hefty uprights supporting a crossbar. These may be pine trunks, or, in the present age, small power poles. There is often some further embellishment on the gate, cow skulls lashed to the uprights, perhaps, or a sign suspended from the middle of the crossbar. One gateway in Bowie is of metal. Welded to the top of the crossbar are two plows, while cauldrons, old boots, and the owner's initials formed of welded chain hang below. A fence in the same town extends the theme even more. The house lot is

A classic "Ponderosa" gate, complete with critter skulls, hanging name, and horseshoes. The cutout sign in the foreground leaves no doubt as to the owner's interests. Near Mission San Xavier, January 1980.

surrounded by a fence whose horizontal elements are old mining car track. Welded to the track, jutting up or hanging from it, is a remarkable collection of old spurs, frying pans, pick and ax heads, crescent wrenches, and screwdrivers—everything, in fact, that one can pick up while exploring in the mountains and deserts of southern Arizona. Together, it forms a wonderful expression of place and continuity.

Similar statements are made with yet another form of boundary art, the mailbox support. Rural mailboxes need some sort of support to bring them to the proper height for mail delivery through a car or pickup window. Often the support is created from an outmoded bit of

Portion of a decorative fence in Bowie, Arizona. The fence is made of mine railroad track; welded to it is a remarkable collection of small metal tools and other found objects. Flywheels and old signs complete the statement of place. Photo taken in May 1982.

agricultural equipment. I have seen plows, milk cans, and old cream separators used as mailbox supports. The ubiquitous horseshoe is a popular raw material. Initials or brands formed of horseshoes welded together can provide an eloquent statement of the rural nature of the owners. My all-time favorite is down by San Simon, where someone drove an old tractor under the shade of a big cottonwood and attached a mailbox to its metal rear wheel. The mailbox is bolted rather than welded to the wheel and the tractor seems still to be in good running order.

Not that all of these supports are symbolic statements of identity. Lengths of chain that have been welded into improbable "S" curves attest to little more than the fact that the person who set them up owned a welding kit. But much of the boundary art one sees in our

One of several mobiles in the Tucson yard of a Mexican-American blacksmith, now deceased. The maker of these assemblages had worked locally all his life as blacksmith and vaquero; his father had helped haul rocks from A Mountain to build the wall around the University of Arizona. His deep sense of identification with southern Arizona and its traditional occupations led him to create this yard art. Photo taken in June 1978.

region and elsewhere in the West seems to be a public statement of identity reflecting an occupation or life-style of the region. Sometimes, however, a much more personal statement is made by means of a cattle brand.

Brands are the heraldry of the cattle-raising West. They are marks of ownership which are burned into the hides of cattle. This may seem cruel and inhumane to contemporary suburban readers, but the simple truth is that there has been no practical way to establish ownership of range cattle other than by altering their appearance permanently.

Brought to Mexico by the Spaniards, the twin practices of branding and earmarking are still important in the western range cattle industry. Once the American cattlemen got hold of the practice, however, they introduced some new twists into branding. From merely a mark of ownership, brands have become a form of written language—a kind of game played with letters and symbols. The knowledgeable person can actually "read" a brand. A letter or number tilted to one side is said to be "crazy." Lying on its back, it's "lazy." One of the best-known writers of cowboy prose and verse, the late Omar S. Barker, had his name legally changed to S. Omar Barker, according to legend, so that he could justifiably claim the "Lazy SOB" brand.

A straight line is a "bar," an inverted "V" over another letter is a "rafter," and so on. As a matter of fact, the reading of brands is complex. Thousands of brands have been registered over the years. Actually, most old-time cowboys seem to be best at reading the brands they are familiar with. I have been told that the old-timers could spend a lot of time arguing over how an unfamiliar brand should be read. Of course, not all brands are composed according to these rules. Some—like the Coffeepot—are representational, while others, like the famous XIT (Ten In Texas, because the ranch was said to cover ten counties) must be known to be read. Even so, with many brands the element of game—of puzzle—is there. And within each state each brand is owned and used legally by only one person, and infringements are taken very seriously.

The Gadsden Hotel in Douglas is a magnificent historic building, complete with a glass skylight depicting a desert landscape. It has long been a favorite gathering place for cowboys and ranchers from both sides of the international border. And covering the walls of its barroom are brands—many of them local Arizona and Sonora cattle brands—painted boldly in brown on a cream background. The Arizona brands are of the sort we have been mentioning, and many can be read using the system outlined above. But the Sonoran brands are something entirely different. In the first place, many of them look different, with lots of little loops and curlicues. And they apparently are not read in the same way that American ones are. In Arizona the question is, "How do you read your brand?" To get the same information from a Sonoran rancher one asks, "What is the name of your brand?" A numeral four above a u-shaped trough, which in the United States would be called a "Rocking Four," or possibly a

The Triangle Anchor brand, worked into the gate at its owner's house. The site is the northern La Osa Ranch near Sasco, Arizona; the house that of John Kinney. Photo taken in August 1978.

"Four in a Ditch" or "Four in a Bucket" is called "el cuatro"—"four" in Spanish. A "P" partially framed by a curved, spearheaded line, is called simply "el P." So while brands came to the American cowboy from Mexico, the games he plays with them and their meaning are apparently his own invention.

Brands are found in many places other than on cows and barroom walls. They are symbols of identity of the ranch or "outfit" to which they belong, and as such are put on pickups, horse trailers, on stationery, and even on sets of china. They are scratched into the wet cement of ranch-house porches. And they are worked into gates and mailbox supports. As Arizona urbanizes, they are becoming less im-

portant than they once were. But at the moment they are still very much with us, visible reminders of the fact that southern Arizona is cattle country and has been so for a long, long time.

SPORTS AND CELEBRATIONS

I have already mentioned the sport of team roping, which is based on skills necessary to the working cowboy. Team roping flourishes all over the Southwest, and "ropin's," as they are called, can be large or small. Local roping clubs organize regular get-togethers at small local arenas. All one really needs is a corral, a chute for the stock to come out of, and some sort of raised platform for the timekeepers to sit on. There are also regional ropings that offer large amounts of prize money, that last for several days, and draw contestants from a wide area.

Not all present-day team ropers live on ranches. I know of one roping club, for example, which consists of middle-class Mexican-American men and their children. Almost all the men live in Tucson and follow urban pursuits, but they are all descended from local ranching and vaquero families. The club was formed to pass the skills and love of roping on to the kids, so that these things, symbols of rural family identity, would not be lost. Anglos, Mexicans, and Indians rope, and they rodeo as well, although the contests and clubs, especially on a local scale, may be organized separately for each ethnic group.

Rodeo is a complex, big-time sport nowadays, with a national following, professional athletes, and big prize money involved. Professional rodeo cowboys go to "rodeo schools" to learn to sharpen their skills, and they follow their sport all over the country, coming into our region for events like the three-day Tucson Rodeo. As it is in many Western towns and cities, Rodeo Week is a big occasion, complete with several days of competition, parties, and a parade, and it is the occasion for all sorts of people to "dress western" for once in the year. Like the "Frontier Days" celebrated all over the West, it gives the community as a whole the opportunity to reaffirm its ties to a West that is part geographic, part historical, and part mythical. But the contests of the rodeo are all real and are, in fact, built upon

skills that are or were necessary to the working cowboy. (A strong possibility exists that this rodeo will soon cease to be as a direct result of the difficulty of getting sufficient liability insurance for the event.)

There are two kinds of competitions in rodeo: those that are timed against a clock and those in which the contestant is judged by a point system on the basis of skill and style. The former include team roping as well as individual calf roping in which the contestant is timed while he ropes a calf, jumps from his horse (which keeps the rope taut for him), runs over to the calf, tips it over on its side, and ties three of its feet together with a "piggin' string." Precisely this same activity takes place whenever a man on horseback needs to brand or doctor a calf on the open range. It takes skill, agility, a well-trained horse, and a good deal of luck. If the calf dodges in an unexpected direction, if the cowboy misses his first loop, if the calf does not go over on the cowboy's first try, precious seconds, and probably any chance at prize money, are lost.

"Bronc" comes from the Spanish word bronco, an adjective meaning "wild." Bronc riding is judged by points. The cowboy's first object is to stay on his horse for the required number of seconds. His second is to spur the bronc in a raking, rhythmic motion, and to ride with style. He is being judged on this style. But if the horse decides to run instead of buck, the cowboy loses any chance at the money. Contrary to what some people believe, bucking stock are not tortured to make them buck; a loose flank strap tied to the saddle only serves as an annoyance. Indeed, all the rodeo stock—calves, horses, and bulls—are athletes almost to the degree that the cowboys are. Good rodeo stock are carefully sought after, well cared for, and highly thought of.

Contemporary rodeo is mostly a man's sport. This was not always true. In the earlier years of the century, women competed in bronc and even bull riding. But in recent years, female rodeo participation has been pretty much limited to barrel racing. That event is a woman's specialty and involves taking a horse at a gallop around three barrels in a cloverleaf pattern. Knocking a barrel over adds a stiff penalty to the contestant's time. Barrel racing requires an excellent horse, a high degree of riding skill, and an indifference to the possibility of injury that is a constant reality all through the rodeo.

While calf roping, team roping (more in the Southwest than elsewhere), saddle and bareback bronc riding, bull riding, bulldogging (or steer wrestling), and barrel racing make up the core of rodeo, one

often finds other featured events as well. In bull riding, a clown is on hand to lure the bull away from the fallen rider, and sometimes the clown will put on his own bullfighting act as an entertaining interlude. Rodeo clowns risk serious injury daily, and perform an important life-saving function, which they cloak in humor and burlesque.

Some rodeos feature chuck-wagon races or wild-cow milking competitions. The latter can get pretty hilarious as contestants struggle to get a few drops of milk out of the uncooperative bovine and into the container, which must then be carried across the finish line. But whatever the events of a given rodeo, or whether it be on the national circuit, the collegiate circuit, or on an Indian reservation, it involves the pageantry of the Grand Entry, the serious business of the competitions, the humor and excitement of the clowning, and a whole lot of strictly regional good times. And as is true of other kinds of rituals and celebrations, rodeo serves as a focus for a cluster of traditional arts. One sees the most western dress during rodeo week, the fanciest saddles at a rodeo parade. One has a better chance of hearing good western music at a rodeo dance than at other times of the year. And at these times one can feel that southern Arizona really is a part of a western cattle country, even if the suburban development one calls home has little to distinguish it from similar streets all over the country.

A totally different tradition of mounted competition is slowly gaining popularity in southern Arizona—*charreria*, Mexico's equivalent to the sport of rodeo. Participants in this sport are *charros*, and the contests themselves are *charreadas*. A charreada differs in many ways from a rodeo, even though the origin of both sports lies in informal contests involving the skills needed to work cattle from horseback. Great emphasis is placed in charreria on the training of the horse, and on the style and grace with which it performs the various events. Charreadas often involve mariachi music, and it is not uncommon to see a charro waltzing his horse while standing in the saddle and performing rope tricks, while horse, rider, and rope all move in time to the music. Although charreria has become extremely popular in the Phoenix area, it is just starting to catch on here in the Santa Cruz Valley. The annual La Fiesta del Presidio, sponsored each April by the Tucson Festival Society, usually includes a group of charros demonstrating their skills.

I have mentioned the myth of the West several times. What is this

myth? It certainly does not seem to have much to do with the realities
of raising beef, or extracting minerals from the earth, or farming, or
storekeeping—the occupations of most civilians in southern Arizona
in the last century. But it does involve violence: the violence of the
Indian Wars; the violence of a lawless society in which, in the words
of "The Ballad of Billy the Kid" (written in this century by a blind
Atlanta, Georgia, evangelist and itself a product of the western myth),
"a man's only friend was his big forty-four." It is a West of gamblers,
gunslingers, and dance-hall girls; of sudden riches and sudden death;
of Mountain Men and the U.S. Cavalry. It is a West that is constantly
being refashioned to reflect the things that contemporary, suburban
people wish they had, among them, independence, excitement, clear-
cut issues, and an easy, violent response to crimes of violence. And
it is this West that most visitors really come to see—the reason why
the permanent western movie set at Old Tucson is a more popular
tourist attraction than the Mission San Xavier, located twelve miles
from downtown Tucson, the same distance as Old Tucson.

Many other towns in the West have some special annual event in
which the residents celebrate their regional identity, often with an
eye to attracting tourist dollars. Tombstone's annual Helldorado Days
is one example. Many times such a celebration includes events like
old-time fiddlers' contests and beard-growing competitions. Often it
provides an opportunity for people, who would otherwise be uncom-
fortable in such garb, to dress up in western clothing. And a parade is
almost always a part of the festivities.

Parades are fascinating affairs, often featuring a whole array of
symbols of western identity and presenting images which combine
myth and reality. In the first place, there are always horses. This is
the occasion to see incredibly ornate silver saddles and tack, worn
by beautiful, well-groomed animals. Sometimes the riders join the
parade as individuals. Frequently they are members of "sheriffs'
posses," organizations which exist in most western counties as support
groups for the local sheriff's department. Although they are seldom
mobilized any longer to go chasing on horseback after escaping male-
factors, they often play a part in local search and rescue operations and
other occasions on which mounted assistance is needed. They sup-
port the sheriff in his programs and agenda. And at parade time, they
bring out their show saddles and other finery and proudly join in.

Various kinds of horse-drawn conveyances are also common in such parades. The Tucson Rodeo Parade, in fact, bans all motorized entries and bills itself as "the longest nonmechanized parade in the world." Horses are a symbol of the traditional West—not just the West of the cattle industry, but the mythic West of the films and novels as well. Both these Wests are affirmed in the parades.

Another common kind of parade entry includes depictions of western violence and lawlessness. Gunfighters stalk the streets; bartenders, gamblers, and dance-hall girls ride on floats. Many of the riders are armed, and often one or more troops of Memorial Cavalry or groups of Mountain Men participate. Memorial Cavalry units are groups of men who, at their own expense, have equipped themselves with accurate reproductions of nineteenth-century military uniforms and equipment and who participate in parades and other civic events. The Mountain Men are a similar group who dress in carefully re-searched beaver trappers' costumes from the 1830s. Other costumed participants recreate the West of outlaws and gunfighters. Many southern Arizona towns, Tucson included, have their groups of "vigi-lantes" who stage mock gunfights and greet distinguished visitors with simulated "necktie parties." Such groups of dedicated hobbyists are frequently prominent in parades and other activities which per-form the dual function of identifying individual and community with the mythic West and attracting tourist dollars.

So it is that many southern Arizonans take time out each year to symbolize their identity as westerners, reaffirming a past that is partly history, partly myth. Curiously enough, there are some long-term components of our community who are left out of the myth to a great extent. Among these are Mormons and miners, two groups who played—and still play—important roles in our region.

OUTSIDE THE MYTH:
A RELIGION AND AN OCCUPATION

Any account of the peoples of southern Arizona must include men-tion of the Church of Jesus Christ of Latter-day Saints, or the Mor-mons. Driven from Illinois and Missouri by the intolerance of their neighbors, the Mormons settled in the 1840s in the Valley of the

Great Salt Lake and shortly thereafter began a campaign of expansion throughout the West. Traditional Mormon culture is a farming culture, and Arizona's Mormon settlements are in the good river bottomland: along the Little Colorado in the White Mountains, along the upper and middle Gila, and along the San Pedro. Mormon communities are readily recognizable. The dwellings are usually clustered into villages, which in turn are surrounded by farming land. Streets are broad, and houses are often of red brick and roofs are pitched. Although Mormon communities lack the rich visual religious art of their Catholic neighbors, they do have their own symbolic ways of stating their identity through the traditional arts.

Perhaps the most important public statement of Mormon cultural identity comes on July 24, Pioneer Day. This is the day on which Brigham Young stood on the hill above the site of Salt Lake City and indicated that the long and painful trek West was at an end; the vanguard of the Saints had arrived in Zion. It is celebrated in Utah as a state holiday and in Mormon communities elsewhere as a time for honoring the devotion, perseverance, and sacrifice of the early pioneers who spread the Mormon faith and culture through the West. Pioneer Day celebrations often include a parade that can present a fascinating contrast to the parades described in the previous section.

In the first place, one sees very few Indian fighters, gunfighters, dance-hall girls, and wild cowboys in the typical Pioneer Day Parade. In their place are hard-working farmers, prosperous townspeople, and other solid citizens. Floats depicting events of local history emphasize the virtues of hard work, family solidarity, and faith, and celebrate the ideal of progress. Church school groups dramatize concepts from the Book of Mormon. Women are present in their various roles within the family context, or as nurses, midwives, or other nurturers.

At one parade I saw in St. Johns in Arizona's White Mountains, the only gun visible was carried by a young man who was enacting the role of a father hunting in order to feed his family, while the only suggestion of frontier lawlessness was a float representing an elder in the church who was jailed by federal officials in the last century for refusing to dissolve his polygamous marriages. A far cry from Doc Holliday, Wyatt Earp, and the O.K. Corral! And yet in the cemetery belonging to this same community were tombstones engraved with legends such as "Murdered by a Mexican mob," and "Killed while

serving his country in a sheriff's posse." The violence was there; however, it was not considered worthy of reenactment.

What we see in these parades is a stable, conservative community celebrating its own identity. Such communities, of course, were not and are not limited in Arizona to those made up of members of the Church of Jesus Christ of Latter-day Saints. Most nineteenth-century western towns of any size had what was called a "progressive element," who promoted law, order, stability, family values, and progress. But by and large the non-Mormon communities do not choose to celebrate this aspect of their past. The myth of the "Wild West" is too strong, and progress and stability, no matter how important, do not make for an attractive tourist spectacle. In addition, I suspect that while many of the Mormons who take part in the Pioneer Day parades are descended from real local pioneers, many of the participants in the other civic parades are newcomers to the West. While one group is honoring a continuity from within, the other is celebrating an outsider's view of western history.

Another place where Mormon folk traditions blossom before the public eye is in the cemeteries. In areas where easily carved sandstone was available locally, town and village stonecutters used it for tombstones. In the nineteenth century, it was fashionable to include, along with the name and dates of the deceased, a pictorial symbol of bereavement or of hope. Hands clasped in a last farewell, doves, evergreen branches, and flowers all appear on hand-carved grave markers dating from this period. Later on, one finds representations of one or another of the Mormon Temples. One such marker in the old Gila River Mormon community of Central has a particularly charming, extremely elongated carving of the Salt Lake City Temple, all towers, spires, and narrow windows.

The old stone carvers have died out in this century, being replaced with craftsmen who sandblast designs on granite for their customers. Although these contemporary, sandblasted monuments are produced by modern technology, they also can reveal much of the tastes and beliefs of the community. Here, too, Mormon Temples figure as themes, along with photographs of the deceased set into the stone itself. Thus the Mormon cultural emphasis on family and religious identity is brought into the cemeteries, just as it is emphasized in the Pioneer Day parades.

Representation of the Mormon Temple at Salt Lake City, on a turn-of-the-century grave marker in the old Gila Valley community of Central. The neogothic shape of this marker, along with the motto, the twining (evergreen) ivy, and the Greek fret pattern at the bottom, are in the mainstream of popular, nineteenth-century American culture; the wonderfully elongated rendition of the temple gives it a distinctive Mormon character.

Mining has long been an important occupation in the Southwest. The very name "Arizona" comes from the name of the site of a fabulous eighteenth-century find of huge chunks of free silver, near what is now the Arizona-Sonora border and west of present-day Nogales. Every mountain range is peppered with mine workings, large and

small, and the huge tailing dumps just west of Green Valley are visible for miles as one drives along Interstate 19. Tombstone, Bisbee, and Douglas would not exist were it not for mining—the first two having been mining towns and the latter the site for a smelter. Numerous ghost towns in various stages of decay dot the landscape, most of them abandoned shortly after their mines played out.

Another legacy of mining is in southern Arizona's cultural diversity. Mining attracted workers of many nationalities, including Mexicans, Italians, Irishmen, and Serbs. Among the mainstays of old-time mining were the "Cousin Jacks," Cornishmen from the southern tip of Great Britain. They followed their craft all over the world and their mark can still be seen in southern Arizona. It can be found in the phone books of former mining towns, where Cornish surnames such as Pemberton and Trevethen testify to the continued presence of the descendants of these skilled craftsmen. And it can be found in the form of the ubiquitous Cornish pasty. Pronounced to rhyme with "nasty" (which in no way describes it), the pasty is a Cornish meat pie, and was standard lunch-bucket fare for Cornish miners. It is shaped rather like a football and is a wonderfully filling and sustaining working-man's lunch. Pasties are still made and sold in mining towns all over the West, and Bisbee is no exception. One local church group has an annual, fund-raising pasty supper. And pasties have for years been on the regular Wednesday menu at Dot's Cafe, just south of the world-famous Lavender Pit open mine. The last time I ate there, the menu featured chimichangas, guacamole salad, and pasties —a combination that could only be found in a mining town on the Arizona-Sonora border!

The other traditional arts of the old-time miners are mostly invisible to the casual traveler, as they were pursued far underground in the well-planned, skillfully blasted, and carefully timbered tunnels and shafts that enabled them to get to the ores they were seeking. Visitors have an opportunity to see the results of this traditional craftsmanship in Bisbee's underground Queen Mine, which offers regularly scheduled guided tours for a small fee.

Another trace of the traditional skills of Arizona's miners is in the beautiful dry-stone masonry of our mining districts. Bisbee's rock walls are things of beauty. Old wagon roads still exist in mountain areas where dynamite was too precious a commodity to use on road building. The roads were, therefore, placed on parapets built out from

Beehive coke ovens across the Gila River from the ghost town of Cochran, east of Florence. This set of three dry-stone ovens stands alone on the north bank of the Gila. The old wagon roads leading down from the north include much excellent stonework where they are parapetted out from the hillsides. Stonework of this quality is found all over Arizona's historic mining districts. *Tom Harlan photo, 1982.*

the slope—stone parapets with each stone so carefully fitted that many of these roads will support the weight of a pickup a century after they were constructed, and perhaps seventy years after they were abandoned. And on the north side of the Gila River, east of Florence, three gigantic stone beehive ovens stand in mute testimony to the skills of the now nameless masons who built them. But the old miners and prospectors made their greatest artistic impact on our region in quite a different way, and for that one must turn to the maps.

It is in names. The names of mines, the names of mining claims. Together, they add a wonderful flavor to the countryside. Sometimes they delineate a geography of optimism, as is the case with the Abundancia, the Copper King (and Queen), the Bonanza, and the Empress of India. Sometimes a person is remembered: Julia, Cora, McDonald, Gibson, Ochoa; or a place: Pompeii, Herculaneum, Saratoga, Albany.

Sometimes the theme is patriotic as in Liberty or Hail Columbia; or descriptive of the environment, as in Mountain View, Summit, or Red Oak. In some cases, one is left to guess the story behind the name: Lost Shaft, Humbug, Noonday, Big Bug. Here are some more: Compadre, Blue Nose, Endless Chain, Golden Gate, Trench. There are thousands of these names all through southern Arizona, giving the region a special flavor, adding a note of poetic flamboyance to our maps, and recalling more than a hundred years of hopes, dreams, hard work, swindles, riches, and poverty.

If you look at the cemeteries of our mining towns and camps you are likely to come across some creative statements of mining identity. In Arivaca, for instance, there is a homemade cement monument. The base was apparently cast from an old washtub, while the upper part consists of a pile of quartz rocks, cemented together. A small tin can is cemented into the rock pile, and on the capping cement slab is a brass plaque that gives the deceased's nickname as "Klondike." Apparently, some old prospector ended up in this small southern Arizona community after a life that included at least one trip to the fabled goldfields of the Far North. His friends honored his memory by building what amounts to a mining claim monument over the last piece of ground he was to occupy. Here and there one can also find more recent, commercially sandblasted headstones with picks, gold pans, and other symbols of the miner's occupation.

Admittedly, the material I have mentioned for miners and Mormons is rather sparse. However, it certainly exists, and much of what is there is fascinating and lovely, although it is neither as all-pervasive nor as dramatic as are the various art forms associated with the cattle industry and its sometimes real, sometimes fictional hero, the cowboy. It appears to me that there are several reasons for this.

The culture of Mormonism is a reserved one, centering on the family and the larger community of faith. Unlike Hispanic Catholicism, it does not involve a multiplicity of visual religious symbols that might be incorporated into public art. (This was not true in the early days of the church, when such Mormon images as the beehive and the ever-vigilant eye were worked into architectural details, furniture, and other objects of everyday life. Those days were passing by the time the Arizona Mormon colonies were settled, however.) Although there is a rich and varied body of Mormon folklore, it functions almost entirely within the context of Mormon culture. Furthermore, it has

His final claim; a grave marker in Arivaca. From the fact that the deceased's nickname was "Klondike," it may be deduced that he was a prospector. The monument his friends erected for him is, to all intents and purposes, a traditional marker for a mining claim. The cairn of white quartz rocks stands on a cement casting of an overturned galvanized washtub. Under the flat cement slab at the top is a small can into which claim papers could be slipped. The brass plaque on top gives the deceased's name and dates. Photo taken in May 1987.

long been a Mormon custom to combine aesthetic participation within the mainstream of American society with a certain reticence concerning their own traditions. So it is that, while there is indeed a body of Mormon folk art, little of it is intended for public display. Only on occasions such as Pioneer Day or in places such as cemeteries do Mormon communities make creative, public statements to the outside world concerning themselves and their identity.

As for miners in southern Arizona, the traces we can see, although they are very real and of great interest, are all traces of the past. Mining by hand is a thing of the past, and has been for at least half a

century. The skills that produced the beautifully laid walls and parapets lay in hands that have long since turned to dust. Modern mining is mechanized labor, infinitely safer than the old ways, but no more liable to produce aesthetically pleasing works of traditional, individual craftsmanship than modern highway building.

There is yet a third consideration, and it is one that is closely involved with the myth of the American West. We have seen in this chapter how the image of the cowboy, working alone in a huge country, has been combined with the reality of frontier violence to produce a set of stereotypes of the West that are part myth and part reality. Miners and Mormons, although they were integral parts of western history, have been to a great extent left out of the western myth. The reasons for this do not seem difficult to find. I have already suggested reasons why traditional Mormon values, important though they are to our continued well-being, do not find a prominent place in Chamber-of-Commerce-sponsored civic parades. Further food for thought may be found in a comparison of the cattle and the mining industries.

In many ways they are similar. Both involve exploitation of the natural environment; both have been traditionally financed by large business interests far removed from the regions in which they were carried out. And in the beginning, both involved solitary, highly skilled laborers. The prospector has in fact become almost as romantic a figure of western mythology as the cowboy. But the prospector's day has long been over, and the skilled, independent miner has become more and more a skilled laborer using modern, heavy machinery. The cowboy, on the other hand, still works as he always has—alone and on horseback, in some of the most spectacularly beautiful country in North America. There is a direct continuity between his work and life-style a century ago and his existence today. The work has changed, to be sure, but many of its demands and dangers remain as they were, and the tools, techniques, and attitudes that were developed in response to those demands and dangers have stayed more or less the same for more than a hundred years.

So it is that the cowboy is a link between the present and our mythic past. His tools—the saddles, boots, spurs, songs, and stories that allowed him to do his work—have survived along with him. They have also become more than tools; they have become objects of export into popular American culture, and reaffirmations of the

myth. The cattle industry has had excellent press agents for over a century, and along with the stories about the brave cowboys and their life, actual bits of that life have entered the outside world in the form of songs, poems, dress, and even horse equipment. They have become parts of the complex opposition of myth and reality that is life in today's West—the myth of the individual, of clean, open spaces, of violence used cleanly toward noble ends; and the reality of hard work, economic dependence, and the sober quest for law and order to protect the fruits of labor.

4

✳ ✳ ✳

The Arts of Immigrant Cultures

Southern Arizona has seen intense immigration in the past several years. One third of the residents of Pima County who responded to the 1980 census stated they had been living elsewhere in 1975, and the intensity of immigration shows no signs of abating in the decade of the eighties. The new arrivals have come from all over the United States and, indeed, from most parts of the world since the middle of the last century when the Gadsden Purchase turned southern Arizona from the Mexican Northwest to the American Southwest. Nineteenth-century Tucson was home to Irish, Chinese, European Jews, blacks, and people of many other cultures. Then as now they brought their own cultural traditions to their new home in the desert.

For the first time in this book, however, we are not dealing with long-established local communities. Immigrants into southern Arizona tend to arrive as individuals or as families. In most cases, where the arrivals settle is determined by factors that have nothing to do with cultural heritage—economics, availability of housing, nearness to schools, and a host of other reasons. Except in the case of blacks and Chinese, who have tended to follow patterns that were established before housing discrimination became illegal, the ethnic neighborhoods

153

of America's older cities have no counterpart in Tucson. If people of a given ethnic heritage are to get together here, it must be on some basis other than neighborhood—ethnic clubs, for instance, or special interest groups or churches.

By the same token, the traditional arts of many of our region's immigrant groups are somewhat hard to find. Rather than being a part of the fabric of the daily lives of a sizeable portion of our community, they tend to flourish only in specific settings: in the household, for example, or in the context of the church or ethnic social club. To experience the arts, one must visit these settings. One setting in which many of these art forms are accessible to the general public is Tucson Meet Yourself. Established in 1974, the event celebrates the richness and diversity of the living traditional arts of southern Arizona's folk and ethnic communities. Its purpose is to present these arts as accurately and respectfully as possible to as wide as possible a segment of Tucson's population. Held on the second weekend of each October in downtown El Presidio Park, the festival has always included the arts of immigrant cultures. Here one can listen to Bluegrass bands, Czech, Slovenian and Italian accordion players, and black church choirs. One can watch Norwegian, Vietnamese, and Chilean dance groups and visit with craftspeople from a wide range of traditions. And one can sample food from a startling variety of ethnic and national cuisines, including Chinese, Thai, Cuban, German, Armenian, Greek, Finnish, Spanish, Turkish, Arabic, and more than twenty other traditions.

SOUTHERNERS, WHITE AND BLACK, AND THEIR TRADITIONAL ARTS

Many Arizonans have strong roots in the southeastern part of the United States. This has come about in several ways. One of the great immigration patterns into our state traditionally led from the South, by way of Texas. Much of southern Arizona's black population originated in Texas, Oklahoma, and Arkansas. In addition, there has been a sort of two-stage immigration into Arizona from the upland South. Many mountain folk moved north in the 1930s and 1940s, seeking work in the great industrial centers like Detroit, Michigan. In recent years some of these people have retired and moved once more, this time to southern Arizona. Southern culture has given birth to some

of our country's strongest living regional folk-art traditions. One of those traditions that has been transplanted successfully in southern Arizona is Bluegrass music.

Bluegrass Music and More

Bluegrass is a modernized form of southern mountain music. This still holds true today, even though the style has moved far beyond the communities from which Bluegrass musicians and audiences originally came. Developed to a great extent by the enormously influential Bill Monroe and his band, the Blue Grass Boys, the music provided for many rural southerners a bridge between the culture of their home and youth and the changing world of the postwar years. Bluegrass has always looked back to the older styles of southern folk music: it mostly avoids electric instruments (and is based on the two most important instruments of the rural South—the fiddle and the five-stringed banjo), and it makes use of tunes, songs, and themes from the old Anglo-Celtic-American traditions. At the same time it has always looked forward. The instruments, while they are acoustic and traditional in form, are played in innovative ways that would surprise most mountain musicians of the 1930s. The old tunes and songs are updated and a lot of material is added from mainstream country and rock music. Beginning in the 1960s, the audience for (and performers of) Bluegrass expanded to include many younger, suburban-raised, college-educated Americans from all over the country. The music changed to suit the interests and cultural perspectives of the new fans. Today's Bluegrass has many substyles, ranging from "traditional Bluegrass" to "newgrass" and "jazzgrass," but the instruments —fiddle, banjo, guitar, mandolin, Dobro or unamplified steel guitar, and bass—have remained the same, as have many of the elements of complexity and virtuosity that first drew audiences to the genre.

I have already mentioned the fiddle and its importance in Mexican, O'odham, and Yaqui music as well as in old-time Anglo-American dance music. It is the "king" of the traditional dance instruments that were brought to America from western Europe and is still an important voice in many kinds of traditional music. Bluegrass fiddling differs in several important ways from old-time fiddling. For one thing, it tends to be faster. One writer described it as "fast, furious and clean." It has borrowed many musical ideas from the blues, that great

Afro-American contribution to twentieth-century American music. It also embodies a good deal of the Texas contest style. The five-string banjo is a traditional American instrument that seems to have had its origins in West Africa. Moving into the world of white America in the nineteenth century via the minstrel stage, it became a popular folk instrument for southern whites. Most southern string bands up into the 1930s included banjos. During the decade after 1935, however, the banjo lost popularity until a young North Carolina musician named Earl Scruggs started recording with the Blue Grass Boys in the mid-forties. Scruggs had developed a syncopated picking pattern, or "roll," using the thumb and two fingers of his right hand, which allowed him to play intricate melodies at high speed without sacrificing rhythmic drive. This, along with special techniques for providing "backup" for another solo instrument or lead singer, led to the revival of the banjo as a popular instrument among southern country musicians.

The mandolin came into southern music in the early years of this century and until the 1930s was played mostly in tremolo style as an accompaniment for sentimental songs or as a ragtime melody instrument. Bill Monroe added speed, a bluesy quality, and precise timing to turn it into one of the important Bluegrass lead instruments. The acoustic guitar, as well, has taken over lead duties while simultaneously remaining an important rhythm instrument. Occasionally, the Dobro, or unamplified steel guitar, adds its special wailing tone to the music. Finally, the Bluegrass sound is filled out by the addition of an acoustic or electric string bass.

These instruments are combined in a special way. In the first place, each of the instruments except the string bass can do solo as well as ensemble work. Bluegrass musicians trade "breaks," or short solos, in a manner much like Dixieland jazz musicians. Timing, precision, and drive are vital to the style. Solo and harmony vocals are frequently high pitched and sung with great force and intensity. Veteran folk music collector Alan Lomax once called Bluegrass "folk music in overdrive," and that image does a good job of conveying the major differences between Bluegrass and the older styles of southern string and vocal music from which it is partially descended.

Bluegrass is not native to southern Arizona, of course. A few local Bluegrass musicians are southerners who have brought the music with them as a part of their cultural heritage. But the majority of 'grassers are younger, suburban musicians who play the more eclec-

tic, contemporary forms of the music. Living in the Southwest, many of these players have been exposed to our own regional styles. It is not uncommon, for instance, to hear a local Bluegrass band play the Bob Wills classic "San Antonio Rose" or some other hot swing tune. Summerdog, a popular Tucson-based Bluegrass band of the 1970s, even incorporated older Mexican songs like "Quiero Que Sepas" or "Adelita" into its repertoire along with swing and jazz tunes from Bob Wills and Duke Ellington, pop songs, original compositions by band members, Bluegrass standards, and even a few traditional southern songs from the family repertoire of one of the band members. By the same token, a few Bluegrass songs and tunes have spread into the repertoires of other regional musicians. The fiddle showpiece, "Orange Blossom Special," is played by local western fiddlers and even mariachis in response to audience demand. In fact, the entire local Bluegrass scene is simply another facet of the fascinating cultural blend that makes southern Arizona such an exciting place to live.

Bluegrass in southern Arizona has another special characteristic. In the South, Bluegrass was, and is, strictly listening music. The strong regional religious bias against couple dancing doubtless had a lot to do with that fact. And it was not really suitable for the older kinds of solo step dancing either. For one thing, the fiddle tunes were speeded up to increase their excitement and entertainment value. This spelled trouble for old-time step dancers. As one older musician put it in the early days of the Bluegrass style, the music was so fast that "it would take a three-legged man to dance to it." Neither is Bluegrass, with its emphasis on solos and virtuosity, suitable for square dancing. Dance sets go on for a long time, and what both caller and dancers really need is a steady, unvaried rhythm without too many distracting changes in the overall sound. For all these reasons Bluegrass is concert music, not only on its home turf but in the rest of the country as well.

But not in southern Arizona. This has always been dancing country, and Bluegrass in our region seems to be primarily dance music. At about the time that the style was coming into the area, in the 1960s, we were experiencing a surge of interest in couple dancing among young adults. Country rock bands were playing in dance halls and couples were evolving the "western swing" dance style I mentioned in the previous chapter. This style makes it easy to dance to the faster-paced Bluegrass tunes. And so to hear 'grass in Tucson, one

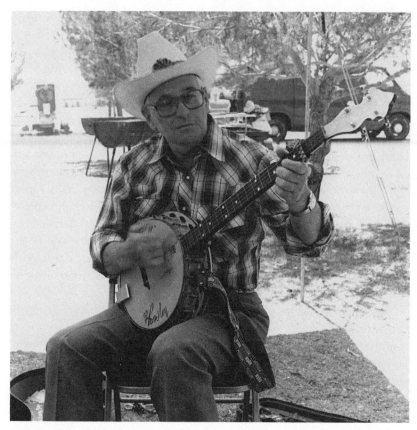

Mountain music in Arizona. The late Bill Hensley, a banjo player and ballad singer from West Virginia, plays in the shade at a local fiddle contest, May 1983. Many traditional musicians who attend fiddle contests do not perform on stage, but prefer to go to jam on the outskirts of the events. Mr. Hensley, who learned to play from his father, appeared in concert at the University of Arizona and in several editions of Tucson Meet Yourself before his untimely death in 1985.

often has to go someplace that features a dance floor. I have even been told that Bluegrass concerts are no fun to attend "because that music is made for dancing"—a comment that would be unthinkable in the South where Bluegrass was born. So Bluegrass music has changed to fit into this new region, and in the process it has had its effect on local culture as well.

Not all the southern traditional musicians in our region identify with the postwar Bluegrass style. There have always been southerners in the area, and some of them are carriers of older musical

traditions. Ballad singers, banjo players, fiddlers, and guitarists have brought their older, family-based musical traditions with them to their new home. Most of these people have little visibility outside their own families and, perhaps, the archival tapes at the University of Arizona's Folklore Center. But every now and then such a musician will appear in public, playing in a dance band, or participating in a fiddle contest, in a concert of older musical styles, or in a festival such as Tucson Meet Yourself. Church is another semipublic setting where such musicians can be found, especially in the more conservative denominations. Baptist churches and Churches of Christ often feature singing in traditional southern styles.

The Church of Christ in particular has maintained many of the religious singing traditions that were important in the rural South of the past 150 years. Because Church of Christ members try to follow as closely as possible the example of the early Christian church as set forth in the New Testament, they do not use musical instruments in worship, although they feel that songs of praise and inspiration should play an important part in church life. Thus their singing is all done a cappella.

There is a long-standing tradition of American Protestant a cappella singing, usually involving four-part harmony or occasional counterpoint. In the nineteenth century, when religious revivals were sweeping the country in regular succession, various kinds of musical notation were devised for the easier teaching of harmony singing from written music. This was simply another face of the importance of innovation and entrepreneurship in nineteenth-century American culture—the same inventiveness and desire to perceive and heed the call of opportunity that played such an important role in the settling and development of our nation during that period of our history. One of the most popular devices was to use not only the position but also the shape of the note on the musical staff to represent a particular tone. "Shape-note hymnals," as they were called, were printed using at first four, and later up to seven, distinct shapes, each of which stood for a specific relative tone within the chosen key. Itinerant music teachers, using these songbooks, were common all over the rural South right up to the time of the Second World War. Although the more archaic shape-note singing traditions such as the Sacred Harp singing conventions never seem to have taken hold in the Southwest, hymnals and Gospel songbooks using this form of musical notation have long

been used by more conservative denominations such as the Church of Christ, as well as by individuals and groups with a strong rural southern heritage.

In a typical Church of Christ Wednesday evening song service, group singing alternates with prayers, scripture reading, and a sermon. A leader will be selected for a particular hymn, the hymn number will be announced, and a pitch given on a pitch pipe. The whole congregation then simply commences singing together in parts. Followers of this tradition do not hold with choirs to do the job that in their belief is the responsibility of every worshiper—praising God through song. While the singers do sing from printed words and music, it often happens that the tradition of a particular individual, family, or congregation will dictate certain unconscious changes in the music as it is actually performed. As Church of Christ members move into a more affluent, mainstream culture, they often abandon the intense, nasal vocal style of the traditional rural white southern singer for the more rounded tones common to American popular and semiclassic music. But no matter what the particular vocal style, the Church of Christ, along with other groups and denominations who preserve unaccompanied shape-note singing within their churches, maintains an important link with our nineteenth-century American heritage.

Solo, duet, and quartet Gospel groups may also be associated with many conservative Protestant churches, many of which stage special Sunday evening concerts. Tucson's Poling Family provides an excellent example of a group that has long been involved in this sort of event. Orris and Ruth Poling were both singers when they met in the 1930s in their native West Virginia. They got married and started singing duets in public, specializing at first in the traditional sentimental and sacred songs with which each had grown up. Their instrumental accompaniment was a slide-style guitar played by Orris to provide rhythm. They moved to Charleston, West Virginia, in 1940 and started performing live over local radio stations. Orris Poling was a carpenter by trade, and music was always a supplementary activity in his and his family's lives, albeit an important and fulfilling one. As the children grew older, the group changed to a trio and eventually numbered six. Although they originally sang a mixture of sacred and secular material, by the early 1950s they were limiting themselves strictly to religious songs. In addition to radio work, the Poling

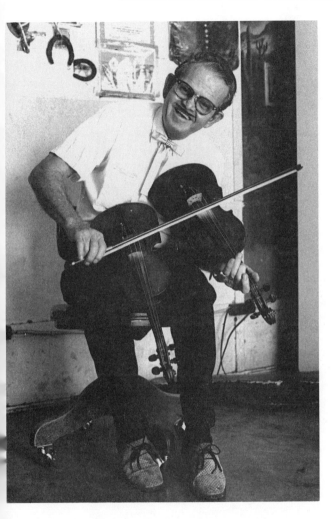

Old-time mountain entertainment. The late V. W. Hamby, better known as Wild Horse Shorty, demonstrating how he used to play two fiddles simultaneously. The tune he played was "Golden Slippers," an old minstrel-show standard. This 1978 photograph was taken in the vestibule of his refrigerator repair shop in Tucson; note the decorative horseshoes on the wall behind him.

Family, as they called themselves, appeared at local churches and concert halls, and even cut a record. In 1954 the Polings moved west to Indiana. As the children got older, the group grew smaller again. By 1968, all four children had settled in Tucson, and they formed a Gospel quartet. Their parents moved here as well, and for a while one could hear the Poling Quartet augmented by special appearances of Mom and Dad Poling. By the mid-seventies, however, the children had moved again and Orris and Ruth were once more by themselves, singing in local churches and for such secular events as Tucson Meet

Passing on a tradition. Martha, Tom, and Sharon Jennings playing old-time music in their living room in Thatcher. Sharon is the fifth generation in her family to play southern string music. Family jam sessions such as this are an important mechanism for preserving much traditional music. Since this photograph was taken in May 1980, Sharon Jennings has moved to Colorado. Her parents appear regularly at Tucson Meet Yourself, where they help put on the Sunday afternoon old-time fiddle workshops.

Yourself. In Orris's words, "We do not sing rock-type songs; just the old-time songs that bring back memories and bless people's souls."

This pattern of intense early music making followed by semiretirement, a move to southern Arizona, and complete or partial renewal of musical activity seems to be a common one for southerners living in our region. Often passionately attached to their music and to the values it represents, these men and women have added greatly to the local musical scene, and many have succeeded in passing on their tunes and techniques to younger local musicians. The late Leslie

Keith, for instance, was born in Virginia and grew up in Alabama. He gained considerable regional fame as a fiddler just before World War II and is credited as the composer of the popular Bluegrass instrumental, "Black Mountain Blues." His wartime service was spent to a great extent entertaining the troops in North Africa. Returning to the Southeast after the war, he toured and recorded with such outstanding groups as the Blue Sky Boys and the Stanley Brothers. He left the music business in the 1950s and moved to southern California, eventually retiring in Tucson. In the last years of his life he became a well-known and loved local figure, forming his own band and sitting in with several others on a regular basis. He willingly taught his songs, fiddle tunes, and hard-driving banjo style to younger musicians and brought his special brand of old-time showmanship and humor to concerts and festivals. He died in 1979, mourned by many. Such older southern traditional musicians as the Polings and Les Keith have added greatly to our local music scene.

One of the important roles played by many of these older musicians has been that of teacher. In the world of folk and popular music, musicians tend to learn from each other by ear and by watching and talking rather than by sheet music and formal instruction. Even though the gaps between cultures are often wide, younger, suburban musicians can and do learn from their older, rural counterparts. The benefits go both ways, and the music itself stays alive, although changed as a result of its move from one community to another.

Black Music

Blacks have lived in southern Arizona since the 1860s. In the early days they worked as cowboys, miners, prospectors, barbers, blacksmiths, domestic servants, and restaurant owners. The all-black Ninth and Tenth U.S. Cavalry—the famed Buffalo Soldiers—had their headquarters at Fort Huachuca, which remained the home of all-black detachments until the U.S. Army was desegregated following the Second World War. Many of southern Arizona's older black families are descended from military personnel. However they arrived, blacks became a part of our region and have made their mark on its history. The best-known and most accessible of their traditional arts is music.

Afro-American music has for more than a century been one of the

great wells of inspiration for American popular and classical music. The minstrel stage, ragtime, jazz, the blues, rock'n'roll—all attest to the strength and vitality of this rich artistic tradition. It is not easy to come up with a set of neatly drawn characteristics that define Afro-American music. Rhythm and subtle variations on the tone of rhythm instruments are vital, as is the whole notion of rhythmic and melodic improvisation. The text often seems of secondary importance, and the same short text may be repeated over and over while the singer is "playing around with" melody and rhythm. The melodies can be broken into short, repeated phrases which jazz musicians call "riffs." The call-and-response form, in which the leader sings against the repeated responses of a chorus of voices or instruments, is a basic Afro-American concept. Often the two parts can overlap to a remarkable degree, resulting in a kind of polyphony. The tone of the voices or instruments can vary wildly in the same performance, from very sweet to a rough, "dirty" growl. Afro-American musical performances integrate costume and body movement into a complex and often dazzling whole. Hand clapping and foot patting are many times important parts of the performance. Finally, the lines between performers and audience are often flexible, with the audience responding vocally to what the performers are doing, and the performers including that response in their artistic calculations.

Afro-American religious music abounds in southern Arizona within the context of the black church. The music ranges from the conservative to the contemporary, but all share the black stylistic elements outlined in the previous paragraph. One well-known church singing group is the Special Choir of the New Hope Baptist Church of Casa Grande, whose members have been featured guests at Tucson Meet Yourself for many years. One of their favorite pieces in these performances is "The Battle Hymn of the Republic." A typical performance of this song starts quite slowly as soloist Laura Flemons sings the first verse. The others join in on the chorus, and the rhythm starts to swing a little, assisted by Rose Johnson's rolling piano accompaniment. On the second verse, "In the beauty of the lilies . . . ," Ms. Flemmons takes her voice from a sweet, full tone to a harsh, throaty growl and back again in the space of a single line, adding to the emotional intensity of the performance. By the second chorus, one or two of the women are clapping and one can hear the word "Glory!" interjected between phrases of the song. The second verse

is repeated once more, and an even more intense, exciting chorus follows. The final chorus is suddenly quiet again until the final line, which rises to a crashing finale. If this is to be the last song of the performance, Ms. Johnson keeps playing the piano and the women, still singing, march slowly offstage. By this time, the audience is on its feet clapping and shouting.

Exciting though such a performance is, it pales before the total experience of a traditional black church service. And some of the loveliest Afro-American musical traditions simply are not suitable to present in a staged, secular context. One of these involves the old "Dr. Watts" hymns. In some churches, the time period before the service actually starts is taken up with a special kind of call-and-response singing which is a holdover from the early nineteenth century when congregations, both black and white, lacked an adequate supply of hymnals. A leader will quickly chant or "line out" the first line of a hymn. The congregation will respond, singing the words slowly, syllable by syllable, to a well-known tune. The leader will line out the next phrase, and so on. The hymns sung in this way are often the oldest known to the congregation, frequently from the pens of such well-known eighteenth-century composers as Dr. Isaac Watts. This style of lining out hymns, lovingly maintained in many black congregations, and in some white ones as well, provides us with an important link to our earliest days as a nation, while offering moments of great beauty and intensity.

Many black churches belong to singing convention groups and will visit back and forth for Sunday afternoon "sings." These take place inside the church and feature the singing of all the choirs as well as of soloists, quartets, and other groups who are present. Prayers and a sermon are also featured. Afro-American sermons and public prayers are themselves forms of folk art, often blending superb traditional oratory with vocal responses from the congregation. This instant feedback on the part of the congregation turns a sermon into a communal creative event and can become a kind of music as well, with the preacher breaking into a chant and members of the congregation providing both background and punctuation.

These religious folk arts of prayer, preaching, and music making are hard to find outside of their own sacred contexts. Many ministers are reluctant to participate with their congregations in events which mix the secular and the sacred, feeling that a Christian's commit-

ment must be uncompromisingly to the godly life, and realizing the strength of the temptations posed by the secular world. Occasionally, a black culture program at the University of Arizona, Pima College, or elsewhere will include a Gospel sing—always an artistically rewarding event to attend. Tucson Meet Yourself features one or two traditional Afro-American singing groups on its Sunday afternoon program, and choirs frequently participate in the annual Juneteenth festival, which I will describe a little farther into the chapter.

In contrast to the religious music, there is not much older black secular music in southern Arizona. Bluesmen would occasionally come through in the old days, but they apparently kept on going to California. I have heard rumors of older blues musicians having been in Tucson, but have never been able to follow them up. Tucson's blues scene was galvanized by the arrival in 1986 of Sam Taylor, a bluesman of great skill and experience. Taylor has gathered about him a number of younger musicians, white for the most part, and appears frequently in local clubs with one or another back-up group. Jazz and soul are strong in Tucson, but are somewhat outside the scope of this book. The following short sketches of two black musicians should serve to give an idea of some of our local resources.

Abner Jay is a street musician, a one-man band. He appears in Tucson from time to time, playing for contributions at places such as the Tanque Verde Swap Meet. He backs his car up to one of the aisles of the informal, open-air marketplace, sets up his mikes and speakers, and sings to passersby while accompanying himself on a six-stringed banjo-guitar, a harmonica on a rack, and a bass drum with a foot pedal. He also plays "the bones"—a pair of beef-rib bones which are held in one hand and clacked together. An ass's jawbone with slightly loose teeth often hangs from his microphone stand. Both of these are traditional Afro-American percussion instruments.

He does not play blues, preferring Stephen Foster type southern melodies and religious songs. In typical Afro-American style he sings over a repeated melodic "riff" on his banjo. In addition to his musical skills, Jay is a fine traditional showman with a wide range of repartee and "street rap" with which he beguiles his mostly white audiences and persuades them to part with their money. When I last saw him, he had several self-produced LPs for sale. One of these featured a wonderful monologue with musical accompaniment about mules as well as items from his standard stock of sentimental songs. Jay

One-man band Abner Jay performing at the Tanque Verde Swap Meet, November 1979. Mr. Jay and his skills are described in the text. The many signs surrounding him are yet another part of his traditional street act.

came to Tucson by way of White Springs, Florida, where he used to set up and play outside the gate of the Stephen Foster Visitors Center. An excellent talker and competent musician, he has carried his traditions of southern black music, speech, and showmanship into southern Arizona.

Willie Walker was born and raised in western Louisiana and east Texas and remembered fondly the accordion serenades he heard in his youth. As a boy he took up the mandolin. In the 1920s, the railroad his father worked for transferred him from Marshall, Texas, to Chicago, and young Willie went along. He arrived in Chicago in time to hear such jazz greats as King Oliver and Louis Armstrong perform in the speakeasies and nightclubs of the south side, and immediately fell under the spell of jazz. He traded his mandolin for a tenor banjo and spent much of the remainder of his life—he died in Tucson in the late 1970s—as a dance-band musician, playing and singing jazz and swing throughout the Southwest. His tenor banjo-playing had a magnifi-

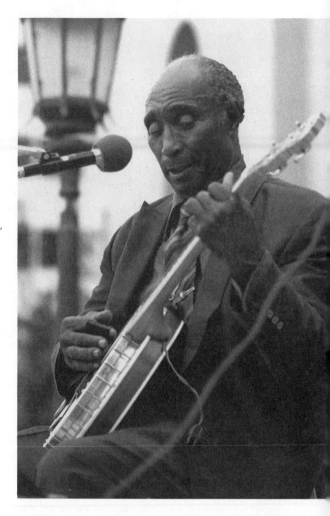

The late Willie Walker playing
tenor banjo at Tucson Meet
Yourself, October 1974. While
Abner Jay dresses in overalls
as a part of his public image
of a country black musician,
Mr. Walker always wore a suit
and tie to perform. Although it
is not visible in this photograph,
the neck and peghead of his
banjo were decorated (by
him) with inset rhinestones
of many colors. The electric
cord dangling from the banjo
activated a flashing light inside
the instrument. *Gary Tenen
photograph, courtesy of the
Southwest Folklore Center.*

cently raggy, syncopated quality as he would accompany himself on
such prewar classics as "Bye-bye Blues," "I Get the Blues When It
Rains," and "Just Because," often joined in harmony by his wife. He
also had a high regard for Bob Wills's music. Willie Walker appeared
in several of the early editions of Tucson Meet Yourself and appears
on one cut of the festival's LP, "Hot Times in Tucson."

Neither of these fine musicians and showmen fits into the Anglo
stereotype of black secular folk music. Stephen Foster and Bob Wills
are just not what most whites have been conditioned to expect from
traditional black musicians. But the style of each one is solidly within
the Afro-American tradition, as I have outlined it above. Doubtless

there have been and still are others like them in our region playing within the context of their own communities. I would certainly like to hear their music.

For the widest conceivable range of black music in Tucson, one should attend Juneteenth, our most intense celebration of black culture. It is held each year in mid-June at Vista del Pueblo Park on the city's southwest side, just south of A Mountain. The precise origins of Juneteenth are lost, but one tradition is that it commemorates the day —June 19—on which news of emancipation reached east Texas blacks. It has long been an important black holiday in Texas, Oklahoma, and Arkansas—states, incidentally, from which many of southern Arizona's blacks emigrated. Sporadically celebrated for several years in the 1970s, it is now a regularly recurring part of Tucson's outdoor festival cycle and provides an opportunity to share in many aspects of traditional black-American culture. Barbecue, hot links, ribs, sweet potato pie, and peach cobbler all make their welcome appearance in food booths. Both secular and sacred music are featured at different times during the weekend. Black theater and black artists appear as well, and it all makes Juneteenth an exciting setting in which to experience black culture and history in southern Arizona.

An increasing number of Africans live in Tucson; I know at least one musician from Zaire who makes his home here. Interest in the cultures of Africa has long been an important force in American black culture, and there are southern Arizonans who prepare African food, perform adaptations of African dances, or create visual arts inspired by those of Africa. For example, Morris Doty of Tucson was one of the founders of the local Juneteenth celebration. He worked as a landscaper and yardman in the late 1970s and early 1980s. Much of his work involved hauling palm fronds to the dump. As he explained it, he felt that something could be done with all that wood he was throwing away, and he began to whittle masks from the pithy palm stalks. These he used to decorate his house, and occasionally he sold a few at Juneteenth. Doty's masks, adapted from illustrations in books and magazines and filtered through his own creative sense, have a strong West African feel to them. They are also powerful and moving works of art.

Another strong current of black music comes into southern Arizona by way of the Caribbean. Black-Caribbean music has retained important African characteristics and has influenced a good deal of jazz. Although occasional salsa and reggae bands form and play in

Tucson, the most readily accessible kind of Afro-Caribbean music in our region is what one hears in the drum jams in many of our public parks. On a Sunday afternoon, one may find anywhere from two to five or six musicians sitting together in Reid Park, for instance, beating out complex rhythms on congas, bongos, and other percussion instruments. These jams, which can last several hours, are at the same time practices, performances, and learning sessions, and they provide the way by which this particular musical tradition is spread within its community, one which includes both black and white musicians. Occasionally, a drummer will chant some words, or a pipe or other instrument will play some melody, but this is by and large percussion music.

TRADITIONS FROM EUROPE

Many immigrants in southern Arizona come directly or indirectly from Europe. This is nothing new. Many of the soldiers who founded the Presidio of Tucson in 1775 were born in Spain; their commander, Hugo Oconor, was an Irishman in the service of the Spanish crown. Irish workers were common on the railroads of the late nineteenth and early twentieth centuries, and Serbs, Croats, and Montenegrins worked in the mines of Bisbee as well as in Globe, Miami, and Superior to the north. Since the Second World War, Americans of European ethnicity have played an important part in our Sunbelt population explosion. Some of these recent arrivals are from families who have been in the United States for generations; others were born in Europe and themselves moved to the New World. Their reasons for coming to Arizona reflect those of everyone else: retirement in a warm climate, business or employment opportunities, or the desire to join family members already in the area. But for whatever reasons they have come, they add a special dimension to our community.

NORWEGIANS ON THE DESERT

Many of Tucson's Norwegians belong to the local chapter of the Norsemen's Federation, one of the two national organizations of Norwegian Americans. The other, the Sons of Norway, is in the process of forming a Tucson chapter. The Norsemen's Federation meets on

a regular basis throughout the year for picnics, potlucks, concerts, films, and lectures on Norway and other matters of interest to Norwegian Americans. In October the federation participates in Tucson Meet Yourself, and each December members join with other Scandinavian Americans for the annual Yulefest. This is an outdoor, social get-together which features a wide variety of traditional Scandinavian activities. There are handmade crafts for sale, live and recorded Norwegian music, social and exhibition dancing, and Scandinavian food in great quantity. For the first several years of its existence, the Yulefest was held in one or another backyard and more or less restricted to the Scandinavian community. In 1986 the event took place in and around a local Scandinavian imports store and was advertised throughout Tucson. This trend will probably continue.

One famous Norwegian dish does not appear at the Yulefests: lutefisk. Made of dried, lye-cured codfish, lutefisk has become a sort of humorous, deprecatory symbol of ethnic identity for many Norwegians. Almost all of them have eaten it; I have met only one Norwegian who claims to like it. Lutefisk jokes abound, and I have even seen a large campaign button that proclaims LEGALIZE LUTEFISK! For older Norwegian Americans it was an important food; for more recent generations it has become a unifying, in-group joke.

The Norsemen's Federation sponsors the Leikarring Dancers, a group of Norwegian Americans who specialize in doing choreographed versions of traditional Norwegian dances at public gatherings. *Leikarring* literally means "ring play," but is a word commonly applied to all sorts of Norwegian folk dancing. The organizer of the group, who supplies the knowledge of the dances, the recorded music, and much of the enthusiasm, is a local Norwegian-American woman who has long been a square-dance and folk-dance enthusiast. Members of the group vary in age from the late teens to the late sixties. The Leikarring Dancers came into existence in 1975, along with the Tucson chapter of the Norsemen's Federation. They have been part of Tucson Meet Yourself ever since, and they appear at other community events as well. In 1985 the group was invited to participate in the prestigious annual Nordicfest in Decorah, Iowa, which is attended by Norwegian Americans from all over the country. The dances performed by the Leikarring Dancers include complex polkas and schottisches as well as exhibition numbers such as the oxen dance in which two men stage a mock fight in time to the music. The dances are mostly learned from written sources and are performed to recorded music.

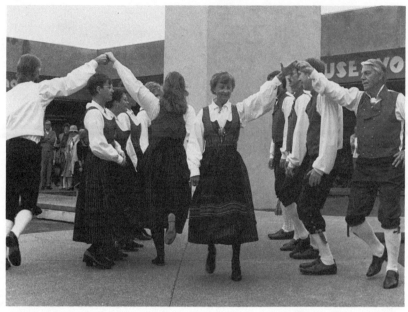

The Leikarring Dancers performing at the 1986 Yulefest on Copenhagen Square, Tucson. This highly popular local Norwegian folklorico group has performed by invitation in the annual Nordicfest in Decorah, Iowa.

Tucson has its share of Norwegian musicians as well, although they do not play for the exhibition dances. Don Johnson represents the third generation of old-time fiddlers in his family. His grandfather came from Norway, and several of his waltzes and schottisches are still in the family. This is not the music Don usually plays in public, however. He is the regular fiddler with two of Tucson's Bluegrass bands and a country-western dance band, and he has competed in local and regional fiddle contests, playing a "hot" western style. It is only at such occasions as Tucson Meet Yourself that he is encouraged to trot out his grandfather's old tunes like "Johann Persnippen" and "Life in the Finnish Woods."

"The Happy Scandinavians" is a local band consisting of fiddle, accordion, guitar, and drums. They developed out of a regular jam session involving local Norwegian-American musicians. Now they play at festivals, dances, and any other occasions that ask for them. Like so many local ethnic musicians, they do not limit themselves to one kind of music, but have a repertoire that includes western swing

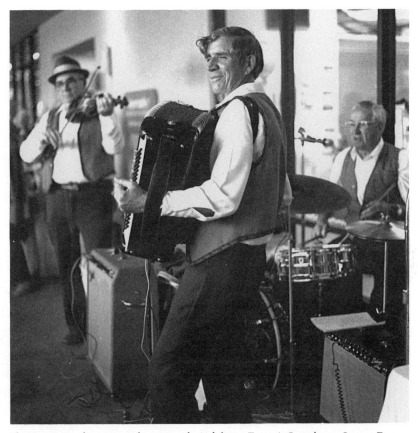

The Happy Scandinavians performing at the Yulefest at Tucson's Copenhagen Square, December 1986. The musicians are, from left, Marshall Flasher, fiddle; Leon Fausher, accordion; and Mike Klekovic, drums.

and country standards in addition to the Scandinavian waltzes and polkas that make up their specialty. Their rendition of the Bob Wills standard "San Antonio Rose" has a wonderful Scandinavian flavor!

At least two other traditional Norwegian art forms are practiced in the Tucson area. Hardanger embroidery is a form of textile handicraft in which an open pattern is made in the cloth, not by building up stitches as is done with lace and crocheting, but by removing stitches from a section of cloth. The stitches must be carefully counted and tied off, and the work requires excellent eyesight and great patience and dexterity. Mexican Americans know this craft as deshilado; to English speakers it is "drawnwork." There are at least two Tucson

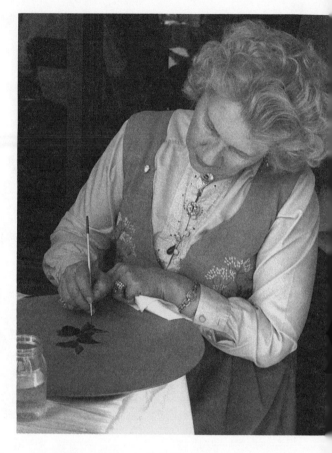

Evelyn Sebree demonstrating Norwegian rosemaling at a Scandinavian gathering in Tucson, March 1987.

women—a mother and her daughter—who regularly demonstrate Hardanger embroidery at Tucson Meet Yourself.

Rosemaling (flower painting) is the traditional Norwegian art of painting designs on a wooden surface. Flowers are the most common motifs, although landscapes, human and animal figures, and geometric patterns are also used. The wooden objects that are so decorated are household items of everyday use such as plates, bowls, ladles, bread and cheese boxes, and even chests, trunks, and clocks.

The heyday of Norwegian rosemaling was in the eighteenth century, when several regional styles developed in Norway and when entire room interiors were often covered with painted designs. Like so many domestic folk arts and skills, rosemaling fell into disuse in the aftermath of the Industrial Revolution when mass-produced uten-

sils became readily available and rural communities could no longer support the itinerant craftsmen who did most of the work. By 1900, rosemaling appeared a thing of the past.

However, urban, educated people all over Europe and the United States were beginning to find new values in many of the older handicrafts and rural art forms. Rosemaling was revived in the present century by a handful of such artists working in both Norway and the United States. Important on this side of the Atlantic was Per Lysne, who worked and taught extensively in the 1940s and 1950s. Heirloom trunks, bowls, and other objects were seen with new eyes and became models for a new generation of artists. Several of the earlier Norwegian regional styles of painting were studied and revived. There are now rosemalers all over Norway and the United States who produce objects of great beauty. One change has been in the sex of the artists. From most accounts, the early painters were men; most American rosemalers I have heard of are women. There are several active rosemalers currently working and teaching in the Tucson area.

UKRAINIAN AMERICANS

About seven hundred people in the Tucson area have their cultural roots in the Ukraine—that vast wheat- and oil-producing region just to the north of the Black Sea in what is now the southwest corner of the Union of Soviet Socialist Republics. This land, whose natural resources have been fought over by its powerful neighbors for hundreds of years, has sent constant streams of immigrants to the New World for well over a century. Whether they were fleeing the upheavals of the last century or the postwar Russian domination of the Ukraine, and whether they settled in the United States or Canada, they brought with them many of their artistic traditions to be carefully preserved and nurtured in their new homes.

The most famous living form of Ukrainian folk art is the *pysanka*, or Ukrainian Easter egg. Several local families make these elaborately decorated eggs each year during Lent, and the custom has received quite a bit of media publicity. Scarcely a year goes by without a local newspaper or television station taking notice of this exacting and lovely art form. *Pysanky*—plural of the Ukrainian word pysanka meaning "to write"—are whole, raw eggs. To make a pysanka, you

draw a design on the egg with molten wax and then dip it in a dye bath of the desired color. The actual drawing is done with a tiny, funnel-like instrument called a *kistka*. If several colors are wanted, the whole process is simply repeated for each additional color. The lighter colors are applied first, then the darker ones. The final step is to melt the wax off, leaving only the colored pattern. This is traditionally done by passing the egg through the flame of a candle.

Although some Ukrainians and others make pysanky for sale, commerce has little to do with the real reason behind this traditional art form. Pysanky are created toward the end of Lent as gifts for family members and other respected individuals. A complex symbolism lies behind the eggs and gives them much of their meaning. For example, a pysanka must be made from a whole, raw egg, if it is to be given away. This is important because what is given is not simply a lovely object but a symbolic gift of life. Many Ukrainians say that even after several years there will still be chemical changes going on inside the egg, and therefore it will still have a life of its own.

The making of pysanky is anything but casual. One older woman told me that her grandmother had taught her always to pray and to wash her hands and the egg when she first sat down to work. Then and only then could she begin to create the designs. These should be carefully selected with the recipient of the pysanka in mind. For instance, a pysanka with a deer running against a dark background makes a suitable gift for an older man; young people of both sexes should get light colors and flowers. For many pysanky makers, each color and design element has several symbolic meanings which are carefully considered when the decoration scheme for a particular egg is chosen. Finally, the completed pysanky are not immediately given away, but are carried to church on Easter Sunday where they are blessed by the priest. Started and finished with prayer and created especially for the person to whom it is to be given, the pysanka in its context is the end result of an ancient and complex tradition.

Ukrainians have been decorating eggs for thousands of years—since long before Christianity arrived in their homeland. In those old pagan days, decorated eggs seem to have been symbols of the sun, signifying fertility and procreation. However, Ukrainians also tell origin stories linking pysanky with the events of the New Testament. Here is one that was told me in Tucson by Ukrainian-born pysanky maker, Mrs. Alexandra Romanenko:

On the evening of Holy Thursday, after Jesus had been tried and convicted, the Virgin Mary went to see Pontius Pilate to try to convince him to free her Son. She took Pilate a gift, as was the custom, but being a poor woman, all she could afford was a dozen eggs in a basket. When Pilate informed her that her quest was doomed to failure, she dropped the basket onto the marble floor of the palace. Instead of breaking, the eggs rolled about on the patterned floor, taking on beautiful designs and colors as they did so. Mary gathered them into the basket again and returned to the house where the eleven remaining Disciples were waiting. She told them of her failure, but showed them the colored and patterned eggs, speculating as she did so that they must represent a sign from God. She then gave an egg to each Disciple, saving the twelfth and last for herself. These eggs were the first Christian pysanky.

Ukrainians are justly proud of their pysanky. Numerous local Ukrainian-American living rooms feature prominent displays of the decorated eggs. Pysanky have become symbols of Ukrainian identity and of the survival of Ukrainian culture far from its homeland. Today's Ukraine is considered by Ukrainian Americans to be a captive nation. Pysanky, being a form of religious art, are actively discouraged in their land of origin. For many of Tucson's Ukrainian Americans, making and giving pysanky are not only social and religious acts of deep significance, but they are also ways of keeping faith with the ideal of a free and independent Ukraine.

The belief that creating a pysanka is itself an act of devotion is widespread. "Every time you make a pysanka it pushes the devil a little bit farther down" was the way one woman put it. She continued to say that if Ukrainian women ever abandon this custom, Evil will on that day be triumphant in the world. With this belief in mind, it is nice to know that many of Tucson's most enthusiastic and prolific pysanky makers are in their teens and younger. Furthermore, Ukrainian women are teaching the art form to others in the community, and for the past few years an annual exhibit and sale of pysanky has been held in the Arizona Inn just before Easter. So it seems that the future in Tucson of this particular traditional way of creating beauty is well assured.

While pysanky decorating is the most widespread and spectacular folk art of Tucson's Ukrainian-American community, it is not the only one. Stefan Tkachyk is a Ukrainian wood-carver who learned his skills, not in his native Ukraine, but in a prisoner-of-war camp

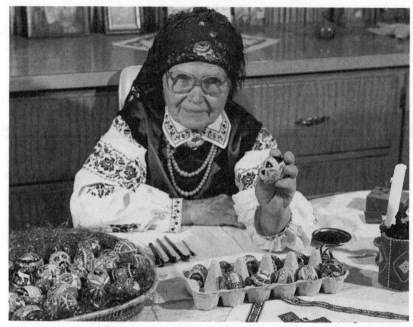

Alexandra Romanenko discussing a Ukrainian *pysanka* or Easter egg on a videotaped interview. Several of the ornate pysanky are visible in front of her. Mrs. Romanenko, who learned to make pysanky from her grandmother in the Ukraine, always dresses in traditional Ukrainian costume for her public appearances. To the right of the picture are the candle and collection of kistkas for applying the hot wax to the eggs. Photo taken in April 1982.

during World War II. Wood carving is the specialty of the Hutzels, or Ukrainian mountain folk, and Tkachyk had always admired their work and wanted to learn to do it as a boy. In prison camp the opportunity came, along with the incentive, not only to avoid boredom, but to earn a little spending money by selling handmade trinkets to his jailers. After the war he immigrated to the United States and settled in Tucson, where at this writing he is employed by a local hospital to run the power plant.

Tkachyk generally carves plates, boxes, crosses, book covers, and plaques and decorates them either with chip-carved patterns and inlaid glass beads or with incised lines which he then fills with colored paints. Some of his work he sells to friends and neighbors; much of it is given away to the hospital where he works; to a local church; or to his church organization for raffling at a fund-raiser. He has taught several younger carvers. To what extent his tradition will be carried

Ukrainian wood-carver Steve
Tkachyk working with a
pump drill in his home for
a videotaped interview. The
tools he made from bits of a
burned-out German tank while
in a prisoner-of-war camp in
Italy are on the table; one of his
finished crosses is partly visible
in the foreground. Photo taken
in February 1984.

on by a new generation remains to be seen. What is clear is that Steve
Tkachyk is a remarkable artist, working within a strictly defined folk
tradition for the satisfaction that it gives him rather than as a means
of making a living. When he has the time, he goes into his tiny work-
shop and takes out the tools he made in POW camp forty years ago.
Putting Ukrainian music on his record player, he starts to work, and
his joy in carving is combined with sadness for his lost homeland. For
Steve Tkachyk, carving wood in the old-time Ukrainian methods and
patterns is a rewarding activity through which he can keep faith with
his cultural heritage.

Many Ukrainian-American women embroider. Easter baskets
should be covered with an embroidered cloth decorated with seasonal
motifs such as crosses, flowers, and pysanky. Icons hung in the home

Anne Meyer creating Ukrainian embroidery in her home. Mrs. Meyer teaches courses locally in pysanky making and embroidery. She is wearing a Ukrainian blouse. Photo taken in February 1984.

are traditionally draped with an embroidered cloth. Cushions embroidered with Ukrainian motifs grace many homes in the area. While the designs used in the old country were often associated with particular regions or even villages, those distinctions here are breaking down, just as they are with pysanky, to form an "all-Ukrainian" style, or set of styles.

In addition to the household furnishings, many local Ukrainian women make items of traditional Ukrainian costume for use on special days. The two major local Ukrainian-American organizations are

St. Michael's Ukrainian Catholic Church and the Ukrainian American Society of Tucson. Each group holds fund-raising dinner dances, at which members often wear items of traditional Ukrainian costume. The Ukrainian American Society also sponsors the Voloshky Dancers. This group, made up for the most part of school-aged boys and girls, learns and performs formalized versions of traditional Ukrainian village dances in traditional costume as a means of perpetuating their cultural heritage and dramatizing it before the general public.

One place to see Ukrainian traditions in Tucson is at Tucson Meet Yourself; another is at one of the seasonal dinner dances sponsored by either the church or the society. Ukrainian food is served, including

Embroidery in context. A portrait of Taras Schevenko, the poet of Ukrainian nationalism, at a public gathering of Ukrainian Americans in Tucson, 1982. The picture was embroidered by a Ukrainian woman living in Australia; it has an embroidered shawl, or rushnyk, draped across it as though it were a religious icon in a Ukrainian home. A book of Schevenko's poems rests on the embroidered tablecloth.

vereneky or potato dumplings, stuffed cabbage, Ukrainian sausage, and a rich and bewildering array of dessert pastries. If the event is sponsored by the society, the Voloshky Dancers may perform. In either event, the dinner is always followed by dancing.

Tucson does not have a Ukrainian band, but it does have several professional groups who specialize in polkas and waltzes, with occasional eastern European ethnic dance tunes thrown in. At a Ukrainian dance, one or more *hopaks* will be played. These are cossack dances, complete with knee bends, leaping splits, and other acrobatic movements. Hopaks are danced for the most part by young men. Cossacks are admired in Ukrainian tradition for their independent resistance to foreign tyranny. The men's dance costumes used by such groups as the Voloshky Dancers are based on Cossack costumes with their full sleeves, baggy pants, and high boots.

The Ukrainian community in Tucson once treated me to a wonderful demonstration of dancing in its social context. The setting was an evening at Tucson Meet Yourself in the early 1980s. The last group to perform at a typical evening program is usually a local ethnic dance band, in this case the Tom Schenek quartet. (Schenek is an accordion player of Hungarian descent, and his quartet of accordion, guitar, bass, and drums regularly plays for many of Tucson's eastern European ethnic groups. The repertoire is always a base of old standards and early rock songs mixed with polkas and waltzes and the specialty dance of whatever group he is playing for. At a Hungarian function he will play some chordashes; for the Ukrainians some hopaks; and so on.) Schenek's group had been invited to wrap up the evening with a typical social dance set. They played a fast-moving, Cossack-style tune, and only one person danced. He wore a floppy felt hat and bib overalls, with a long black beard into which was braided a small bell. He had been hanging around the festival for most of the evening, drinking wine and showing off for the visitors. At this particular moment he was clowning to the music of the band, and the audience was tempted to encourage him with applause and laughter.

All of a sudden, a young man in his twenties walked out onto the dance floor. Standing quite straight, he walked up to the drunk and looked him in the eye. Then he began to dance a magnificent hopak, leaping several feet into the air and touching his toes at the same time, crouching down while flinging his legs out alternately,

all with his arms crossed. The drunk stood there watching him, and after a moment wandered off. The dancer finished his dance, and, still ramrod straight, left the floor. Schenek's band launched into another tune.

What we had seen was Ukrainian folk dance as it was used originally in village communities—as a means by which one young male established ascendancy over another. No amount of costumed, choreographed dancing I have ever seen has made the impact upon me of that one, totally unrehearsed incident. And I never saw the drunk again.

SERBS, BISBEE, AND A GUSLAR

Southern Arizona has long had a Serbian community. Serbs were one of the last great groups of unskilled laborers to leave Europe for America. They left their homeland in the Austro-Hungarian empire, now a part of Yugoslavia, in a great wave that lasted from the 1870s through the first decades of this century. In the American West, Serbs went to work in the mines—into such places as Butte, Montana, and Globe, Miami, Bisbee, and Douglas, Arizona. Bisbee, especially, once boasted a large Serbian community. The St. Stephen Nemanja Serbian Orthodox Church has been a well-known local landmark since the 1930s, and the Bisbee cemetery contains grave markers bearing inscriptions in the Cyrillic alphabet. There are even headstones displaying the old Serbian coat of arms with its two-headed eagle. Even though one still finds names like Vlahovich and Yuncovich in the Bisbee phone book, most of the town's Serbians have left. Many moved to the Phoenix area, others to Tucson and to Nevada, the latter another traditional area of Serbian settlement. Until very recently the Serbian community in Bisbee held an annual reunion celebration called "Nights in Belgrade." Serbs and others would gather from many parts of the state to feast, to enjoy music and dancing, to visit, reminisce, and "catch up" on one another.

Many of the activities were similar to those described for the Ukrainians in Tucson. There would be Serbian food, including dishes like *sarma* (stuffed cabbage), roast chicken with paprika, and *potica* (walnut bread). A Serbian-American *tamboritzan* orchestra, some-

A Serbian's last resting place in Bisbee. A double-headed eagle, symbol of Serbian (as well as Austro-Hungarian) identity, adorns the grave of a man born in the old country in 1884. Several Bisbee grave markers display this emblem; many more are inscribed in the Cyrillic alphabet. Photo taken in April 1987.

times from as far away as California, would be present, playing intricate kolos and other traditional dance melodies. Tamboritzans are musicians who play uniquely Slavic stringed instruments that look superficially like guitars, mandolins, and stringed basses, but which are actually quite different both in tone and tuning. Phoenix at this time of writing has two tamboritzan orchestras; Tucson is in the process of acquiring its first. One unique feature of most "Nights in Belgrade" celebrations was a short presentation by Dan Dusich, the *guslar* of Bisbee.

A *gusle* is a one-stringed violin native to the Balkans, a guslar a person who plays the gusle. He bows out a drone pattern on the in-

Dan Dusich, guslar of Bisbee, in his kitchen. For the occasion of this portrait Mr. Dusich has donned a traditional Serbian vest and cap. The modern gusle he holds has its neck carved in the likeness of a mountain goat.

strument while chanting long, partially memorized, partially impro-vised narrative poems about past military exploits. In the same part of the world that gave birth to the Homeric epics thousands of years back, the guslar maintains a similar tradition of heroic poetry. Gusle playing is linked with the fierce nationalism of the Serbs. The story is still told in Bisbee families of a guslar who was captured by the Turks, many years ago. As a last request, he asked that he be allowed to play his instrument and sing prior to his inevitable execution. The request was granted, and what he sang—in Serbian—was a detailed account of the strengths, weaknesses, and battle plans of the Turkish army. He was executed, but not before his hidden listeners had heard all. The next day the Turks were defeated in battle.

Dan Dusich, the guslar of Bisbee, was born in Serbia and immi-

grated to America in the 1920s. He prided himself on his strength —strength that allowed him to do grueling, demanding underground work and still be able to enjoy himself afterwards. When I visited him in the 1970s, he proudly played his gusle—an instrument he had mastered as a young man. So it was that I was able to sit in a small stone house on a hillside in Bisbee and listen to a man who was a descendant in a direct line of an ancient, eastern Mediterranean epic tradition.

WYCINANKI AND SOLIDARITY

Decorative paper cutting in Poland is called *wycinanki*, literally, "cutting paper," and was widespread as a peasant craft in the eighteenth and nineteenth centuries. In its original context wycinanki was a sort of Polish parallel to Norwegian rosemaling in the sense that the paper cuttings were often used to adorn the interior walls and ceiling beams of peasant cottages. There are several styles of wycinanki in Poland, but a basic difference between them involves whether one piece of paper is used or whether several layers of colored paper are applied one on top of the other. The paper is folded into complex patterns, cut, and unfolded to reveal the cut-out design. The basic patterns are often symmetrical arrangements of flowers or roosters facing each other. In the old days, sheep shears were used to cut the paper; now any sort of good scissors will do.

Barbara Glinski was a successful clothing designer in her native Poland. She was married to an artist and poster designer heavily involved in the now-outlawed Solidarity movement. When he fled his homeland, she accompanied him to America. Although she had learned to do wycinanki from her artist mother and had even documented regional styles as part of a government-sponsored folk-art survey, the art form was of little importance to her until she found herself in Tucson, unable to speak much English and trying to raise a young family. Sending to her mother for patterns, she started doing the paper cuttings as a means of reaffirming her cultural identity and at the same time immersing herself in an all-absorbing, relaxing activity.

She folds a sheet of heavy black paper and snips away, finally unfolding it to reveal complex, symmetrical arrangements of flowers

Barbara Glinski demonstrating traditional Polish paper cutting at Tucson Meet Yourself in 1987. Several finished cuttings behind her have the traditional theme of two roosters facing each other. The light-colored cutting to the left is done with pastel-colored paper and is Ms. Glinski's innovative response to the currently popular "Southwestern style" in interior decoration. *Photo by David Burckhalter, courtesy of the Southwest Folklore Center.*

and roosters. She then adds details by gluing on bits of colored paper, often in several layers. She has demonstrated her skills at Tucson Meet Yourself and occasionally sells her work through local outlets. In addition to wycinanki, Barbara Glinski does a Polish version of rosemaling, and designs and makes traditional Polish costumes.

OTHER EUROPEANS

These examples of European traditions that can be found in southern Arizona are intended as a sort of chart or road map into which additional information can be fitted. Many immigrant ethnic groups such as the Norsemen's Federation have formed their own social and cultural organizations in Tucson. These organizations, with

names like the Czechoslovakian American Social Club, the Serbian-American Club, and the German-American Heritage Klub serve as focal points for social activities and provide settings in which many traditional foodways and other art forms are maintained. Some, like those just named, are purely local institutions. Others, such as the Norsemen's Federation and the Sons of Italy in America, are branches of national organizations. Religious organizations such as St. Demetrios' Eastern Orthodox Church and St. Michael's Ukrainian Catholic Church also provide settings in which cultural traditions are maintained. All these organizations serve to unify immigrant ethnic communities in a region where traditional ethnic neighborhoods are almost completely lacking.

The high point of the year for most of these ethnic organizations is the annual or semi-annual dinner dance. Although the nominal purpose of such an event is often to raise funds, the event is also an important end in itself for many of the members of the groups. It provides a time for visiting, celebrating, and reaffirming one's cultural identity. Ethnic food, prepared by members of the group, is usually served at dinner. If the club or organization sponsors a dance group, it will perform. Otherwise, a semi-professional folk dance group, say the Tucson Ethnic Dance Ensemble, which presents costumed dances from a number of traditions, may be asked to provide a program. Finally, there will be a dance. A number of bands in the Tucson area, similar to the Tom Schenek group mentioned above, add an occasional ethnic dance number such as a kozotski or a chordash to their standard repertoire of waltzes, polkas, foxtrots, and rock hits of the fifties. For a really special occasion, an out-of-town group may be invited: a Greek or Serbian band from Phoenix, for instance, or perhaps a group from Los Angeles. These evenings are important times for many groups, and it is often considered worth spending the extra money.

There are also a number of southern Arizonans who, like Barbara Glinski and Dan Dusich, have maintained in their new home the special skills learned earlier in life. A weekend spent at Tucson Meet Yourself will acquaint the visitor with some of these people: Joe Soukup, for instance, a Czech accordion player from Ohio; or Knut Pedersen, who can still make fishnets the way he did when he was a young man in Denmark. They live unassumingly among us, pleased to share their special skills and knowledge when given an opportunity.

For every such individual whom I know, I suspect there are several whom I have yet to meet—hidden resources, quietly keeping faith with their respective heritages.

ASIAN IMMIGRANTS

Another group of immigrants to southern Arizona comes from Asia. There have been Chinese in southern Arizona since at least the 1870s. Earlier in this century, they owned many of the markets in Tucson and raised vegetables along the Santa Cruz River in the days when water was closer to the surface than it is now. This old, stable Chinese population has been joined by Chinese from both Taiwan and the People's Republic of China, and most recently by ethnic Chinese refugees from Southeast Asia. In addition to the Chinese, there are in Tucson Japanese, Koreans, and Filipinos. It is difficult to generalize about these immigrants, many of whom are here only temporarily as university students or as faculty members. The bulk of Tucson's East Indian community and many Japanese seem to fit into this category. Others, among them Filipinos, Japanese, and Thais, came as the brides of American men who married them overseas. Still others, including many Vietnamese, Laotians, and Cambodians, are here as refugees, fleeing the Communist-dominated countries of Southeast Asia. However they arrived, and no matter how long they stay with us, they add to the cultural life of our community.

The most obvious way in which Asians have contributed to the local cultural scene is through their traditional foodways. Chinese restaurants are the most common simply because the Chinese population in the area is larger and has been here longer than other ethnic groups. There were forty-six Chinese restaurants listed in the Yellow Pages of the 1985–1986 Tucson phone book. In addition, there were listings for Korean, Vietnamese, Japanese, Thai, and Malaysian restaurants, and for five markets specializing in Oriental foods. Chinese cooking is an ancient and complex tradition, and at its finest is one of the world's great culinary arts forms. There is no way in which it can be dealt with adequately in the limited space available here. But there are a few general comments that might prove helpful.

China is not only the home of an ancient civilization; it is a huge

country, made up of a number of specific regions. Each of these has its own climate, culture, and food products, and its own cooking styles and traditions. For instance, wheat is grown in the north; rice in the south. Wheat is, therefore, an important staple of northern cooking —not in the form of bread, as it is in Europe, but as the basis for a wide variety of noodles and dumplings. Cabbages grow in the north and are an important part of northern-style cooking, and of Korean cuisine as well, but they are not found in the south. Rice is important in most parts of China, but especially so in the south, where it also forms the basis for noodles. Finally, southern foods seem sweeter than their northern counterparts.

All these differences are reflected in the foods one finds in Tucson's Chinese restaurants. Most of the early Chinese immigrants to the United States came from the Canton region in southeastern China, and Cantonese cooking, therefore, is the basis for most American-Chinese food. Cantonese foods are frequently stir-fried or steamed. Rice is the important staple. The Cantonese tradition emphasizes bringing out the distinct, natural flavor of each ingredient in a given dish, and spices are used quite sparingly. In fact, Cantonese cooking can seem quite bland to palates accustomed to highly spiced foods, but it is also sweeter than other Chinese styles; even the sweet-and-sour sauce, which is found in many parts of China, tends toward the sweet end of the taste spectrum in the hands of Cantonese cooks.

Some very popular Chinese foods in America are not truly Chinese at all, but rather Cantonese-American. Chop suey is an example. The name seems to be an American pronunciation of a Cantonese term meaning "leftovers," or, more accurately, "bits and pieces." According to one legend, the dish had its origin when an American walked into a Chinese restaurant somewhere in the West and requested food. He did not know anything about Chinese cooking, and the restaurant staff had no idea what to serve him. So the cook combined a large number of ingredients and cooked them together in the hopes that he would like at least some of them. This, according to legend, became standard practice in serving Americans and was the forerunner of American chop suey.

Twenty years ago, most Chinese restaurants in our region served little besides Cantonese-style food. In recent years, however, Americans have become more aware of some of the regional variations of Chinese cooking, and considerable variety is now available in Tucson.

The most commonly found food styles, after Cantonese, are Szechuan and Peking, or Mandarin. Situated in southwestern China, the Szechuan region produces foods that are often highly seasoned and can taste very "hot" even to southwestern palates accustomed to Sonoran cooking. Common Szechuan dishes found in Tucson include all manner of spicy chicken, pork, and vegetable dishes. Another region of Chinese cooking is the northeast, centering on the capital city of Peking (Beijing in modern orthography). Peking Duck is the most famous of the sophisticated, elegant foods from this area. While the northeast also produces spicy foods, the seasoning tends to be more restrained and subtle than in Szechuan-style cooking.

Any restaurant depends on its chef for the style and quality of the food produced. Tucson's Chinese chefs have been known to have a very high rate of turnover. Many of the chefs currently working in the area are from Taiwan, which has been since the 1940s the home of the exiled Chinese National Government and its supporters. In other words, Chinese from Taiwan may have parents who come from widely separated regions of the Chinese mainland. Thus, regional distinctions in cooking have tended to become rather blurred. Other Chinese chefs in Tucson are from families who have lived in Southeast Asia for generations. These ethnic Chinese, as they are often called, have been coming to the United States as refugees in vast numbers and have brought with them their own experiences and tastes in food preparation. A given Szechuan dish, for example, may taste quite different when prepared by a Chinese chef from Vietnam. But these distinctions are to a great extent academic and of interest more to the gourmet or serious student of Chinese cuisine than to the casual diner. My advice to the latter is to experiment, taste, and enjoy—most of what you will find is good eating, and Tucson's Chinese restaurants draw upon an ancient culinary tradition that is constantly growing and changing.

I mentioned earlier that there were also Vietnamese, Korean, and Japanese restaurants in Tucson. Vietnamese food is a part of the same great East Asian tradition as Chinese food, but there are subtle differences. One of these—the importance of sauces and especially fish sauce—may be due to the fact that Vietnam was a French colony for so many years. Other differences are there as well, and one can have a lot of fun investigating and trying to understand them.

Korean cooking has a totally distinct set of flavors. Some of this is

due to Kim Chee—a kind of fermented pickle that appears on most Korean tables. Once again, for most of us it's a new world to explore.

Although rice is still an important staple and the use of chopsticks regulates the size of the food, Japanese cuisine offers yet another distinct method of food preparation and presentation. In the first place, fish and other seafoods are universally important, just as one would expect from an island people. Flavors tend to be the natural ones of the food: little strong spice is used, except for the wasabe or hot horseradish that appears with servings of sashimi or raw fish, another Japanese specialty. Rice is prepared so that it is sticky, combined with raw or cooked fish and with vegetables, and rolled in seaweed to produce sushi. This, too, is uniquely Japanese.

Japanese-American cuisine has developed in a way quite different from Cantonese-American cooking. While chop suey has a comfortable niche as an inexpensive dish, California-style sushi rolls with avocado and cooked crabmeat, developed to please the tastes of Americans who might not be comfortable with the idea of eating raw fish, are exquisitely prepared and presented, and are costly, like any other variety of sushi.

Japanese cooking stands apart in its appearance. The visual aspect of food preparation is important in most Asian traditions, to be sure. But great care with how a dish looks is often limited in Chinese restaurants to gourmet food, while in Japan, food of the working classes is visually presented with what can seem to a Westerner to be unusual attention. In addition, Japanese cooking often uses brilliant colors: reds, pinks and yellows, dark green, white, and black. It seems important to keep the colors separate and sharply contrasted. For many Americans, this meticulous attention to visual detail and arrangement is one of the most immediately striking characteristics of Japanese culture.

THE MARTIAL ARTS

Second to food, the martial arts provide the most visible Oriental presence in our region. Turning once again to the Tucson Yellow Pages, we find seventeen organizations listed as teaching various forms of Oriental martial arts and an additional nine companies selling martial-arts equipment and supplies. Japanese and Okinawan

karate, Chinese Gung Fu, Korean Tae Kwon Do, and Vietnamese martial arts all have their schools in Tucson. In many cases the instructors are Occidental, but the basic philosophies and disciplines have their roots in Asian traditions. Forms and styles of the martial arts from the Far East are many, both ancient and modern; some involve the use of weapons and others use only the human body. Many of the "empty-handed" martial arts were originally developed for the protection of such classes as monks and peasants, who traditionally did not carry arms.

While all the martial arts are, in fact, systems of self-defense and combat, they are much more. Each involves a set of personal disciplines and philosophical principles. Paradoxically, as a person becomes more adept at a specific martial arts discipline, fighting or self-defense often becomes less important, and he or she begins to concentrate more on the philosophical aspects of the art.

One of my friends used to tell a long, "shaggy-dog" joke in which a young Chinese archer, after many trials and vicissitudes, is finally permitted to meet the greatest archer in the world. Confronting this incredibly ancient sage in his mountaintop retreat, the aspiring archer proceeded to question him: "Is it true, O Master, that you are the Greatest Archer in the World?"

"Yes, my son," replied the old man coming out of his meditative trance. "I am indeed the greatest archer in the world."

"Then tell me, O Master, which is more important: to hold the bow correctly, or to release the arrow carefully?"

To this the sage replied, "Bow? Arrow? What are those things?"

Like so many jokes, this one contains a grain of truth beneath its preposterous exterior. The higher degrees of knowledge in many of the traditional Asiatic martial arts are indeed more concerned with meditation, philosophy, and the following of a complete and coherent "Way" than with the actual business of besting one's opponent. However, this is more apparent in Asia than in the United States. One friend explained it to me this way: When a Japanese man enrolls at a Dojo or academy to work on improving his karate skills, he has already learned the basic moves of combat in school where karate is one of the regular subjects. He is, therefore, more likely to be after discipline and control of thought and movement. When an American signs up in Tucson, however, chances are that what he or she is looking for is the opportunity to learn self-defense.

A Tucson organization notable for its adherence to many facets of the martial arts traditions is Fong's Wing Chun Gung Fu Federation. Augustine Fong, the director, is from Hong Kong and is skilled in most aspects of his tradition, including the use of traditional Chinese healing techniques. His academy is also unique locally for performing the Lion Dance. The Lion is represented as coming down out of the hills to visit the city, bringing good fortune with it. The huge head with its waggling lower jaw and rolling eyes is carried by one dancer; another supports the tail. Moving in time to the beating of a large drum and led by a masked dancer brandishing a fan, it performs a series of complex movements which require a high degree of agility and stamina from its bearers. The Lion Dance in China is a specialty of Gung Fu academies and is danced at New Year's celebrations and other occasions when the good fortune that the Lion brings with him is needed. The local Lion Dance may be seen at various public occasions and has been performed in the past at Tucson Meet Yourself.

TRADITIONAL CRAFTS, MUSIC, AND DANCE

A number of individual Tucsonans maintain skills that they brought from their Asian homelands. Some are musicians, others craftspeople and visual artists. They are best thought of as people who happen to know how to "do something" of a traditional nature. The things they "happen to know how to do" can add to the flavor of the community in which they live.

In traditional Japanese culture, just as all young men and boys are supposed to have some knowledge of the martial arts, so girls and young women should have certain aesthetic accomplishments. Called okeiko in Japanese, they include such skills as playing the koto, conducting a tea ceremony, and ikebana, or the art of flower arranging that emphasizes form and balance.

In the arranged marriages which still sometimes take place in Japan, the question is often asked: "What okeiko does the young woman have?" Contemporary okeiko also include Western skills such as playing the piano. As was the case with the martial arts, the reason for learning the okeiko has less to do with being able to perform the aesthetic activity well than with the personal grace and serenity which come from the training. Thus it is often said that Chanoyu, the traditional Japanese tea ceremony, has little to do with serving and

The Japanese Tea Ceremony being performed by Kyoko Doko at Tucson Meet Yourself, October 1982. The real purpose of this exercise is not to drink or share tea, but rather to perform a series of highly styled actions with the utmost grace and serenity. *Helga Teiwes photograph, courtesy of the Southwest Folklore Center.*

drinking tea. Rather, it provides for both guest and host a time of tranquillity and harmony in which one may bring oneself more in tune with an ideal serenity. The benefits come from the discipline involved in being able to perform relatively simple, set gestures with perfect grace—a discipline which can be applied to other aspects of

life. First brought to Japan from China by Zen Buddhist monks some-time around the twelfth century, the Way of Tea was organized and codified in the late 1500s and remains to this day an aesthetic symbol of Japanese culture.

Origami, the art of paper folding, is a traditional Japanese art form whose practice has been widely imported to America. It is said to have a history of more than one thousand years. Whether or not this is so is less important than the fact that generation after generation of Japanese children have shared this activity with their parents and grandparents. With small squares of thin, colored paper, one can do almost anything. Children and adults together can recreate scenes from folktales, make "props" with which to tell new stories, make simple room decorations, and just have a lot of fun. In typical Japanese fashion, there are acknowledged "masters" of origami, but most adults and children content themselves with creating relatively simple boats, boxes, fish, cranes, or ostriches. One particularly dramatic and more complex creation involves folding and refolding the paper many times to create a completely flat, lozenge-shaped object. At the last moment, you put your lips to one end and blow . . . and up pops a complete frog! Origami kits and instruction booklets can now be found in many children's stores, and many Japanese in southern Arizona know the art of paper folding.

Tucson's Japanese population shifts and changes. Many of the Japanese living in Tucson at any given time are connected with the university or with one of the city's hospitals for a period of just a few years. During their stay many contribute their traditional skills to our community. Thus, Tucson Meet Yourself has at one time or another featured demonstrations of the tea ceremony; origami; ike-bana; temari, the making of elaborately embroidered decorative balls out of thread; and koto playing.

Southeast Asians have been coming in increasing numbers to southern Arizona in recent years. Among them have been several Thai women who are trained and skilled in their classical dance tradi-tion—a courtly ballet which retells stories from the Hindu epic, the Ramayana, and other themes. Occasionally, a musician will be able to demonstrate a traditional instrument at Tucson Meet Yourself. A few years ago, a family of Hmong Mountain people lived here for a while and created and sold their intricate appliqué and embroidery work. Sometimes a Lao will be able to play the kaen—a kind of mouth-

blown miniature organ of bamboo which is typical of several of the cultures of Southeast Asia. Several Vietnamese men create intricate, low relief carvings in soft wood with the aid of sharp knives and jeweler's saws.

Weaving is a traditional cottage industry in Laos. Many homes have several looms, and the women spend their spare time creating lengths of cloth either for family use or for selling outside the home. When Laotians came to the United States, they brought with them the knowledge of how to set up looms. At the moment there is at least one such loom in Tucson.

Bunyang Michael has a loom in the carport of her home on Tucson's south side. She uses it in her spare time to create cloth for traditional Lao wrap-around dresses, both for herself and for the Laotian traditional dancers who occasionally appear at celebrations within their own community as well as at occasions such as Tucson Meet Yourself. Typical handwoven cloth lengths are of a single, solid color, blue or red or green being very popular, with stripes and small decorative motifs at either end. Bunyang Michael and her loom have been welcome fixtures at Tucson Meet Yourself since the early 1980s, and she adds a special dimension to that celebration.

While these people and their skills are a real part of the community, they are relatively hidden. No stores sell locally made Lao weaving or Vietnamese wood carvings. Thai dancers and Lao kaen players might perform in public, but their appearance can often have the flavor of a demonstration rather than that of a complete performance. There are some settings, however, in which ordinary Tucsonans can catch a glimpse of these art forms. The most accessible of these is Tucson Meet Yourself.

Chinese, Japanese, Laotians, Vietnamese, Thais, Cambodians, Filipinos, Sri Lankans, and Indians all participate in that annual celebration of ethnic diversity with food booths, craft demonstrations, and occasionally performances of music and dance. The Lao, Vietnamese, Filipino, and Indian communities all have exhibition dance groups. Vietnamese Kaens, Indian tablas, and Thai and Chinese stringed instruments have all been played on the main stage or in the workshops, while Vietnamese woodcarvers, Chinese calligraphers, Lao weavers, and Japanese origami artists and flower arrangers have been among the craftspeople demonstrating their traditional skills.

Other opportunities for observing traditional Asian cultures exist

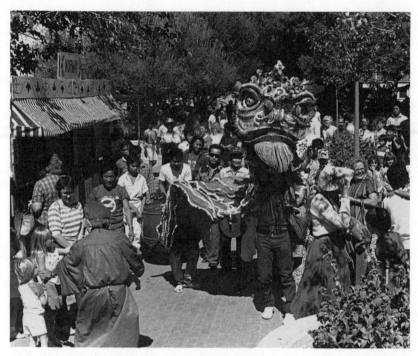

The Vietnamese Unicorn or Lion dance at Tucson Meet Yourself, October 1987. This extremely vigorous performance was cosponsored at the festival by the Tucson Vietnamese Association and the Tucson Vietnamese Buddhist Association. The drummers for the dance are visible behind the animal's body to the left; the robed figure in the foreground is the masked clown who leads the Lion. *David Burckhalter photo, courtesy of the Southwest Folklore Center.*

in southern Arizona. Several different communities hold regularly recurring celebrations to which the public is invited, and they are usually announced in the newspaper. In May 1986, for instance, Tucson's Korean Zen Buddhist temple staged its first open house, at which traditional Korean foods were served.

The Lao New Year is usually celebrated in April, and often involves a public day of festivities. Community elders pray in a blessing ceremony. Traditional foods are served and recorded music is played. The Lao dance group performs and a Miss New Year's contest is often held. The latter has less to do with American beauty pageants than one might suspect. The Lao beauty pageant is grounded in an ancient legend. Its purpose is to select a young woman to preside over the New Year's ceremonies.

Doangporn Piet in costume for a Thai dance at Tucson Meet Yourself, October 1983. *Bill Doyle photograph, courtesy of the Southwest Folklore Center.*

Another feature of New Year's celebrations in the Lao community of Tucson is a dance featuring the local Southeast Asian band, made up of Lao and Thai men. The band performs what can best be described as urban, Southeast Asian cabaret music on electric guitars and a regular set of dance drums. Mixed with regional variations of rock music, one hears melodies and rhythms that are definitely Asian, although they are performed on Western instruments.

Once a year, for the past three years, Tucson's Japanese-American community has presented a traditional fall equinox festival (Higan Matsuri) in the parking lot of a local restaurant. Although its direct inspiration is the fall festival, it also contains some elements of Obon,

the day in which the souls of the dead come back. In Japan, this day is celebrated with bonfires and food offerings, and it ends with the launching into the nearest stream of thousands of tiny boats, each one bearing its little bonfire down to the ocean, symbolic of the return of a soul to its home. In Tucson, the two festivals are combined, and the only traces of Obon are in the lanterns that decorate the festival site and in some of the dances that are performed.

The festival is really a time of celebration of Japanese cultural identity and heritage. Japanese foods are sold in various small stands, traditional dances are performed, and artists and craftspeople demonstrate their skills and offer their wares for sale. Frequently, a calligrapher is present to write names in Japanese characters. A dance group sometimes comes from as far away as Sierra Vista. Higan Matsuri, sponsored annually for the past several years by the Japan America Society of Tucson, provides us all with an opportunity for experiencing Japanese culture adapted to this desert community.

A FEW ADDITIONS

Any catalog or listing is at the mercy of its system of organization. By dealing with immigrants from the mainstream traditions of Europe and Asia, I have been able to point out certain important patterns and perhaps make the essay more readable. But in doing so, I have neglected a people and a region, each of which is very much a part of our southern Arizona scene. The people are Tucson's Jews; the region, the Middle East.

There has been a long-standing Jewish presence in southern Arizona, leaving aside the entire issue of whether or not any Mexican family traditions reflect Jewish origins. One frequently hears fascinating stories about such traditions; the following example should suffice. I was recently told that a friend of a friend had been visiting a Mexican-American Catholic family in Guadalupe, Arizona, when he noticed a seven-branched candlestick on the family altar. He asked why it was there, and the response came that it was a family custom —something they "had always done"—to light seven candles on the altar around Christmastime. The candlestick itself had been acquired by the speaker's grandfather many years before. Now the seven-branched candlestick is a Jewish ritual object called a menorah, used

particularly during Hanukkah, or the Jewish Festival of Lights, which occurs in December. The implication of this story is that the family were Marranos, or Spanish Jews who converted to Christianity in Renaissance times in order to escape persecution, but who nevertheless maintained certain Jewish traditions. Such families are known to have come to Mexico, and I have heard stories such as this one for many years.

But setting aside the question of Marranos, there have been Jews in southern Arizona for more than a century. Arriving as merchants, many stayed to found prominent local families. Tucson's oldest synagogue on South Stone Avenue has in recent years been given a historical marker, symbolizing and dramatizing this important component of our regional culture. But when one looks for public manifestations of Jewish culture on the folk or popular level, one does not find a lot. This is a family-centered tradition, with the added restraints caused by centuries of discrimination and persecution. Southern Arizona's Jewish community has made its presence felt, of course, but as supporters of high and academic culture rather than as producers of public folk expression.

There are some exceptions, of course. Temple Emanu-El on North Country Club Road has wonderful interiors filled with Jewish liturgical art by a local artist, as well as a display of heirloom ritual objects. Much of the liturgical art centers on the elaboration and formalization of certain Hebrew characters—this is a religion in which the written Word of God is of paramount importance.

Much of what is usually considered traditional Jewish folk culture in America is actually eastern European culture, carried and modified by generations of eastern European Jews. Jewish food is a case in point. There are delicatessens in Tucson, of course, but for the most part they serve a community united by enjoyment of deli food, rather than a specifically Jewish community. One exception is Feig's Kosher Foods on East Fifth Street. Here one finds an echo of the traditional Jewish neighborhood culture of the older cities, with the restaurant functions of the operation being almost incidental to the kosher food and butchering service.

There are other traces of older European-based folk culture as well. A local musician has formed a small klezhmer band that performs eastern European Jewish music at weddings, barmitzvahs and other occasions. A small Yiddish language group meets regularly to read

Yiddish literature. And occasionally in the fall of the year, one can glimpse over someone's backyard fence a decorated Succoth booth, serving as a ritual reminder of the years the Jews spent in the wilderness. Folk dance groups specializing in Israeli dance also exist from time to time, and there are several Israelis living in Tucson.

Which brings us to the neglected region—the Middle East. The University of Arizona's emphasis on arid lands agriculture has long attracted students from this other great desert region. There are at least three mosques in Tucson, serving the needs of Islamic residents. Lebanese Christian families attend a local Orthodox church. Several restaurants specialize in Middle Eastern foods. Occasionally, one finds musicians from the region performing at such public events as Tucson Meet Yourself.

One Middle Eastern art form which has recently become visible in southern Arizona is almost completely restricted to non-Middle Easterners, however. Belly dancing caught on here in the 1970s, and two belly-dancing studios are listed in the 1987 Tucson Yellow Pages. The dancers, almost without exception, however, are American women. Strict rules of female modesty in traditional Muslim society ensure that, although the art form may have been transplanted into American culture, it is as an art form, rather than as an expression of cultural continuity.

GENERAL THEMES

This is by no means a complete list of all the immigrant communities of Arizona, nor of all their art forms. The arts scene is constantly changing as people move into our area and leave again, and every year brings new "discoveries" to the producers of Tucson Meet Yourself. What has been mentioned, however, is typical of the situation, and certain patterns seem to emerge.

In the first place, many of the art forms described herein are relatively new to southern Arizona. Asian martial arts studios have sprung up in the last few years, as have most of the Chinese restaurants in town. Twenty years ago, Tucson had no Korean, Thai, or Vietnamese restaurants. I suspect that the same holds true for Ukrainian pysanky makers as well. Few of these art forms have been in this particular cultural environment long enough to have developed any

sort of local character—Tucson has made little impact even on Chinese restaurant cooking. But the arts in question have certainly made their impact on Tucson. Tucsonans are infinitely more cosmopolitan than they were when I came here thirty years ago, and much of that is due to recent immigration. Each year, it seems that a new kind of restaurant opens—a sure sign that people from a different part of the world have made Tucson their home. And as these bearers of different traditions come to southern Arizona, and as more and more people who are used to those same traditions in other parts of the country arrive here as well, the cultural face of our community is changed forever.

Some Final Thoughts

In this book I have tried to describe some of the living traditional arts of southern Arizona's folk and ethnic communities. All these arts are accessible to the interested public. They contribute much toward making our region special. Nowhere else in the world is there this precise mix of the regional and the imported; the old and the new; the survivals and the innovations.

Few of the arts are just as they were a hundred years ago. We tend to think of folk arts as survivals from an earlier time, and to an extent this is true. But if a custom does not play a meaningful role in its society, it will be changed or abandoned. As societies all over the world are changing at a rapid rate, their traditional arts change with them in order to survive. Sometimes the change involves the role they play in society. O'odham women still make baskets as they did in 1900, but those baskets, no longer made for domestic use, are fashioned for sale to an outside market. This has resulted in such new shapes as wastebaskets, coasters, and hot pads for tables. It seems to have resulted in the use of more representational patterns, including scenes such as dancing and saguaro fruit picking. The black devil's claw at the center of an old-style basket served as an insulation against the

204

hot coals used for parching grain; the centers become less important when the baskets are made to go on the wall rather than for actual use in the kitchen. The outside market for the baskets has changed as well. As baskets are sold as Indian art rather than Indian curios, their price increases and a greater emphasis is placed on fine craftsmanship. None of these changes make today's O'odham baskets any less real or authentic than those of three generations ago; they are simply being adapted to the current needs of the culture which produces them.

I have already pointed out the changes that took place in old-time fiddling as the musicians ceased to provide dance music for small communities and shifted their energies to participation in contests. Tempos slowed down; rough edges and highly individualistic styles were smoothed out. Techniques that were once common in some parts of the country, such as tuning the instrument in nonconventional ways, were discouraged or even disqualified by judges and contest organizers. In a sense the music is becoming codified, even classisized, as fiddlers from many regions compete with one another. There are now considered to exist standard, "correct" versions of many tunes. As I suggested in chapter 3, there is even a standard "contest" style with its roots in Texas. I have heard that some fiddlers' associations in Wyoming and elsewhere are trying to combat this trend by discouraging the "contest" or Texas style at competitions in their territory.

Many fiddlers are teaching young students their art, not by example as a few generations ago, but by giving formal lessons and writing out scores. Indeed, many younger fiddlers in southern Arizona have learned fiddle music, not through their own communities of birth, but through exposure to it after basic training in classical violin. Contemporary old-time fiddling is strongly rooted in Anglo-American folk tradition, and many of the tunes played today as well as the techniques used to play them have been handed down for generations. But like all aspects of human culture, it must constantly change and adapt in order to meet the needs of the communities it serves. Otherwise, old-time fiddlers would eventually share the position of guslar Dan Dusich of Bisbee and become elderly musicians who retain in their memories and fingers a skill which nobody requires.

Other art forms have moved from one culture to another, and we have discussed some of the effects on Bluegrass of such a transfer. Mariachi music seems to be making a shift from one class to another within Mexican-American society. Concert mariachi groups are to

a great extent made up of young, educated, middle-class musicians, most of whom read music. They do not have the economic need to go cascareando, placing themselves at the whim of chance-found patrons in public places. Rather, they work out polished, complex arrangements for a relatively small number of songs. The music has changed as it has moved into the concert hall, with the introduction of medleys or potpourris. Rather than sing a single corrido about a horse race, for example, many concert groups will assemble into a single medley a number of famous horse corridos, intimately known to all the Mexicanos in their audience. This approach provides variations of rhythm and melody to catch the interest of listeners who might not understand Spanish.

Rosemaling was for all intents and purposes dead before its revival in this century. Doubtless there are differences in style and appearance between the rosemaling of the 1800s and that of today; however, I suspect that those differences are not as important as the fact that everything else about the art has changed. Rosemaling used to be done by itinerant craftsmen for peasant families. It was a functional art; many of the objects decorated were used on a daily basis. The reason for painting room interiors was to cover the sooty effects of open heating and cooking fires. Contemporary rosemaling is done for the most part by women. Most of the rosemalers I know do not follow their art out of economic necessity, but for a combination of other motives. People talk about its recreational value, its aspect as a part of a specifically Norwegian cultural heritage, and the importance of "not letting it die." Contemporary rosemaling is owned, not by self-supporting peasants, but by middle-class business and professional people. And many of the objects so decorated are reserved for display rather than being used as domestic tools.

Arts change in other ways. In the Ukraine, the appearance of pysanky was to a great extent determined by where they were made. Regions, and even individual villages, had their own styles. These began to break down in the immigrant communities where Ukrainians from many districts lived close to one another and saw one another's work. Further standardization followed the publishing of pysanky instruction books. At the same time, other changes were taking place. Although pysanky made during Lent and given away at Eastertime are still raw eggs, more and more pysanky makers are removing the meat from the egg when the finished pysanka is to be displayed as an object of art. Teachers also have their students blow their eggs as a

practical matter. So now there are "secular" pysanky as well as the ritual sort.

In the old country, pysanky making was a part of traditional religious ritual and custom. In America, something more has been added. Ukrainian Americans have selected pysanky as one of several potent symbols of their ethnic identity. The decorated eggs have come to stand for both the old country and the freedom that no longer exists there. They are a reminder of the ideal of an independent Ukraine.

A good many art forms besides pysanky have been maintained or created as symbols of identity. Serbian tamboritzan music and kolo dancing, Chicano murals, and mariachi music are good examples of these. Folklórico dancing is an even more obvious identity symbol. Although the term "folclórico" most properly applies to choreographed versions of traditional, regional Mexican dances that are primarily performed for audiences, many other ethnic groups have similar institutions. (I have used the different spellings to indicate the difference between the specific Mexican "folclórico" and the generalized "folklórico.") The Leikarring Dancers and Voloshky Dancers mentioned in chapter 4 are certainly folklórico groups in this sense, as are the Desert Indian Dancers with their O'odham chelkona dance. Similar groups currently exist within Tucson's Greek, Turkish, Spanish, Armenian, black, Filipino, Vietnamese, Lao, Indian, Yugoslav, Colombian, and Chilean communities. The characteristics each shares with the others are that all are composed primarily of children or young adults and involve transmission of a specific minority cultural heritage. They perform formalized, choreographed versions of traditional village dances and dress in special costumes, and most dance to recorded, rather than live music. All are primarily performance groups, usually dancing for an audience in a more-or-less formal setting.

Why are these groups such popular vehicles for expressing ethnic heritage? Partly, I think, because they are fun to participate in and fun to watch. Partly, too, because there are opportunities for such groups to perform: in festivals, at malls, at annual dinners. But I suspect another reason is that they are safe. Few people will direct ugliness toward costumed children. The old, nasty words of ethnic jealousy probably won't be applied there, as they might toward adults. And so folklórico groups are often an immigrant culture's most visible aspect within the context of our greater society.

Much of the art we have been looking at is highly symbolic. Of

course, there are exceptions: many ethnic restaurants have a primarily economic function. But look at the various cowboy crafts discussed in chapter 3. Saddles, boots, spurs, reins—all these are purely functional items, necessary tools of the working cowboy. Yet when they are purchased and used by people who are not working cowboys, they take on a symbolic value as well. They make a statement concerning the cultural or regional identity, taste, or wealth of their owner. And when a cowboy selects his gear, other considerations than purely functional ones come into play. Styles of floral carving on saddles change, and those changes have to do with taste rather than with the efficiency of the saddle. Even the basic roping techniques of tie-fast and dally roping appear to be for the most part matters of style and preference rather than of strict practicality. And at least some of the criteria for selection of style involve the sort of person one wishes to be taken for.

All these considerations are fascinating, and they can enrich one's understanding and appreciation of the many folk and traditional arts of southern Arizona. Flour tortillas and tripas de leche have a bit more flavor for me when I realize that I am partaking of the direct results of Father Kino's work in the Pimeria Alta almost three hundred years ago. I am fascinated by the notion that the baroque style that Mission San Xavier displays so well lives on in contemporary household shrines and grave markers. The infinite variations with which a man armed with a welding torch and cast-off metal agricultural equipment can tell the passerby something about himself intrigues me. But just as the art leads me to the people and their heritages, thinking about those various traditions and their histories inevitably takes me back to the objects in a sort of full circle. The art is all around us, visible, tangible evidence of a wonderful diversity of cultures. We cannot share in the values, beliefs, aspirations, and anxieties that have given rise to the Yaqui Easter ceremony, to O'odham chicken scratch music, to Afro-American religious song, to all the ways in which southern Arizona's folk and ethnic communities decorate their lives. Not unless, that is, we are members of those communities. We can be aware of the wonderful variety of created beauty with which our human environment is filled, and let it enrich our own lives. It will if we give it a chance.

Bibliographic Essay

INTRODUCTION

Erwin Panofsky defines a work of art as "a man-made object demanding to be experienced aesthetically" on page 14 of his book, *Meaning in the Visual Arts* (Garden City, N.Y.: Doubleday, 1955). Taking that definition as my starting point, I suggest that to the extent that any human-made object demands to be experienced aesthetically, that object may be considered to fall into the category in Western culture called "art."

The three-level concept of contemporary American society echoes a notion long familiar to folklorists; one expression of it, applied to music, is in Jan Brunvand's *The Study of American Folklore* (New York: Norton, 1968). The term "folk art" is used in many ways; I refer the interested reader to Henry Glassie's "Folk Art" in *Folklore and Folklife* (Richard Dorson, ed., Chicago, University of Chicago Press, 1972) or Simon Bronner's "Introduction" to his *American Folk Art: A Guide to Sources* (New York: Garland, 1984). My broad usage of the concept of the folk arts echoes the approach of the Folk Arts Division of the National Endowment for the Arts.

Most regional studies of folk art to date have been connected with exhibitions and are thereby limited to the visual arts. For two excellent western examples see Suzi Jones, ed.: *Webfoots and Bunchgrassers: Folk Art of the Oregon Country* (The Oregon Arts Commission, 1980) and Steve Siporin, ed. *Folk Art in Idaho, "We Came To Where We Were Supposed To Be"* (Idaho

Commission on the Arts, 1984). Suzi Jones's *Oregon Folklore* (Eugene: University of Oregon and the Oregon Arts Commission, 1977) is closer to this book in scope, but closest of all are the illustrated booklets that the Smithsonian Institution produces for its annual Festival of American Folklife. That is no accident; I have for thirteen years organized a local folklife festival, and festival production is a deeply ingrained part of my experience and approach.

Finally, in this section as throughout the book, much of what I say is based, not on published material, but on personal experience as an "interested visitor" who for thirty years has tried to understand southern Arizona, its people, and their traditional arts.

1. THE ARTS OF MEXICAN AMERICANS

My favorite book on traditional Mexican cooking is *The Cuisines of Mexico* by Diana Kennedy (New York: Harper and Row, 1972). The "well-fried beans" translation of *frijoles refritos* is from page 282 of this source. Amalia Ruiz Clark's *Special Mexican Dishes, Easy and Simple to Prepare* (Tucson: Roadrunner Technical Publications, 1979) is the best cookbook I know specializing in southern Arizonan and northern Sonoran traditional recipes. The wild chiltepines of the Sonoran desert are well described by Gary Paul Nabhan in his excellent book, *Gathering the Desert* (Tucson: The University of Arizona Press, 1985).

I know of no reliable published history of mariachi music; therefore, I look forward to the day when Philip Sonnichsen publishes the results of his extensive research. An excellent introduction to all styles of Mexican-American music is still Philip Sonnichsen's "Chicano Music" on pages 44–51 of *The Folk Music Sourcebook* by Larry Sandberg and Dick Weissman (New York: Alfred A. Knopf, 1976). There are dozens of fine mariachi records on the market; the listener cannot go wrong with any of the recorded work of El Mariachi Vargas de Tecalitlan, the oldest mariachi extant, and one that easily wears the title of *el mejor mariachi del mundo*—"the best mariachi in the world." Their *LXXV Aniversario* record (Mexican RCA Victor MKS-1977) is only one of their many excellent LPs. (For residents of cities with sizable Mexican-American populations, I suggest looking in the Yellow Pages for specialty Mexican record or *discos Mexicanos* stores. They may not have the Arhoolie and Folklyric LPs I'll cite later—those can best be obtained by mail order—but they will have a lot of good Mexican music in all styles.)

For the norteño or conjunto style, the best book is Manuel H. Pena's *The Texas-Mexican Conjunto: History of a Working Class Music* (Austin; University of Texas Press, 1985). It has an accompanying LP by the same title (Folklyric 9049), with examples of the development of the style in Texas between 1935 and 1966. The Folklyric label is devoted to reissues of authentic

American folk, ethnic, and regional music from old and often rare original recordings. Its sister label Arhoolie is devoted to contemporary performances in the same musical genres. Both have magnificent norteño LPs on their lists. Both are available from Down Home Music/Arhoolie Records, 10341 San Pablo Avenue, El Cerrito, California 94530. Individual musicians to watch for in discos Mexicanos stores include Narciso Martinez, Santiago and Flaco Jimenez, and Los Alegres de Teran.

Two excellent reissues of early recorded corridos from the southwestern United States are *Corridos, Part 1* (Folklyric 9004) and *Corridos, Part 2* (Folk-lyric 9005). They are volumes 2 and 3 in Folklyric's excellent series *Una Historia de la Música de la Frontera* (A History of Border Music), which now numbers more than twenty albums, all reissued material from now un-available singles. Part 2 includes "El Corrido de los Hermanos Hernandez," written about two brothers from Casa Grande who were executed for murder in Florence in 1934.

"The Kennedy Corridos: A Study of the Ballads of a Mexican American Hero" by Dan William Dickey (The University of Texas at Austin: *Mono-graph No. 4 of the Center for Mexican American Studies*, 1978) is an excellent case study of the response of Mexican and Mexican-American folk poets to a specific person and event in recent history.

Of the three border corridos I cited in the text, two are obtainable on LP. "Contrabando de Nogales" is sung by Phoenix mariachi singer Alberto Pino on Side A, Band 1 of the LP *Contrabando de Nogales* (Musimex MM-5089), while both it and "Los Tres Mojados" are sung norteño style on Side A, Band 3 and Side B, Band 2 respectively of the LP *La Voz Norteña de Pedro Flores* (Discos Cisne CI-2019). "Tragedia en el Desierto" is performed by Julio Alberto con los 4 Cometas on the 45 RPM single PAJ-28, issued by El Pajarito—J.R.S. Records, P.O. Box 8648, Phoenix, Arizona 85066. Singles may not stay long in print; I do not know whether this latter record is still obtainable.

An excellent mariachi-style performance of "El Moro de Cumpas" by the great Sonoran singer Gilberto Valenzuela is on Side 1, Band 2 of *La Voz de Sonora: Gilberto Valenzuela* (Discos GAS-4076). (GAS—The Great American Sound—is produced at GAS Records, 2716 West Pico Blvd., Los Angeles, California 90006.)

Marguerite Collier's papers, photos, and memorabilia concerning her pio-neering work in Tucson's Carrillo Elementary School await the serious re-searcher in the Arizona Folklore Archive of the Southwest Folklore Center.

The story of the Bishop of Morelia and his piñata party comes from Frederick Starr's *Catalogue of a Collection of Objects Illustrating the Folklore of Mexico* (London: *Publication XLIII of the Folk-Lore Society*, 1898). This is the baseline for the study of Mexican popular art and custom, is well

illustrated and makes fascinating reading. More on Tucson's piñata makers can be found in my "Ernesto and Gloria Delgadillo: Professional Piñata Makers," pp. 62–66 of *Traditional Craftsmanship in America*, Charles Camp, comp. and ed. (Washington, D.C.: The National Council for the Traditional Arts, 1983).

Respect and Continuity: The Arts of Death in a Border Community (Nogales and Tucson: The Pimeria Alta Historical Society and the Southwest Folklore Center, 1985) gives a detailed look at the cemetery art and All Souls' Day celebrations in Ambos Nogales. Ann Hitchcock wrote a four-part study of Papago, Mormon, Chinese, and Mexican-American cemeteries in southern Arizona. It is published under the general title "Gods, Graves, and Historical Archaeologists" in vol. 1, nos. 2 and 4 (1971–72), vol. 2, no. 2 (1972) and vol. 3, no. 3 (1973) of *AFFWord*, published by the Arizona Friends of Folklore (Northern Arizona University, Flagstaff). Terry G. Jordan's *Texas Graveyards: A Cultural Legacy* (Austin: University of Texas Press, 1982) presents comparative material in a thoughtful manner.

The roots of contemporary, traditional Mexican and Mexican-American ironwork are well treated in *Southwestern Colonial Ironwork: The Spanish Blacksmithing Tradition from Texas to California*, by Marc Simmons and Frank Turley (Santa Fe: Museum of New Mexico Press, 1980). The wrought-iron cross on the dome of Mission San Xavier is illustrated on page 166 of this work. For published information on the Garden of Gethsemane, see the leaflet *Garden of Gethsemane—Felix Lucero Park*, published for the June 24, 1982, opening of the park by the Downtown Development Corporation, 100 North Stone Avenue, Suite 907, Tucson, Arizona 85701. Linda Ann Fundling's article "Short Trips: Sculptor Tilled Monument Garden" on page 1 of the South/West Edition Roundup Section of the *Arizona Daily Star* (Wednesday, May 2, 1984) has good information as well.

An overview of the mural movement in the United States is given in *Toward A People's Art*, by Eva Cockcroft, John Weber, and James Cockcroft (New York: E. P. Dutton, 1977). Tucson's murals are treated in "The Power of Cultural Identity, Mexican Mural Art," prepared in 1980 by Frank de la Cruz for the Sonoran Heritage Project of the Tucson Public Library, in William Clipman's "Up Against the Walls," vol. 3, no. 39 of the *Tucson Times*, (Nov. 8–23, 1979; pp. 12, 13), and Maria I. Vigil's "Hello Walls: Tucson's Murals" in the Tucson Citizen Newsletter, pp. 14–16 (*Tucson Citizen*, Saturday, March 29, 1980).

A good treatment of low riders in Texas is William Gradante's "Low and Slow, Mean and Clean" in *Natural History*, vol. 19, no. 4 , pp. 28–38 (New York: American Museum of Natural History, April, 1982). Some Tucson cars and their owners are discussed in "Colorful low riders enter world of art" by Steve Cheseborough (Tucson: The *Arizona Daily Wildcat*, Encore Section,

October 9, 1982) and "Low Riders: Cars with personality, mystique cruise into Tucson Meet Yourself exhibition" (Tucson: *El Independiente*, October 1, 1983, page 5).

The finest published treatment of the visual arts of any Mexican-American community is *Art Among Us/Arte Entre Nosotros*, by Pat Jasper and Kay Turner (Texas: The San Antonio Museum Association, 1986). It deals with the traditional arts of San Antonio's West Side, and is a model for all who work in this field.

2. THE TRADITIONAL ARTS OF NATIVE AMERICANS

The Desert People: A Study of the Papago Indians by Alice Joseph, Jane Chesky, and Rosamond Spicer (Chicago: The University of Chicago Press, 1974 reprint) and *Of Earth and Little Rain: The Papago Indians* by Bernard Fontana (Flagstaff: The Northland Press, 1981) are excellent general introductions to the culture and traditions of the Tohono O'odham. *The Papago Indian Reservation and the Papago People* (The Papago Tribe, n.d.) has much general information as well. A good source for many of the traditional stories of the O'odham is Dean and Lucille Saxton's *O'othham Hoho'ok A'Agitha: Legends and Lore of the Papago and Pima Indians* (Tucson: The University of Arizona Press, 1973).

Clara Lee Tanner's *Indian Baskets of the Southwest* (Tucson: The University of Arizona Press, 1983) has a good presentation of Tohono O'odham basketry, as does Terry DeWald's *The Papago Indians and Their Basketry* (Tucson: published by author, 1979). *Papago Indian Pottery* by Bernard L. Fontana, William J. Robinson, Charles W. Cormack, and Ernest E. Leavitt, Jr. (Seattle: The University of Washington Press, 1962) is still the basic source for information on that craft.

The Desert Smells Like Rain: A Naturalist in Papago Indian Country (San Francisco: North Point Press, 1982) and *Gathering the Desert* (Tucson: The University of Arizona Press, 1985), both by Gary Paul Nabhan, deal sensitively with traditional Tohono O'odham foodways, among many other subjects. Ruth Murray Underhill's *Singing for Power: The Song Magic of the Papago Indians of Southern Arizona* (New York: Ballantine Books, 1973 reprint of 1938 original) provides a thoughtful and accurate view of Tohono O'odham poetry and its uses.

The two songs I quote are from the general repertoire of Big Fields Village on the Tohono O'odham Reservation. They appear on Side B, Band 5 of the LP record *Folk Music in America, Volume 13: Songs of Childhood*, edited by Richard K. Spottswood and Rick Ulman (Library of Congress, Music Division, Recording Library LBC-13). The translations are from page 10 of the accompanying booklet, and were made by Danny Lopez of Tucson.

Excellent collections of traditional Tohono O'odham songs are found in *An Anthology of Papago Traditional Music*, in two volumes (Canyon Records C-6084 and C-6098). These as well as the other records of Native American music cited in this chapter are available from Canyon Records, 4143 North 16th Street, Phoenix, Arizona 85016.

I have discussed waila or "chicken scratch" at greater length in "Waila, the Social Dance Music of the Indians of Southern Arizona: An Introduction and Discography" on pages 193–204 of the *JEMF Quarterly*, vol. 15, no. 56 (John Edwards Memorial Foundation: The Folklore and Mythology Center of the University of California at Los Angeles, Winter, 1979). Canyon Records has produced more than thirty LPs and tapes of waila; *Chicken Scratch Fiesta* (CR-8055) is a good sampler featuring several bands.

No recordings are yet available of the older fiddle band music. The music may be heard each year at the All-O'odham Old Time Fiddle Orchestra Contest on Saturday evening of the annual Wa:k Pow Wow. The event takes place in early March at Mission San Xavier.

A detailed discussion of O'odham folk Catholicism is in William Sherman King's unpublished M.A. thesis, *The Folk Catholicism of the Tucson Papagos* (The University of Arizona, 1954). My unpublished Ph.D. dissertation *The Catholic Religious Architecture of the Papago Reservation, Arizona* (Tucson: The University of Arizona, 1973) deals with the architecture and its uses, as does the short article "The Folk Catholic Chapels for the Papagueria" in vol. 7, no. 2 of *Pioneer America* (Falls Church, Virginia: The Pioneer American Society, July, 1975). The Fiesta de San Francisco in Magdalena is the subject of vol. 16, nos. 1–2 of *The Kiva* (Tucson: The Arizona Archaeological and Historical Society, October-November, 1950). Bernard Fontana's "Pilgrimage to Magdalena: The Feast of San Francisco Reflects Past and Present in Sonora" in vol. 18, no. 5 of *American West* (September-October, 1981) gives an excellent picture of the fiesta as it was in the early 1980s. My article "Magdalena Holy Pictures: Folk Art in Two Cultures" in vol. 8, nos. 3–4 of *New York Folklore Quarterly* (Binghamton, N.Y.: New York Folklore Society, Winter, 1982) deals with the reverse glass paintings which are made in Magdalena for sale to O'odham pilgrims.

The most complete treatment of Yaqui culture in Arizona and Sonora is Edward H. Spicer's *The Yaquis: A Cultural History* (Tucson: The University of Arizona Press, 1980). *With Good Heart: Yaqui Beliefs and Ceremonies in Pascua Village* by Muriel Thayer Painter (Tucson: The University of Arizona Press, 1986) gives a detailed discussion of Yaqui religious tenets and practices in one Arizona community. *A Yaqui Easter* by the same author (Tucson: The University of Arizona Press, 1976) is an excellent introduction to the Yaqui Lenten and Easter drama as it is presented in Tucson. *Old Men of the Fiesta: An Introduction to the Pascola Arts* by James S. Griffith and Felipe S.

Molina focuses on the pascola complex of Arizona, Chihuahua, and Sonora. Last but not least, Larry Evers and Felipe S. Molina's *Yaqui Deer Songs/ Maso Bwikam: A Native American Poetry* (Sun Tracks, vol. 14; Tucson: Sun Tracks and the University of Arizona Press, 1987) is a beautifully sensitive treatment of that important body of Yaqui poetry.

The first Yaqui deer song quoted in the text comes from page 37 of *Old Men of the Fiesta*; the other comes from the liner notes of the LP record *Yaqui Fiesta and Religious Music* (Canyon 7999-C). Both were translated by Felipe S. Molina. Other excellent general recorded collections are *Yaqui: Music of the Pascola and Deer Dance* (Canyon C-6099) and *Yaqui Ritual and Festive Music* (Canyon C-6140). *Yaqui Pascola Music of Southern Arizona*, performed by Francisco Molina (violin) and Marcelino Valencia (harp) (Canyon CR-7998), is also very good. The fifty-one minute videotape "Seyewailo: The Flower World" concentrates on Yaqui Deer songs in their fiesta context and is available from Clearwater Publishing Company, Inc., 1995 Broadway, New York, New York 10023. It is one of a series *Words and Place* dealing with Native American literature of the Southwest. The series was edited by Larry Evers.

The San Xavier Fiesta, sponsored each year by the Tucson Festival Society on the Friday evening after Holy Week, provides an opportunity for the general public to see Yaqui pascolas, deer dancers, and matachinis, as well as O'odham keihina (circle) dances. Frequently, other Tohono O'odham music and dance traditions are presented as well. The event is free of charge.

I am aware of no good published introduction to powwow. The short article, "Powwows in 1978," in the May 1978 issue of *Sunset Magazine* is helpful. Some of my information on Plains style dancing comes from Reginald and Gladys Laubin's *Indian Dances of North America* (Norman: The University of Oklahoma Press, 1977). Although there are no commercial recordings of southern Arizona drums, Canyon Records has an extensive catalog of powwow music from the Great Plains region.

Powwows are often held in connection with tribal fairs. The annual Wa:k Pow Wow takes place at San Xavier on the first weekend after the Tucson Rodeo, usually in early March. Other events are announced in the papers.

3. OTHER REGIONAL ARTS

There are many published discussions of the interplay between myth and reality in the American West. *The American Cowboy* by Lon Taylor and Ingrid Maar (Washington, D.C.: The American Folklife Center of the Library of Congress, 1983) and C. L. Sonnichsen's *From Hopalong to Hud: Thoughts on Western Fiction* (College Station: Texas A & M University Press, 1978) are good starting points.

My favorite treatment of traditional ranch cooking is Stella Hughes's *Chuck Wagon Cookin'* (Tucson: The University of Arizona Press, 1974). Hughes dishes out a generous helping of stories along with her recipes and descriptions of techniques. All are worth reading.

Ramon Adams's *Western Words: A Dictionary of the American West* (Norman: The University of Oklahoma Press, 1968) gives the derivations for many of the terms I mention in this chapter, along with a host of others. A thoughtful discussion of the tie fast–dally roping controversy may be found in chapter 9 of John R. Erickson's *The Modern Cowboy* (Lincoln: The University of Nebraska Press, 1981).

Cowboy Slang by Edgar R. "Frosty" Potter (Phoenix: Goldene Wests Publishing Company, 1986) is a good recent collection of colorful word usage from the world of cowboys. The phrase about "pawin' the white out of the moon" comes from the song "The Zebra Dun." A representative text of this cowboy classic may be found in John A. Lomax's *Cowboy Songs and Other Frontier Ballads* (New York: MacMillan, 1916), itself a classic in its genre. The verse about riding among the planets comes from the rare song, "The Spike Horn Bull," as performed by Chuck Lakin of Tolleson, Arizona, on tape in the Arizona Folklore Archives.

Don Dedera's *The Cactus Sandwich and Other Tall Tales from the Southwest* (Flagstaff: The Northland Press, 1986) is a fine collection of Arizona and other "windies," old and new. For some gems by the late Dick Wick Hall, see *Dick Wick Hall: Stories from the Salome Sun by Arizona's Most Famous Humorist*, edited by Frances Dorothy Nutt (Flagstaff: The Northland Press, 1968).

"The Cowboy's Prayer" is from *Sun and Saddle Leather* by Charles Badger Clark (Tucson: Westerners International, 1983). Gail Gardner's poems appear in his *Orejana Bull for Cowboys Only* (Prescott: Sharlot Hall Museum, 1987); an excellent discussion of him and his poems appears in John I. White's *Git Along Little Dogies: Songs and Songmakers of the American West* (Urbana: University of Illinois Press, 1975). Incidentally, this last book is one of the best ever written on cowboy songs and their composers.

"Arizona: How It Was Made and Who Made It; or The Land That God Forgot" (also known as "Hell's Half Acre" and "Arizona: 4000 B.C.") has appeared on many printed sheets, a number of which are on file in the Arizona Folklore Archives.

There are several excellent collections of cowboy songs. My favorite recent one, by a working cowboy who spent some time in southern Arizona, is *The Hell-Bound Train: A Cowboy Songbook*, by Glenn Ohrlin (Urbana: The University of Illinois Press, 1973). Hal Cannon has recently edited *Cowboy Poetry: A Gathering* (Salt Lake City: Peregrin Smith Books, 1985), a collection of old and new poems from the cowboy recitation tradition. The best recent essay on that tradition is by Carol A. Edison, and appears in her *Cow-*

boy Poetry from Utah: An Anthology (Salt Lake City: Utah Folklife Center, 1985).

Cowboy songs performed by practicing or former cowboys are available on a number of LP records. *When I Was a Cowboy: Songs of Cowboy Life* (Morning Star 45008) contains fourteen fine recordings from the 1920s and 1930s. It is available from Morning Star Records, Dalebrook Park, Ho-Ho-Kus, New Jersey 07423. *Glenn Ohrlin: The Wild Buckaroo* (Rounder 0158) has eighteen performances by cowboy and rancher Ohrlin, who is a 1985 recipient of the National Endowment for the Arts Heritage Award for his work in maintaining and fostering his cowboy traditions. *Tioga Jim: Ranch-house Songs and Recitations* by Van Holyoak (Rounder 0108) preserves the performances of a much-loved singer, poet, and reciter from Clay Springs, Arizona. Both are available from Rounder Records, 186 Willow Avenue, Somerville, Massachusetts 02144. Slim Crichtlow—Cowboy Songs: *"The Crooked Trail to Holbrook"* (Arhoolie 5007) features a former radio entertainer of the 1930s and includes a fine performance of the rare title song which describes an 1880s trail drive from central Arizona to the shipping pens at Holbrook.

Two other records by professional Arizona entertainers contain interesting material. *Katie Lee Sings Ten Thousand Goddam Cattle* (Katydid KD-10076) has twenty-eight performances of old and new cowboy songs and is available from Katydid Records, Box 395, Jerome, Arizona 86331. *The Liar's Hour* (no number; Latigo Records, P.O. Box 1317, Cortaro, Arizona) by Travis Edmondson and Bill Moore mixes songs and recitations. Edmondson is a veteran of the 1960s "Folk Revival" and half of the famed "Bud and Travis" duet; Moore is a cowboy, a dude wrangler, and fine poetry reciter.

A good history of the Sons of the Pioneers may be found in *Hear My Song: The Story of the Celebrated Sons of the Pioneers* by Ken Griffis (Folklore and Mythology Center, UCLA: The John Edwards Memorial Foundation Special Series No. 5, 1977). Several recordings by the Sons of the Pioneers are in print. *The Sons of the Pioneers* (JEMF 102) contains twenty performances recorded for radio use in 1940 and is available from Arhoolie Records. The contemporary sound of the "Sons" may be heard on *Celebration Vol. 1*, available from Silver Spur Records, Inc., 12403 West Green Mountain Circle, Lakewood, Colorado 80228. *Back in the Saddle Again* (New World 314/315) is a two-LP set of both cowboy and western songs by a variety of contemporary and early day performers. It is available from New World Records, 231 East 51st Street, New York, New York 10022. Like many of the records cited in this book, most of these have extensive and informative liner notes, often by leading scholars in the field.

Dude Ranching: A Complete History by Lawrence R. Borne (Albuquerque: The University of New Mexico Press, 1983) is an excellent introduction to that important subject. Much information on dude ranching and the re-

lated chuck-wagon restaurant movement may still be obtained through short interviews and conversations with people who have been involved in both of these interpretive institutions.

The Camp Family has released several records and tapes of their Triple C Ranch performances. Those that are still in print are available from The Triple C Ranch, 8900 West Bopp Road, Tucson, Arizona. In particular their Triple C Chuck Wagon Stage Show, a live recording, gives an excellent notion of this genre of western entertainment. A cassette of a 1987 live performance by the Sons of the Pioneers at the Triple C Ranch is also available from the same source, and it contains some fine traditional country comedy.

San Antonio Rose: The Life and Music of Bob Wills by Charles R. Townsend (Urbana: The University of Illinois Press, 1976) gives an excellent introduction to the man credited with originating western swing. Bill J. Malone's *Country Music, U.S.A.* (Austin: University of Texas Press; revised edition, 1985) is a superlative introduction to the entire field of American country music, including many of the genres discussed in this and the following chapters.

The Bob Wills Anthology (Columbia KG 32416) offers an excellent cross section of Wills's earlier recordings. A series of anthologies on the Old Timey label (Old Timey 105, 116, 117, 121–123, available from Arhoolie Records at the address given in the notes to Chapter 1) provide an overview of the genre as it changed from the 1930s through the 1950s. A blend of old-time fiddling and "hot" western swing fiddling as played by two important members of the Sons of the Pioneers may be heard on *"The Farr Brothers— Texas Crapshooter* (JEMF 107, available through Arhoolie Records).

I know of no book or article that gives a good discussion of old-time fiddling either on a national level or for Arizona specifically. However, a multitude of LPs and tapes are currently available covering virtually every regional fiddle style that has grown up across North America. *Old-Time Fiddle Classics* (County 507) contains reissued pre-World War II performances by outstanding fiddlers from the Southeast and Texas, while *Texas Farewell* (County 517) concentrates on Texas fiddlers of the same era. Both are available from County Records/Sales, P.O. Box 191, Floyd, Virginia 24091. Texas Hoedown (County 703) features excellent performances by a number of influential fiddlers in the Texas contest style. *Fiddlin' Wes—Texas Style* (Goldust LPS-172) is a collection of tunes by Wes Nivens, a Texas fiddler now living in southern New Mexico who appears frequently at Arizona contests. This record, which includes several tunes made famous by Bob Wills, may be ordered from Goldust Records Company, P.O. Box 998, Mesilla Park, New Mexico 88047. The same company also carries the work of other important regional fiddlers, in particular the nationally known Junior Daugherty of Mesilla Park and Hyram Posey, a former Bisbee resident.

Arthur Woodward's article "Saddles in the New World" in the *Los Angeles County Museum Quarterly* (vol. 10, no. 2, pp. 1–5, 1953) discusses the Spanish and Mexican origins of the western stock saddle. Russell H. Beattie's *Saddles* (Norman: The University of Oklahoma Press, 1981) provides a thorough, well-illustrated introduction to the entire subject. Bruce Grant's *Encyclopedia of Rawhide and Leather Braiding* (Centreville, Maryland: Cornell Maritime Press, 1972) is a complete treatment of those complex subjects on a "how to do it" level. Faye E. Ward's *The Cowboy At Work: All About His Job and How He Does It* (New York: Hastings House, 1976) is still the best introduction to the tools, techniques, and accoutrements of traditional cowboying. *Hot Irons* by Oren Arnold and John P. Hale (New York: Cooper Square, 1972) and *The Manual of Brands and Marks* by Manfred R. Wolfenstine (Norman: The University of Oklahoma Press, 1970) are useful introductions to many aspects of brands and branding.

Several books of varying quality have recently been published on the subject of rodeo. Two of the most useful are Kristine Frederikson's *American Rodeo from Buffalo Bill to Big Business* (College Station: Texas A & M University Press, 1985) and Bob St. John's *On Down the Road: The World of the Rodeo Cowboy* (Austin, Texas: Eakin Press, 1983).

The rest of the material in this chapter, in particular the discussions of costumes, parades, and Mormon and mining lore, come from my own personal observations. Some of those observations on Mormon Pioneer Day as celebrated in St. Johns, Arizona, are set forth in more detail in "Pioneer Days in St. Johns, Arizona: A Celebration of Values" (Salt Lake City: *Utah Folklife Center Newsletter*, vol. 18; Spring 1984). Interesting images and discussions of traditional Mormon visual arts occur in the catalogs of two recent exhibitions in Utah. They are: *Utah Folk Art: A Catalogue of Material Culture,* edited by Hal Cannon (Provo: Brigham Young University Press, n.d.) and *The Grand Beehive,* compiled and with an introduction by Hal Cannon (Salt Lake City: The University of Utah Press, 1980). Much useful information concerning old-time miners and their skills can be found in an excellent book by Otis E. Young, Jr., called *Black Powder and Hand Steel: Miners and Machines on the Old Western Frontier* (Norman, The University of Oklahoma Press, 1976). The list of mining claims is taken from USGS topographic maps of southern Santa Cruz County. There is a lot of poetry on those topo sheets.

4. THE ARTS OF IMMIGRANT CULTURES

The best printed discussion of Bluegrass is Neil V. Rosenberg's *Bluegrass: A History* (Urbana: The University of Illinois Press, 1985). His exhaustive bibliography and discography provide excellent guides to further

reading and listening. For the sound of Bill Monroe's Blue Grass Boys, see any of Monroe's in-print albums on the MCA (formerly Decca) label. Most record stores carry Bluegrass albums: important traditional bands are the Stanley Brothers, the Osborne Brothers, and Jim and Jesse and the Virginia Boys. Rounder Records and County Records (addresses given in the notes to Chapter 3) have both produced excellent reissue albums of early historic Bluegrass. Bands with the "Newgrass" sound include the Country Gentlemen, the Newgrass Revival, and the Seldom Scene. Hot Rize is a fine Colorado-based group that blends the traditional and the contemporary sounds.

For local Bluegrass music, my review article, "Some Southern Arizona Bluegrass Records," in *Southwest Folklore* (Flagstaff: The Arizona Friends of Folklore, 1979) gives the range of what was available in the late 1970s. Little has been published since, and I suspect that most, if not all, of the records I reviewed are out of print. None of the bands mentioned in that article is still playing.

More details on the careers of Orris and Ruth Poling may be found in my article, "Coming Full Circle—West Virginia Musicians Continue Singing in Arizona," vol. 4, no. 4 of *Goldenseal* (Charleston: October-December, 1978).

The First Hundred Years: A History of Arizona Blacks by Richard E. Harris (Apache Junction, Arizona: Relmo Publishers, 1983) gives useful historic information on Arizona's black communities.

The Gospel Sound by Tony Heilbut (Garden City, N.Y.: Anchor Books, Doubleday, 1975) is an introduction to modern black religious music. Its discography is thorough and helpful. The only LP of Arizona black sacred music I am aware of is *An Evening With Rev. Louis Overstreet, His Guitar, His Four Sons, and the Congregation of St. Luke Powerhouse Church of God in Christ* (Arhoolie 1F-1014). Reverend Overstreet, born in Louisiana, was recorded in Phoenix in 1962. He has since died.

A sampling of the sounds of the 1975 and 1976 editions of Tucson Meet Yourself may be heard on *Hot Times in Tucson: Arizona Music from Tucson Meet Yourself*, available from the Southwest Folklore Center, 1524 East Sixth Street, Tucson, Arizona 85719. Among the artists appearing on the record are Willie Walker and Leslie Keith, both mentioned in this chapter. My two articles, "Tucson Meet Yourself—A Festival as Community Building" (The Arizona Friends of Folklore, Flagstaff: *Southwest Folklore*, vol. 1, no. 1, 1977) and "Tucson Meet Yourself" (pp. 131-43 of *Folk Festivals*, by Joe Wilson and Lee Udall, Knoxville: The University of Tennessee Press, 1982), present the aims and some of the details of that annual festival.

Rosemaling is given a thorough discussion in chapter 4 of J. S. Stewart's *The Folk Arts of Norway* (Madison: The University of Wisconsin Press,

1953). The Tucson rosemaling scene is treated briefly in the article, "Nordic Rosemaling Finds 'velkommen' in Land of Earth Tones and de Grazia," by Bonnie Henry in the January 17, 1985, edition of *The Arizona Daily Star*. The Norsemen's Federation publishes a bimonthly magazine, *The Norseman*, available from Nordmanns-Forbundet, Radhusgt. 23 B - Oslo 1, Norway.

For information on Ukrainian-American folk art in Tucson, as well as suggestions for further reading on Ukrainian folk art, see my *Celebrating a Heritage: The Traditional Arts of Tucson's Ukrainian-American Community* (Tucson: The Southwest Folklore Center, 1984). The Winter 1986 edition of *Bisbee Magazine* (The Bisbee Observer, 7 Bisbee Road, Suite K, Bisbee, Arizona 85603) contains "A Serbian Christmas" by Ignacio Ibarra. Further information on Bisbee's Serbian population comes from various printed programs on file in the Southwest Folklore Center.

Barbara Glinski, her life and her paper-cutting craft are discussed in "Home in New Land Free of 'Oppression' " by Drez Jennings in the *Arizona Daily Star* (Tucson: Thursday, September 22, 1983; "Neighbors" Section).

Much of my information on the techniques, ingredients and regions of Chinese cooking comes from *The Thousand Recipe Chinese Cookbook* by Gloria Bley Miller (New York: Grosset and Dunlap, 1973) and *Regional Chinese Cooking* by Kenneth Lo (New York: Pantheon Books, 1979). *Japanese Cooking* by Susan Fuller Slack (Tucson: HP Books, 1985) provided much useful information as well. The experiences of a Vietnamese wood-carver who immigrated to Tucson are recounted in "Woodcarvings Done with a View" by Chip Warren in the *Arizona Daily Star* (Tucson: Thursday, August 4, 1983; C-4).

Much of the information and ideas in this chapter (and indeed in the entire book) comes from the experience of researching and organizing Tucson Meet Yourself, a process that began in 1974 and continues to this day.

Index

About the Author

JAMES S. GRIFFITH has been the director of the Southwest Folklore Center of the University of Arizona since 1979. With his wife Loma, he founded Tucson Meet Yourself, an annual autumn festival celebrating the ethnic foods and folkways of southern Arizona. Griffith holds a Ph.D. in anthropology from the University of Arizona, and in addition to publishing a monthly column in *City Magazine*, he is a regular guest on Tucson radio and television.